Haciendas

Haciendas

Spanish Colonial Houses in the U.S. and Mexico

LINDA LEIGH PAUL

Principal photography by Ricardo Vidargas

RIZZOLI
NEW YORK

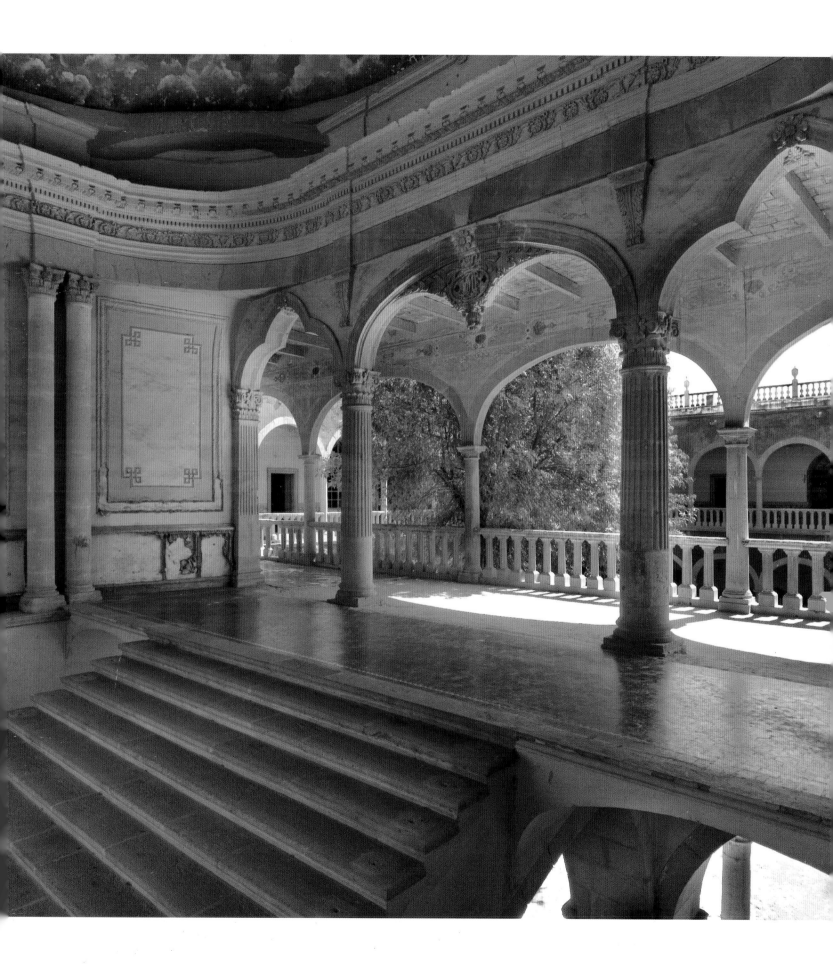

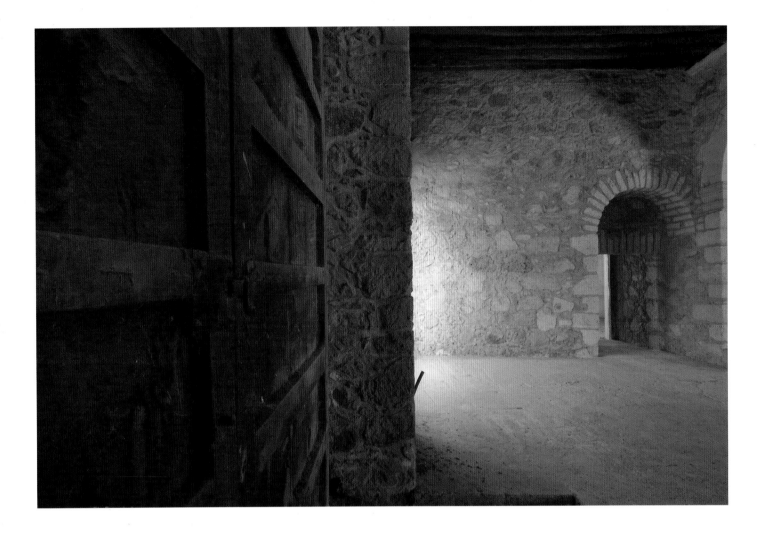

PREVIOUS PAGE: The once-grand staircase and balcony at the ruins of the Hacienda San Diego de Jaral de Berrios. ABOVE: Cool shadows and dusty light in a stable of stone, wood timbers, and doors at Hacienda San Diego de Jaral de Berrios. OPPOSITE: Long, low stairs and small-cut openings allow air to flow throughout a system of passages that kept temperatures cold for goods held in cherished wine and food cellars. FOLLOWING PAGES: The extraordinary arches, arcades, loggias, courtyard, and towers are just a small glimpse of the Hacienda San Diego de Jaral de Berrios.

CREDITS
pp. 3, 4, 5, 7, 8, 10, 13, 14, 17: Ricardo Vidargas
p. 11 *Non me Toques* Photograph by Charley Brown
p. 12 *Entre sueños de calas y memorias pasadas* Photograph by Charley Brown
p. 16 *Rosa Hemisphaerica* Photograph by Basil
p. 18 *Casa Llena* Photograph by Basil
p. 88 *Non, L'Ho Notato L'Ho Propio Visto* Photograph by Margarita Leon
p. 150 *Out on a Limb* Photograph by Basil
p. 216 *Sueño de Oleander (Detail)* Photograph by Margarita Leon
p. 222 *Esparanza, A Necessary Condition* Photograph by Margarita Leon

First published in the United States of America in 2008 by Rizzoli International Publications, Inc.
300 Park Avenue South
New York, NY 10010
www.rizzoliusa.com

© 2008 by Linda Leigh Paul

2012 2013 2014 / 10 9 8 7 6 5 4 3

Printed in China

Design by Lynne Yeamans

ISBN: 0-8478-3099-3
ISBN 13: 978-0-8478-3099-2

Library of Congress Control Number: 2008926180

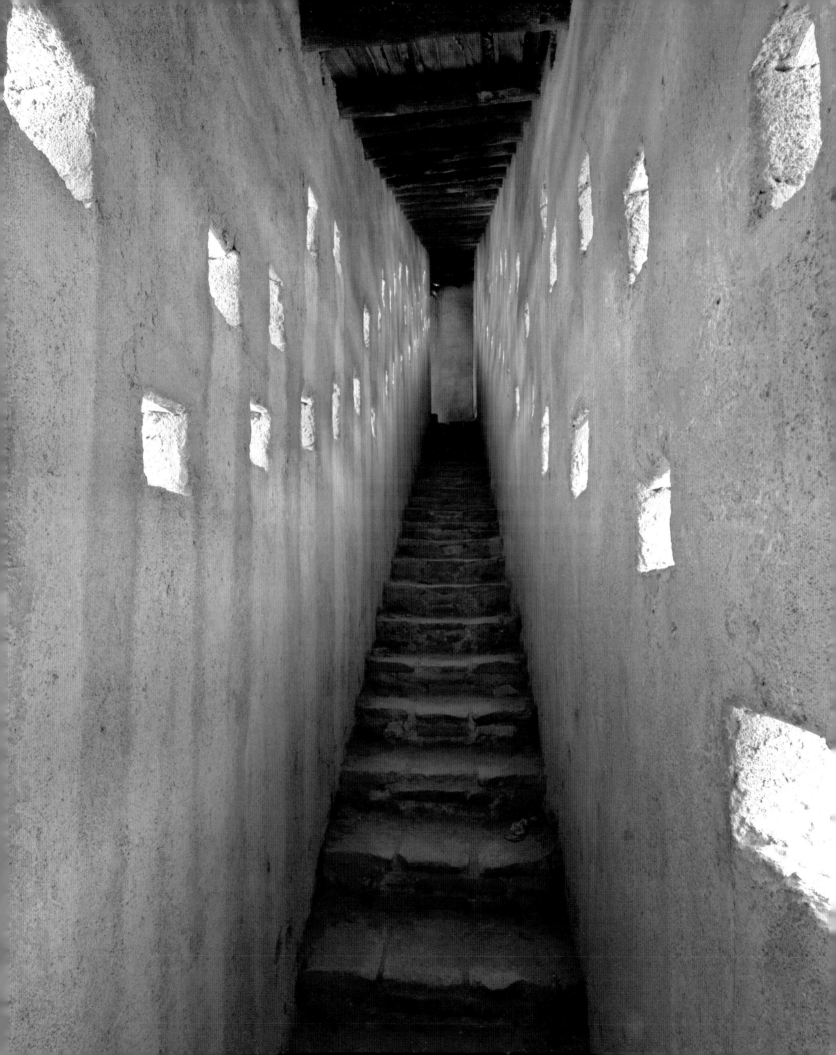

CONTENTS

RIGHT: The once-grand staircase and balcony now in ruins at the Hacienda San Diego de Jaral de Berrios.

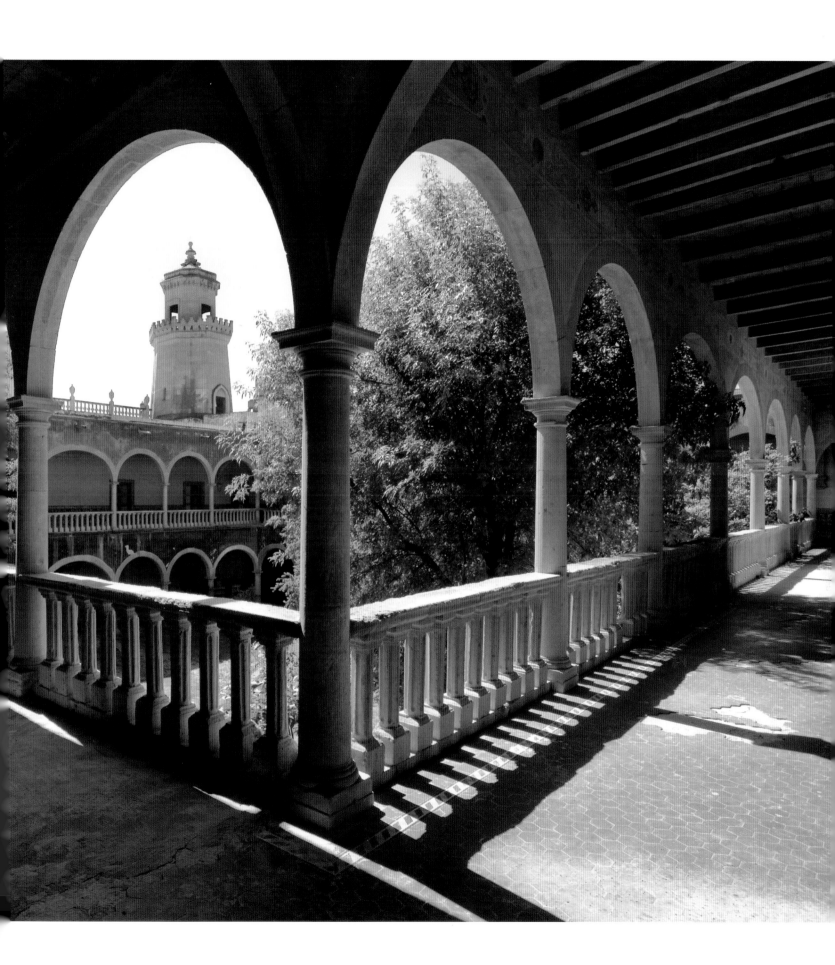

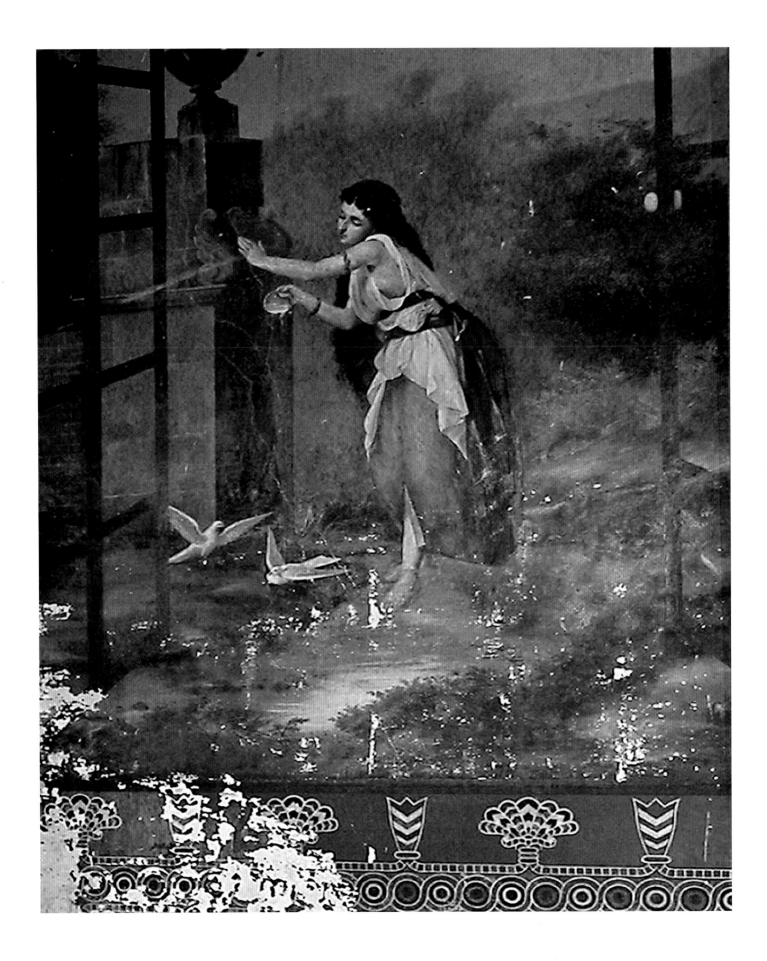

PART I

I think that the ideal space must contain elements of magic, serenity, sorcery and mystery.
— Luis Barrágan

OPPOSITE: A detail from the wall mural *The Girl at the Gate Watering Doves* has captured hearts since circa 1891. The painter is N. Gonzales.

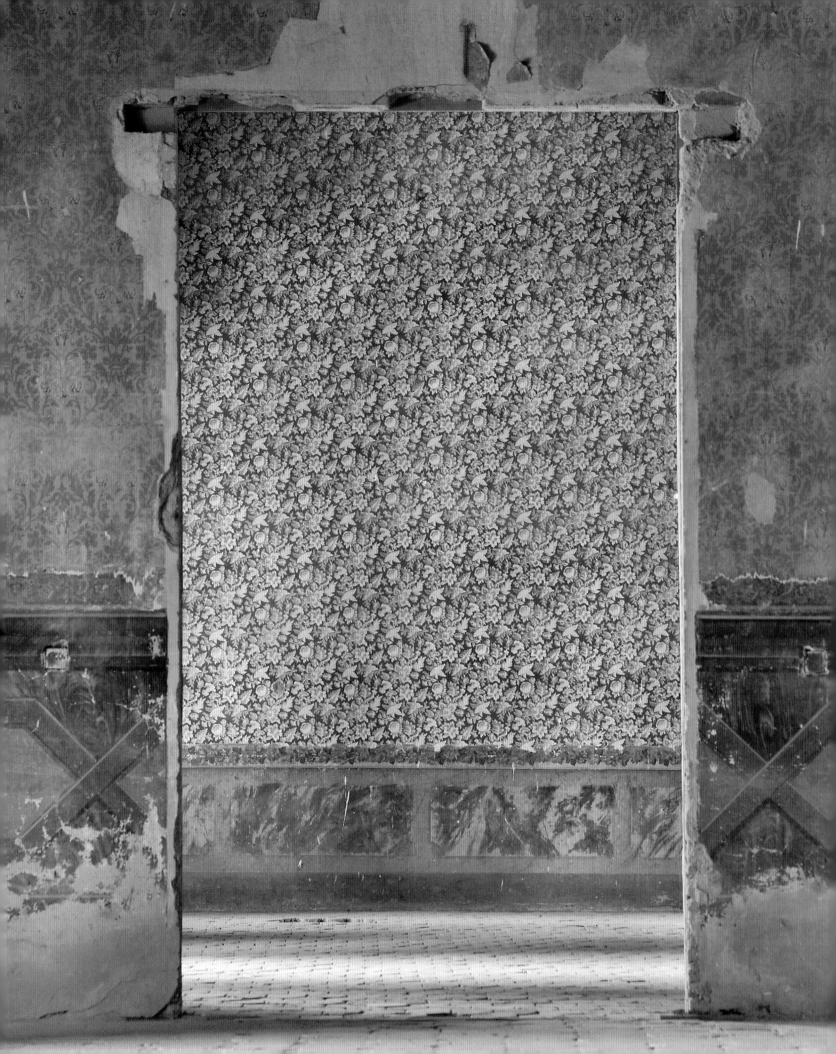

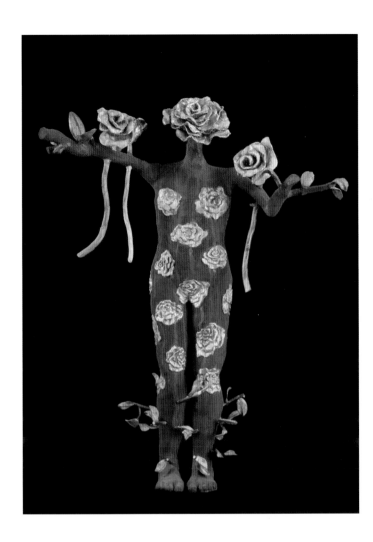

LEFT: Textures are built by the complex coordinating of wallpaper patterns, large borders in paint, colors, and floors clad with terra cotta tiles. ABOVE: *Non me toques*; Margarita Leon; Clay, wood, iron, patina, resin; 33"h x 28"w x 6"d.

Introduction

The hacienda exists ab aeterno.

In our dreams images represent the sensations we think they cause...
 —Coleridge

There must have been a multitude of gods to dream the hacienda. Rising up in the thickest jungles or loneliest deserts, brush lands or wilds—wherever their borders crested and crossed distant hills, valleys, and rivers—they grew. Buildings do, ultimately, dissolve when abandoned, and hacienda ruins offer little defense against time. That all things vanish at a distance is an idea based in part upon the creation of places where the body no longer goes, but the evening botany of dreams might one day induce the gods to bring them closer.

The quintessence of this dream on earth was begun in Mexico by pious Mendicant Orders, whose scheme included authority over every facet of daily life in New Spain. The first to arrive was a band of Franciscans known as the Apostolic Twelve, an extraordinary troop of radicals who led the Catholic parade in 1524. They were untiring, compassionate champions of Indian rights against the white colonists. They began to build, using their inherent gifts of genius as well as their intuitive interpretations of the eclectic moods, architectural fantasies, and beloved rituals that had been closeted in their surroundings of European Christian architecture. They used venerated forms such as vaults with delicate intersecting ribs inspired by the Gothic and Baroque; arcaded arches, towers, domes, and porticoes from their reinterpreted traditions of ancient Rome; and the pure Italian High Renaissance that pushed into Spain. Thin architectural columns flowered, and squinches became decorative. Effulgent canopies inspired Charles V to build the Alhambra in Granada, in the style of this architecture called Moorish. The Moors, of course, guided their architectural legacies with messages written in the walls to remind us that *Wa al-ghalib billah*—Only God is the Conqueror—which abetted the Franciscans, who furiously constructed their buildings from

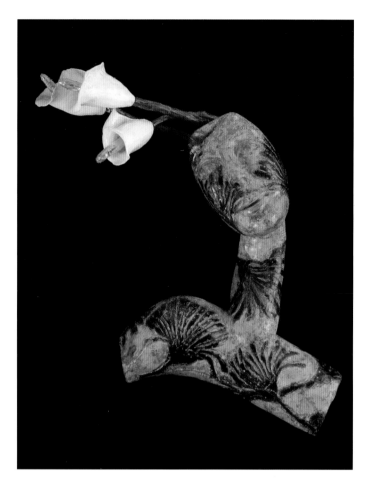

ABOVE: *Entre sueños de calas y memorias pasadas;*
Margarita Leon; Wood, oil paint, copper sheeting;
24"w x 30"h x 6"d. RIGHT: Pure Moorish styling in the
interior rooms reveals remnants of lattice above the
center doorway.

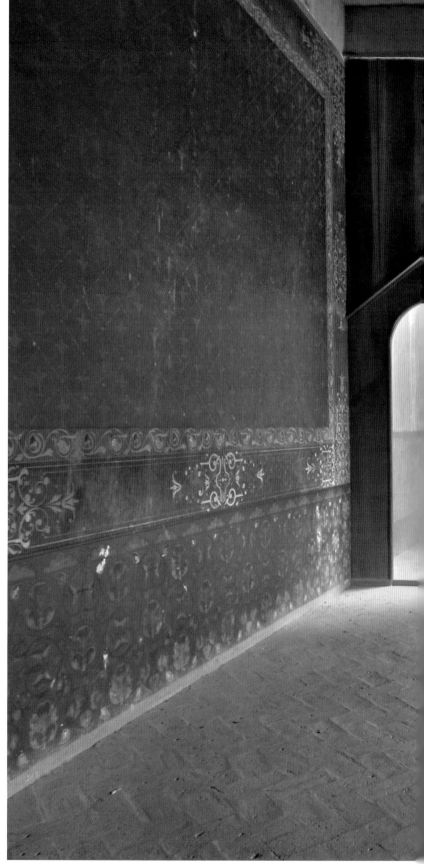

memory, instinct, and a keen sense of improvisation that would
be the genesis of a new hemispheric architectural legacy.

Joining the gods of the Spanish, the Italians, the Moors, and
the Goths were the Indian deities of Mexico. They were warrior
gods, rain gods, gods of the winds, and agriculture gods. They,
too, had for centuries created monuments of imperial scale: thin
stairs leading two hundred feet into an open sky, where small,
open plateaus crown the broad-based, narrow-peaked temple-
pyramids of stone. On the ground the entrances were approached
in reverence via a large *atrio*, where communities of indigenous
peoples venerated their gods in large, open areas advancing toward
the temple-pyramids. The design of the atrio is an adaptation of

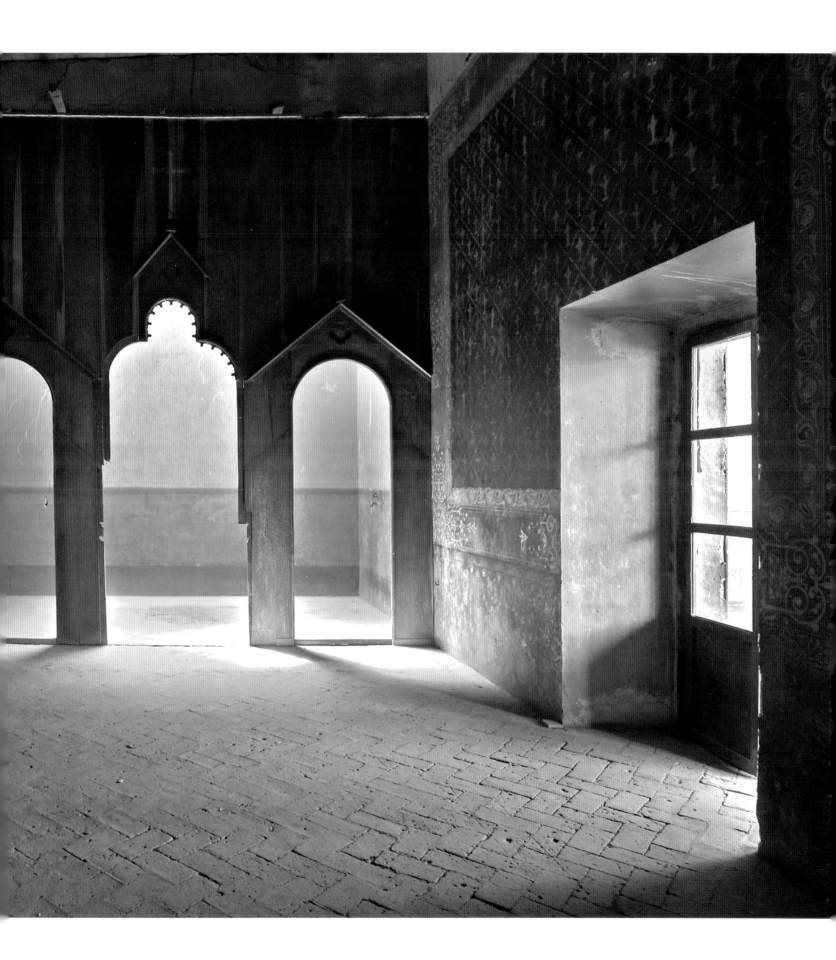

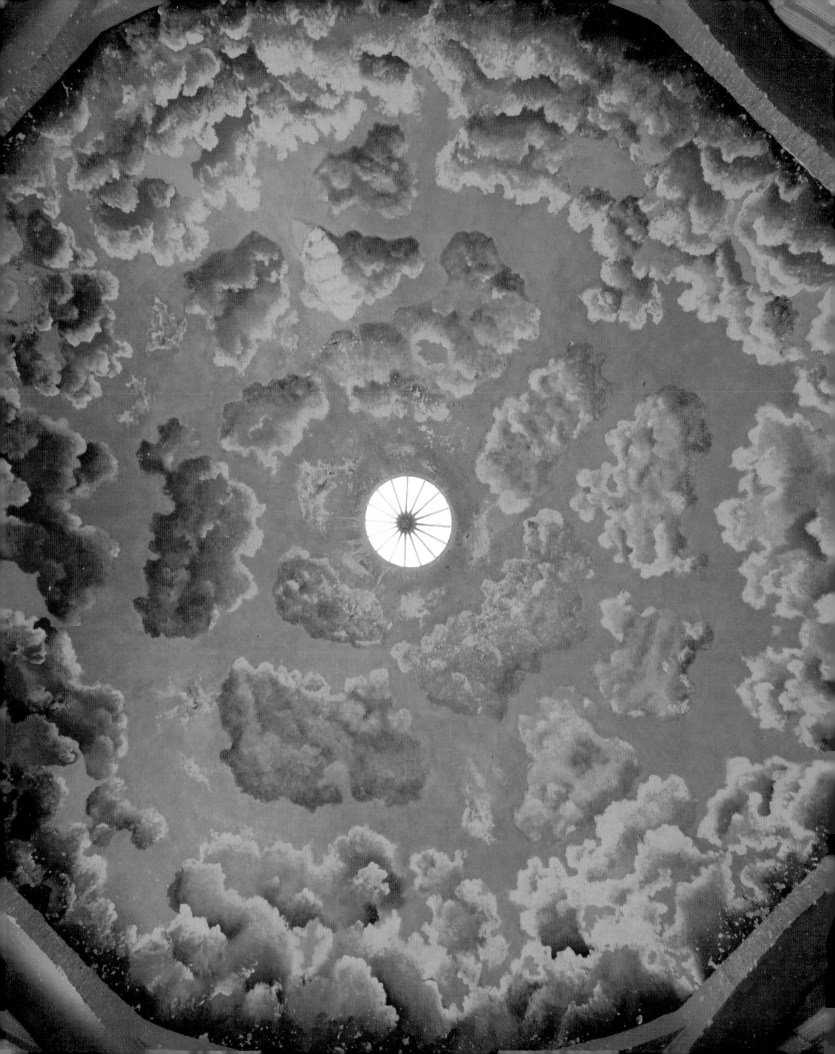

the Aztec religious courtyard: it was not an architectural feature of landscape, nor was it a variation of the court design at the Muslim mosque or the atrium of early Christian basilicas. The use of the open religious courtyard was a necessity among Indians. It perpetuated their desire to continue a recognizable echo, a formality, of their pre-Conquest[1] rituals. Repetition is necessary to any ritual:

...when it is filled by a communal impulse to connect the past (the last time we performed this act) and the present (the ritual we are performing now) and the future (will we ever perform it again?) [2]

When the meaning of an action is found to be inaccessible to someone, the repetition of the ritual opens a way for a subtle, subjective means of discovery and a way of experiencing its purpose. How often have we passed a bronzed poem in the stair before it becomes our cherished relic? The repeated sharing of architectural, artistic, or religious vestiges, and the honoring of illuminated messages engraved in frescoed walls, can take place in old, exquisite rooms that have been constructed from vast and diverse layers of belief over time.

American architect, writer, and humorist Charles Linn once remarked that a nightclub in a Las Vegas hotel had the power to "inspire a nostalgia for experiences people probably never even had" and added that we are living in a period in architectural history where "some of the experiences people want cannot be had in any real place."[3] I think it is exciting that one might believe she is nostalgic for things and places she has never known, and far more extraordinary perhaps is the desire for places and things that have never existed. The desire for a stimulating architectural spatial experience can itself be an ideal. The hacienda, for example, has a

composite structure and nature that is made up of Platonic forms. They separate, they connect, and they contain everything. Near the mid-sixteenth century, before the advent of the hacienda itself in Mexico, the new forms began to appear in lavish country houses. The hacienda is a collection of natural spatial experiences, which in turn generate sensations and which are thought of as reflections of the past: bred-in-the-bone with promise; enduring labyrinths of enlightenment and, of course, purpose. It may be that architecture such as this can save us; or conversely, that it simply reflects our mortality. Monuments and monuments to monuments each tumble into their own injured loss.

And so it goes. A century and a half before the Spanish conquest of Mexico, an Italian monk began writing stories of his dream-inspired visions of landscapes and gardens, which he adorned with architectural components and fragments—in essence, stone ruins. Francisco Colonna's writings, *Hypnerotomachia Poliphilli*, so influenced the Italians of the day that their gardens soon overflowed with stone replicas of broken arches, fallen columns, collapsed footbridges, and stone stairways leading nowhere—all designed purely for the sake of a casual stroll with a lady through the gardens. Often the contemplation of genuine ruins proves inspiring. However, what sort of psychic peace or inspiration could be found by contemplating false ruins?[4] It is absurd, of course, to design and build to satisfy such false nostalgia. But nostalgia has become our imperative. It is not for a desire to turn back, as we see in the ghostly and crazed aristocrat Don Jaime Terán, who, "through sheer nostalgia . . . could force himself back generations to a time when life had a sense of purpose and his family were worshipped like gods."[5] It is to learn to infuse the present with the comfort of authentic, ritualistic events and customary purpose.

A cloud and sky mural was painted into the dome above the grand staircase, with delicate iron and an eyelike glass opening, or oculus, at its apex.

[1] George Kohler, *Mexican Architecture of the Sixteenth Century*, Vol. 11 (New Haven: Yale University Press, 1948), 423.
[2] Lucy R. Lippard, *Overlay: Contemporary Art and the Art of Prehistory* (New York: The New Press, 1983), 160.
[3] Charles Dana Linn, "Lighting," *Architectural Record* (May 1998), 259.
[4] Christopher Thackery, *The History of Gardens* (Berkeley: University of California, 1979), 97.

The sublime rooms of voids and style found in a hacienda are a trove of forms from diverse countries. The Hacienda San Diego de Jaral de Berrios was built over a period of centuries. Its early section reflects a sixteenth-century Spanish architectural style, showing thick, heavily buttressed exterior walls. The interiors are lavish decorative mixes of Gothic, Italian Renaissance, and Moorish interior motifs. The mix, known as *Plateresco* or "silversmith like," is often unrelated to the structures of the buildings to which it is applied. The main practitioners, sculptors, architects, and painters included Diego de Siloe, Alonso de Covarrubias, Rodrigo Gil de Hontañón, and the inspired N. Gonzales, whose mural, *The Girl at the Gate Watering Doves*, has stolen hearts since circa 1891. Who might she have been in her bare feet and gauzy wraps, caught between the gate and the stone wall, placed in eternity over the purity of Aztec designs appearing in the border of imported wallpaper? Moving into the nineteenth century, the hacienda's interiors and exteriors were enhanced by features such as solid rosewood interior spiral staircases, European glass, and lead skylights in bluesy, circular, and delicate rectangular shapes. Vaulted ceilings were embellished with silk paintings of clouds or banderoles or streamers, which would be attached to the oculus at the apex of the domed ceiling and draped at the room moldings.

After a recent abandonment of a brief fifty-five years or so, the Hacienda San Diego de Jaral de Berrios is being recommitted to its grandeur and reality by architect Roberto Burillo and a group from Mexico City that is supporting its restoration and the production of factories to make high-end mescal once again. And just as the mescal is returning, we may see that hacienda volumes, arches, arcades, loggias, courtyards, and fountains are still the forms of nostalgia and desire that offer extraordinary comfort and purpose. To these eternal forms I have added images of the sculptures of Margarita Leon of Venezuela. Her work speaks via the soul of the Doñas, who knew all the secrets, beauty, pain, and strength of the hacienda.

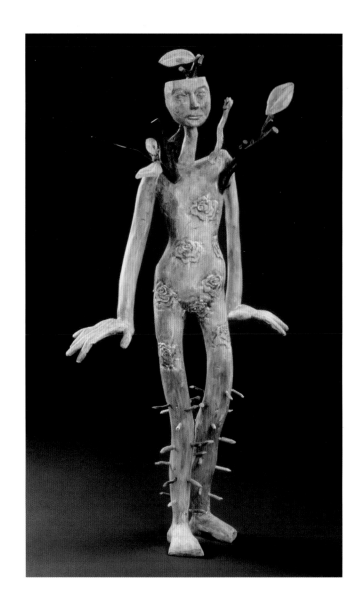

ABOVE: *Rosa Hemisphaerica*; Margarita Leon; Wood, resin, oil paint; 53" h x 34"w x 10"d.
RIGHT: The shortest passage opens into a garden.

[5] Lisa St. Aubin de Terán, *The Hacienda: A Memoir* (New York: Little, Brown and Company, 1997), 2.

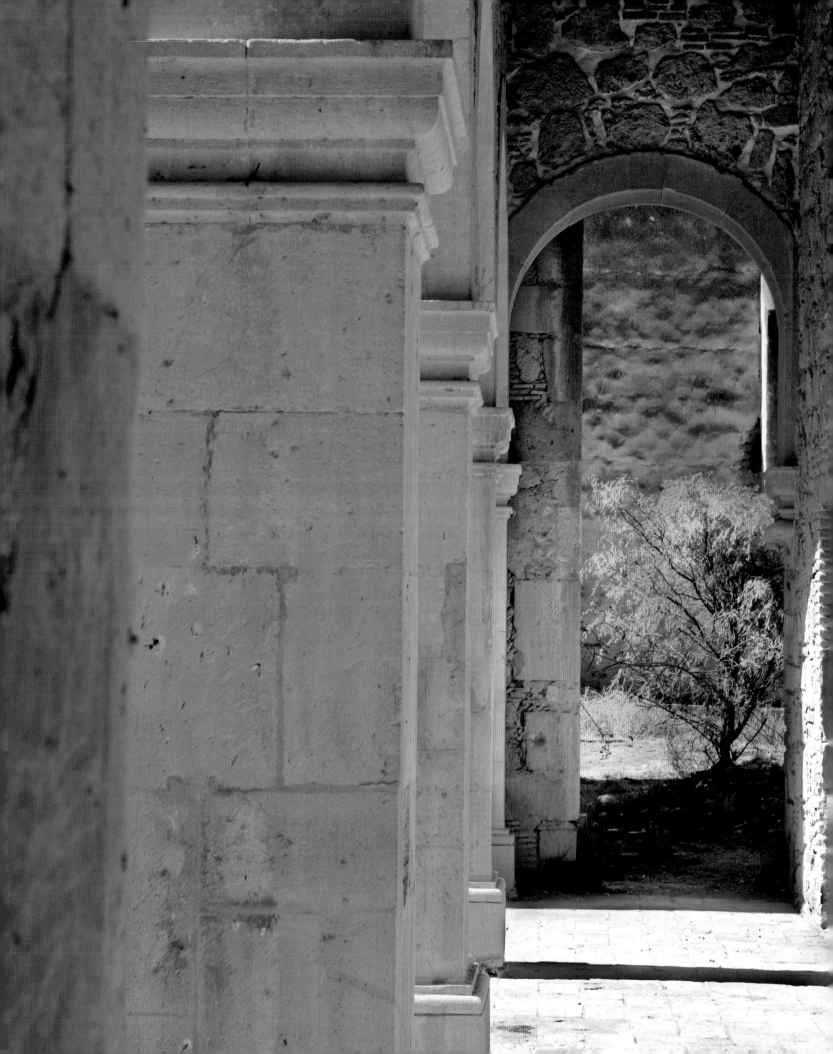

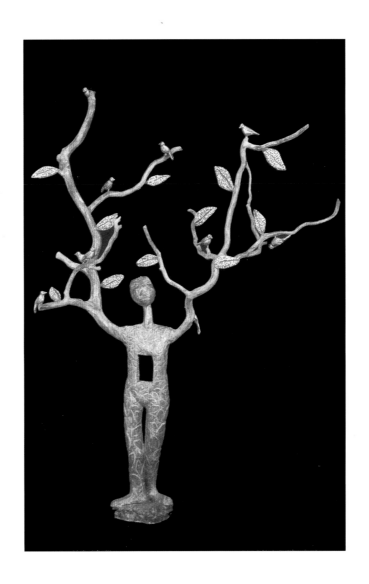

PART II

European furniture fits very well with hacienda-style architecture. I have oriental rugs from both of my grandmothers and my mother. I have my maternal grandmother's dining table, chairs, and sideboard, as well as her mother's matrimonial bed. I have my paternal grandmother's living room sofas and wing chairs and her father's grand piano . . . my mother's antique bureaus, desks, coffee tables, miniature powder room chairs, and the brass bed from the bedroom I grew up in. Hacienda living is graceful and accommodating and provides the perfect setting in which to display and enjoy it all.

— Alexa Fullerton
Hacienda del Angel

CASA LLENA
Margarita Leon
Clay, copper sheeting, wood, eggshell
42"h x 32"w x 11"d.

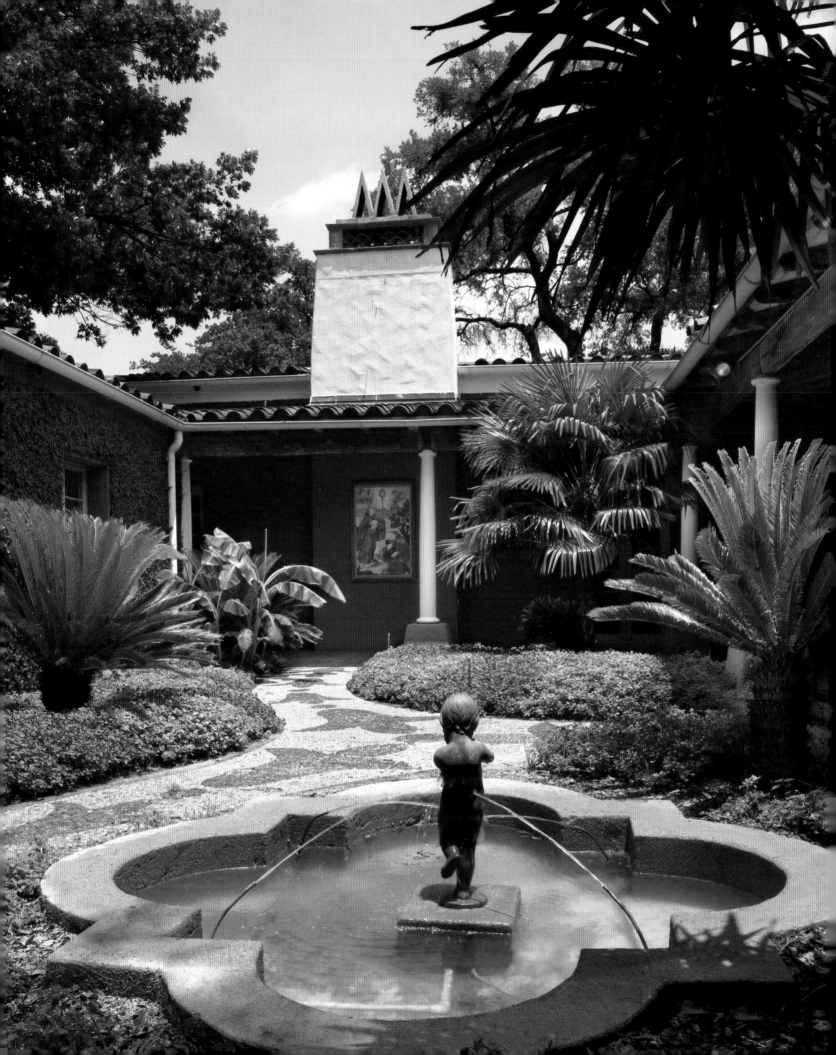

DeGolyer Hacienda

ARCHITECTS: Burton Shutt and Denman Scott

PHOTOGRAPHER: Charles Davis Smith

Hacienda architecture was so well suited to its hot climates, as well as a wet one, that the best features traveled north and south of Mexico with tremendous variation. The DeGolyer estate in Dallas was the home of Everett Lee DeGolyer and his wife, Nell. Their desire for a Spanish Colonial Revival style was inspired by Everett's extensive work and his success as a petroleum geologist in Mexico.

In 1937 the architects Burton Shutt and Denman Scott came to Dallas to design the house on forty-four acres on the shores of White Rock Lake. Shutt and Scott were important California architects at the time, having designed the Hotel Bel-Air in California and many other significant historic residences and buildings. Their design for the Dallas residence included many exterior arches, courtyards, a bell tower, seven distinct chimneys, and a red tile roof. The sprawling hacienda was what Mr. DeGolyer himself called, "a Beverly Hills architect's idea of what a Texas oilman thinks a Texas hacienda should look like."

LEFT: The small interior garden courtyard with a fountain on the south side of the hacienda is reminiscent of the warmth of the Mexican hacienda. ABOVE RIGHT: The east portico entrance at the porte cochère. RIGHT: The northeast yard has a path leading to the long, arcaded loggia, patterned after the mission at San Juan Capistrano in California.

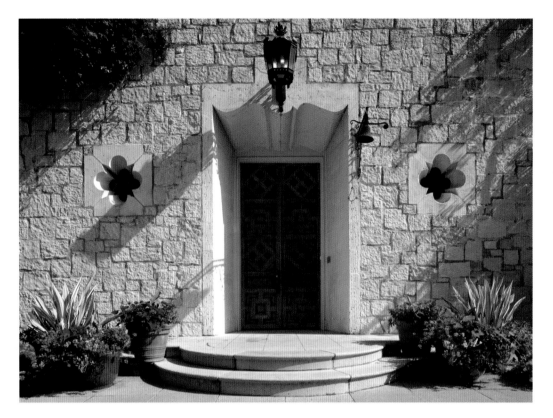

RIGHT: The main living room is furnished in seventeenth- and eighteenth-century styles and has an intricately carved, coffered ceiling. LEFT: Carved simplicity offers elegance to the main entrance. BELOW LEFT: A view from the spacious foyer into the living room. BELOW RIGHT: The heart of the hacienda: the rare-book library of fifteen thousand volumes.

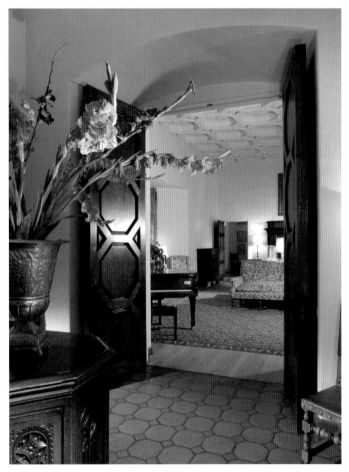

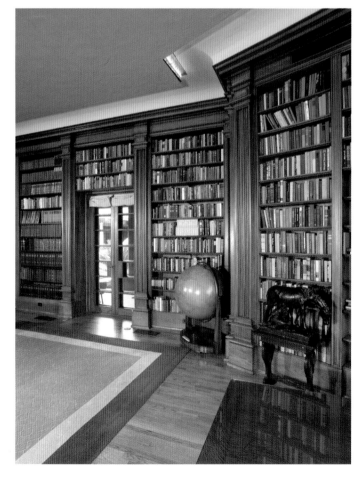

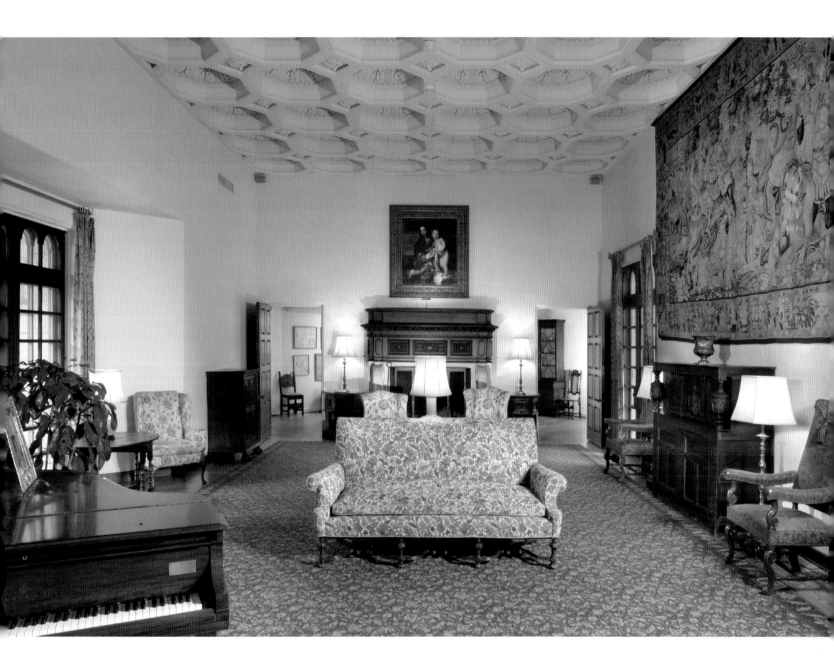

The one-story structure consists of thirteen rooms. The long, arcaded loggia is patterned after the historic San Juan Capistrano mission in California, while the more intimate inner courtyard is reminiscent of the warmth of the Mexican hacienda.

The interiors were furnished in Mrs. DeGolyer's preferences for seventeenth- and eighteenth-century English styles.

Special features include an intricately coffered ceiling in the living room, an elaborately carved fireplace mantle, a shell-shaped alcove in the dining room, and a pueblo-style Indian Room. Other architectural features are a spacious foyer and a generously sized living room and dining room, which each reflect the sophistication of the estate. The heart of the hacienda is a magnificent library

of rare books—Mr. DeGolyer's passion—with enough shelf space for fifteen thousand volumes. The DeGolyer estate is now a treasured part of the Dallas Arboretum and Botanical Garden.

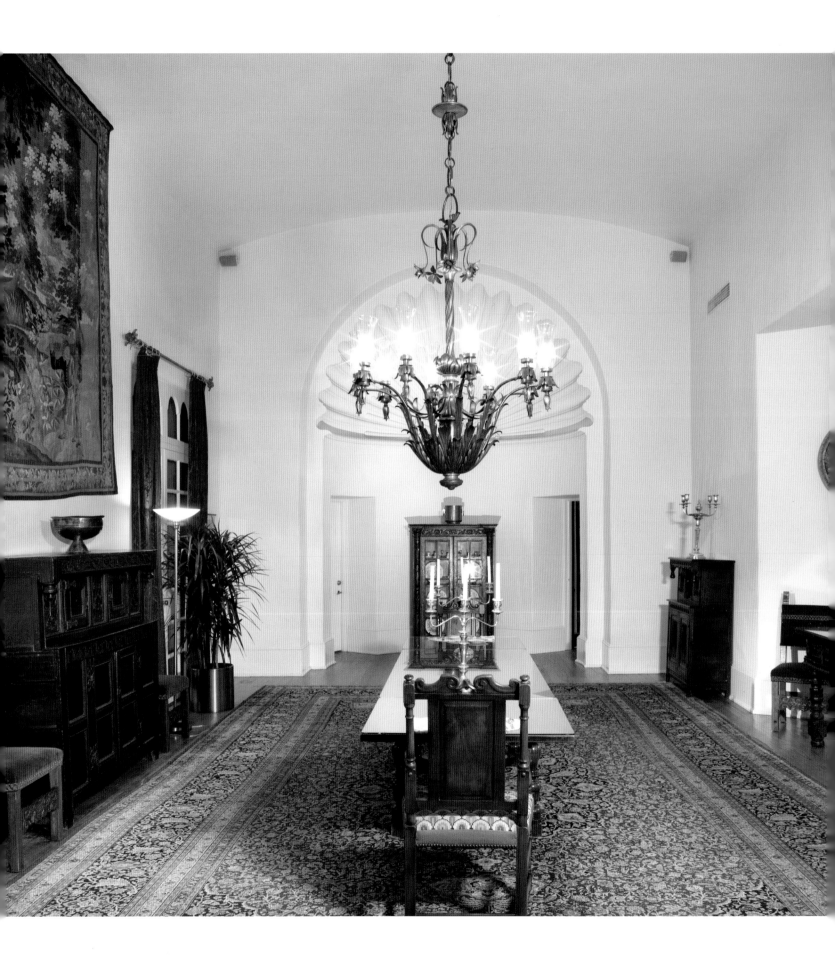

LEFT: The formal dining room has a slight curvature in the ceiling and a scallop niche detail above the double entrance. RIGHT: The morning and breakfast room has curved beamed ceilings, a pantry, and an entrance to the dining room. BELOW: A spacious master bedroom suite has four sets of arched and louvered doors between rooms and enclosing closets.

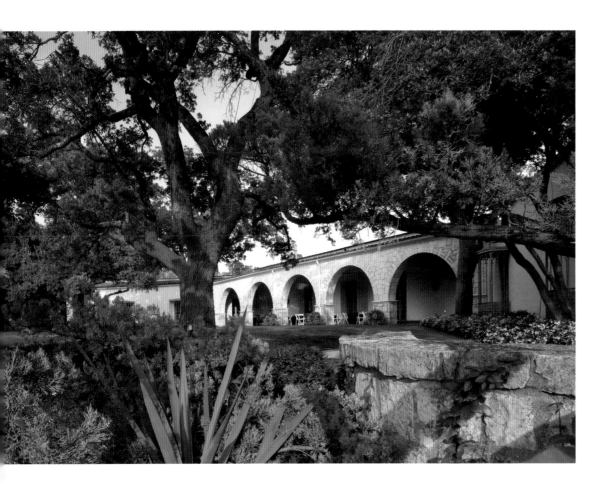

ABOVE: The arcaded loggia
overlooks Whiterock Lake.
RIGHT: A bay window in the
library overlooks the lake.

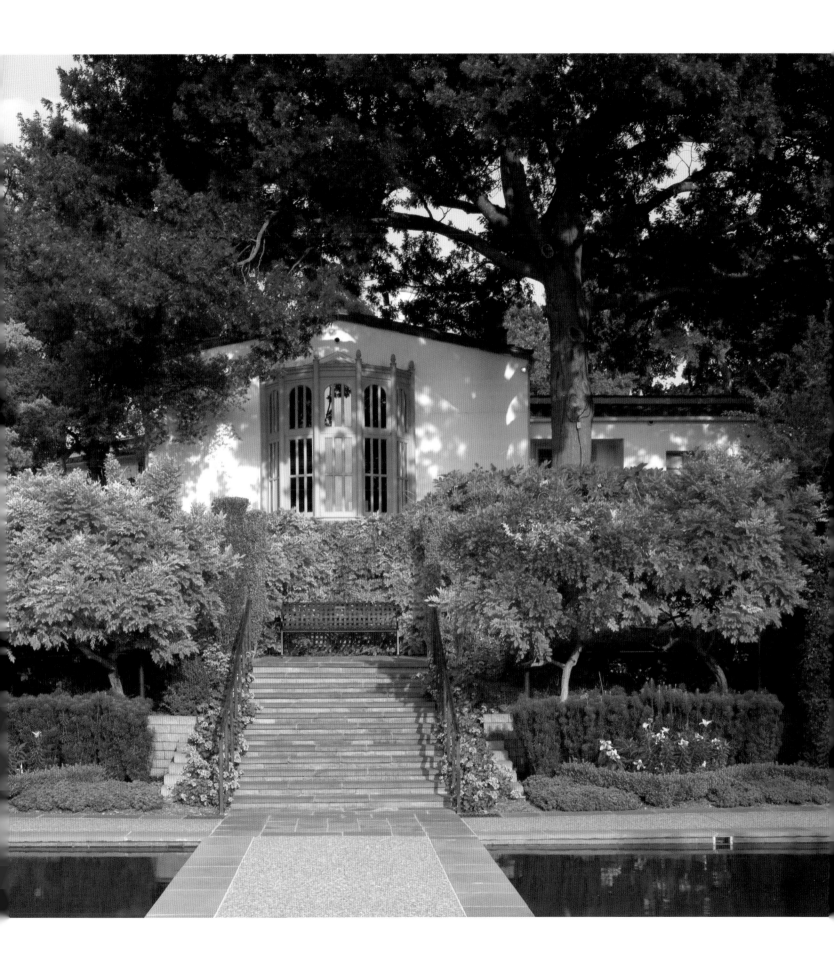

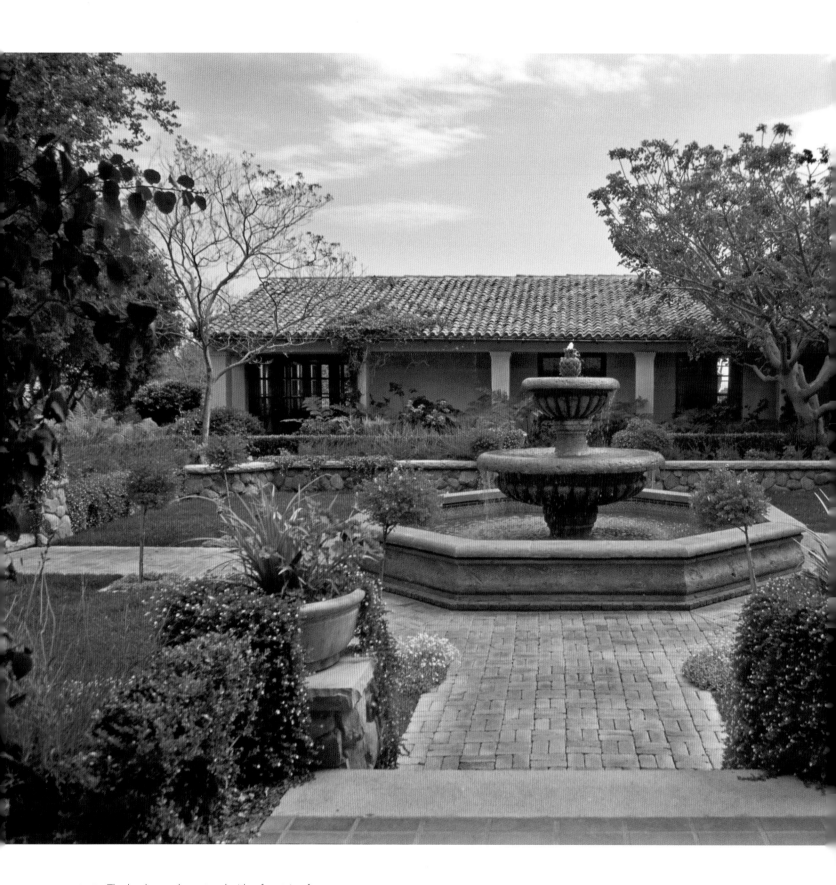

ABOVE: The landscaped courtyard with a fountain of
serenity is the interior focus of the hacienda's three wings.

Cima del Mundo

ARCHITECT: Myron K. Hunt

PHOTOGRAPHER: Thomas Ploch Productions

The landmarks visible from this hacienda on a clear day are unlike any others: the Channel Islands, the Santa Barbara harbor, the Montecito Valley, and the Santa Ynez mountain range. The sun rises over the crests and summit of the mountains to burn off the morning mists in the valley. High above in the afternoon it bedazzles the harbor waters, and when the evening comes, this sun beautifully sets the Channel Islands aglow. It couldn't be more spectacular. The 360-degree views inspired the name *Cima del Mundo*—Crest of the World.

In 1924 the distinguished architect Myron K. Hunt was commissioned to design this splendid Spanish hacienda for Lora Moore Knight. In the style of every outstanding house builder, Mrs. Knight wanted to make certain that she would be building in exactly the right spot. She spent many days and nights camping on the property. When at last she selected what she considered to be the perfect site to take advantage of the surrounding amenities, her architect, whose specialty was the design of hacienda-style houses, began work on the tile-roofed residence with its three wings enclosing the landscaped courtyard.

Century-old trees stand guard around the house and the circular drive. The foyer and den are paneled in rich oak, and open

RIGHT: A secluded corner fire pit and lounge overlook the Santa Ynez mountain range.

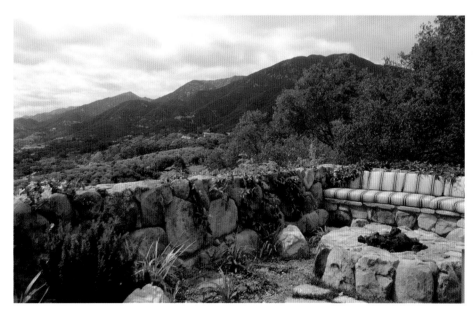

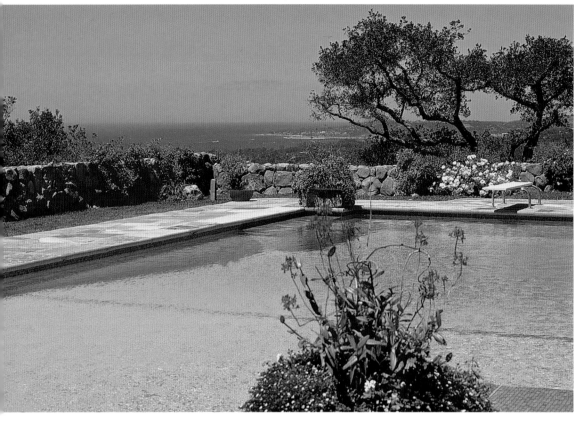

LEFT: Poolside with a manzanita tree and a view of the Santa Barbara Harbor. BELOW: Master bedrooms, balconies, and the traditional sweeping veranda have views of the Pacific and every sunset. RIGHT: The long galleria is paneled in teak, with oak flooring crowned by a hand-stenciled barrel ceiling.

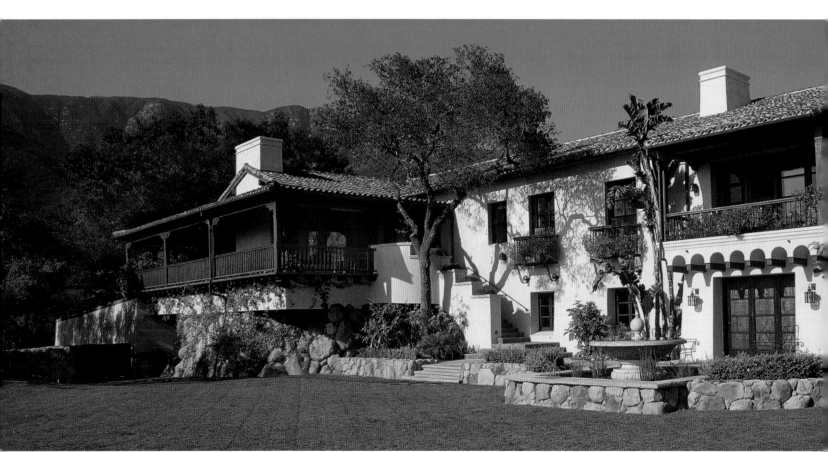

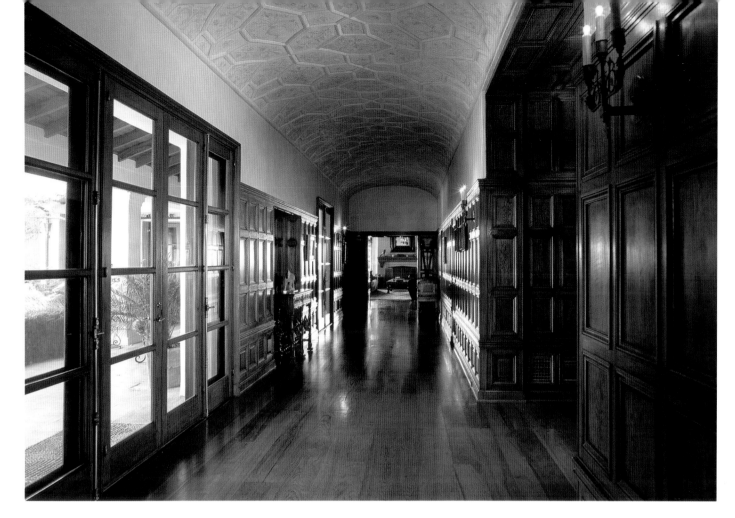

to a galleria, which is paneled in teak, with a hand-stenciled barrel ceiling. The grand living room flaunts an elaborate hand-carved, vaulted teak-beam ceiling, a hand-carved limestone fireplace, and windows designed to capture the sunset. French doors open to an outdoor patio with a fireplace and built-in barbecue. The bedrooms have marble fireplaces, and the original light fixtures are in place. The master suite is a dream come true, nearly rivaling those enjoyed during slumber. The house was designed during Prohibition, and the blueprints show a small room off the living room labeled the "trunk room." The gregarious Mrs. Knight loved parties, and the trunk room is thought to have actually concealed a built-in bar.

Olive trees, fountains, patio views, and lawns evoke traditional hacienda living.

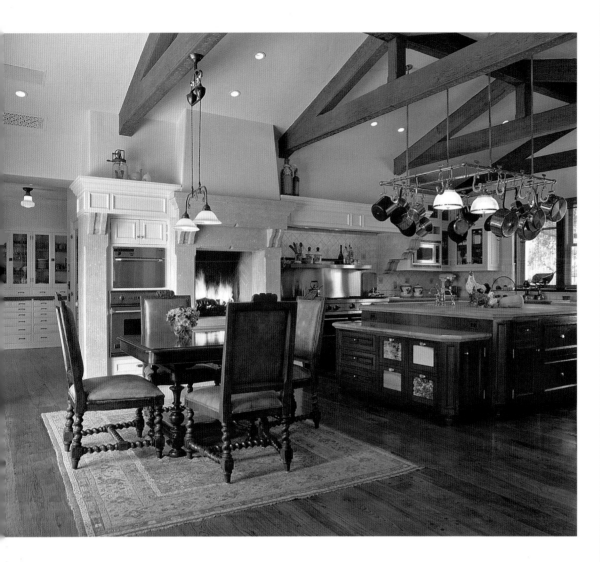

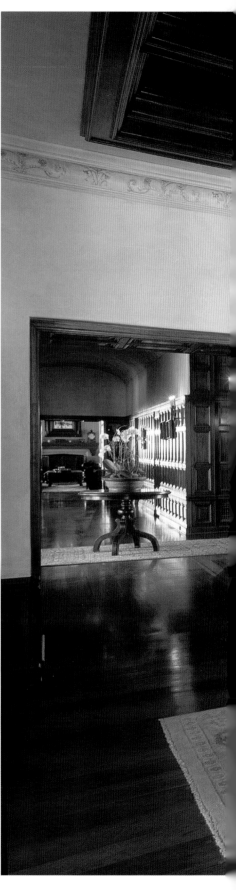

ABOVE: The welcoming kitchen has space for cooking, enjoying the fire, eating breakfast, and a large pantry. RIGHT: A large dining room off the main galleria has a deeply coffered wood ceiling and high baseboards. Hand-plastered molding accents the tops of walls.

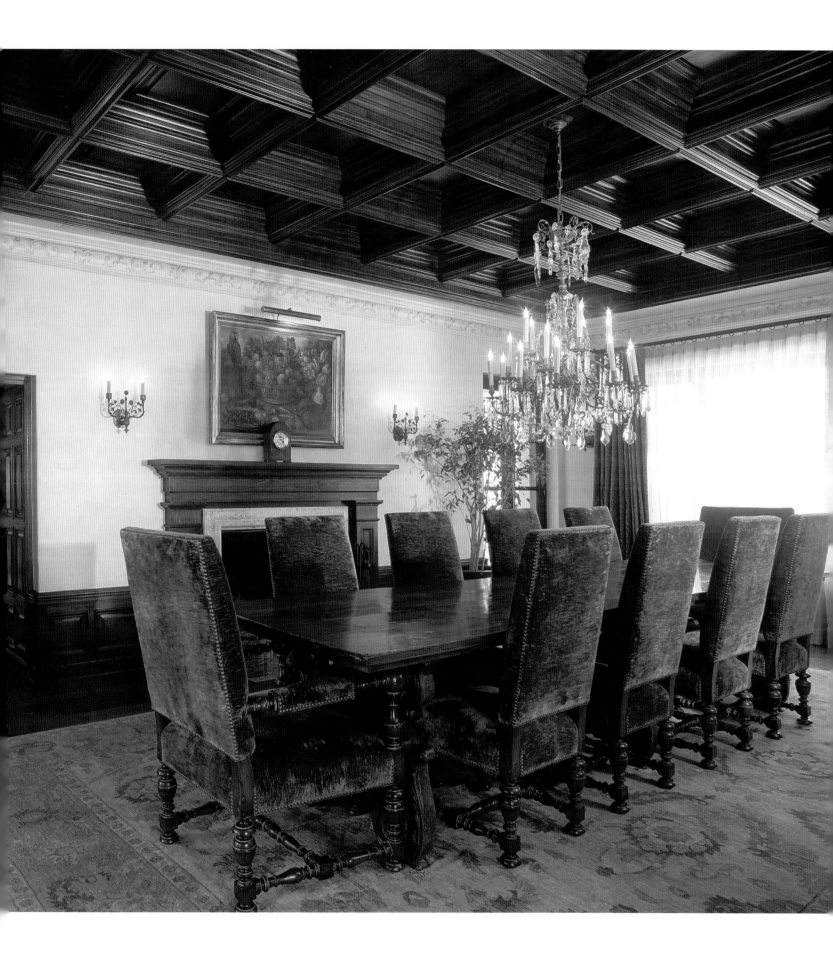

The living room has a hand-carved limestone fireplace. Overhead, arched beams are a delight of intricately carved wood moldings featuring patera and rosettes, Romanesque billets, keel forms, and luscious foliage-covered bosses.

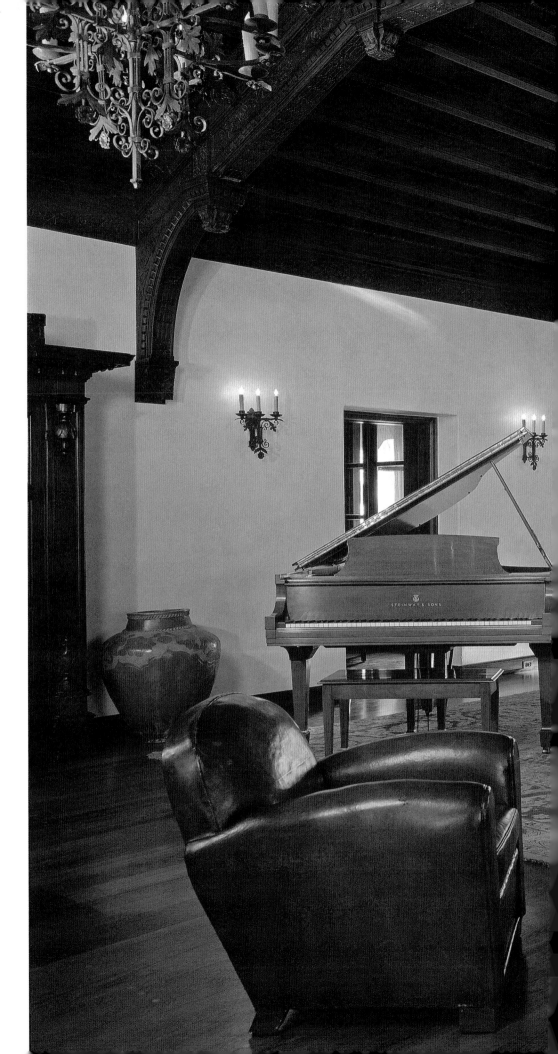

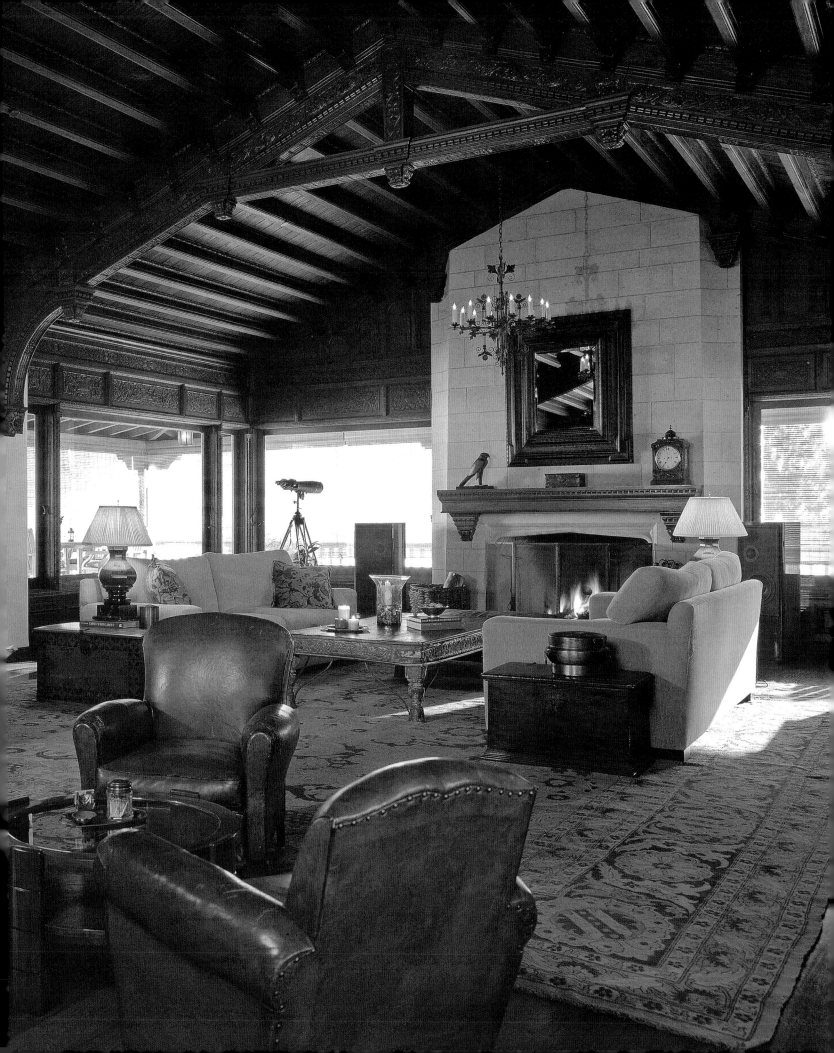

ABOVE: The main driveway from Montecito Valley appears to lead to the top of the world.
OPPOSITE: The first glimpse of the tile-roofed hacienda shows its large, classic wraparound veranda and a view of the Channel Islands.

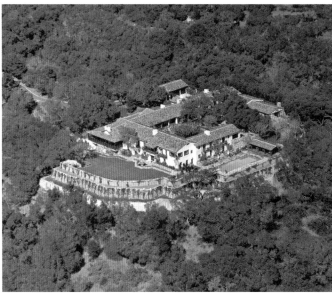

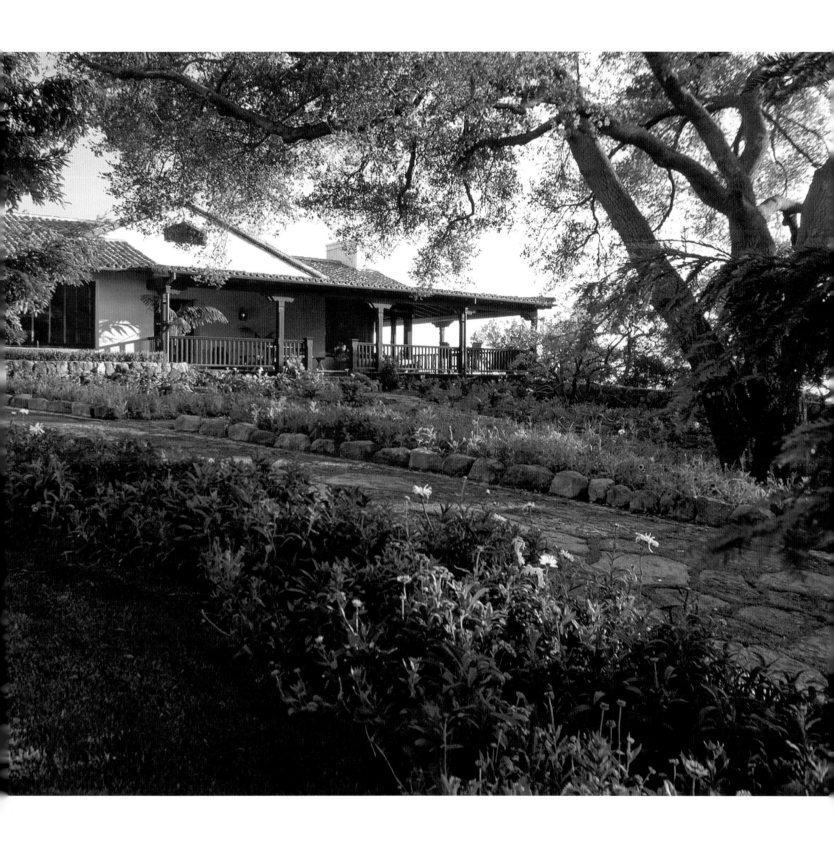

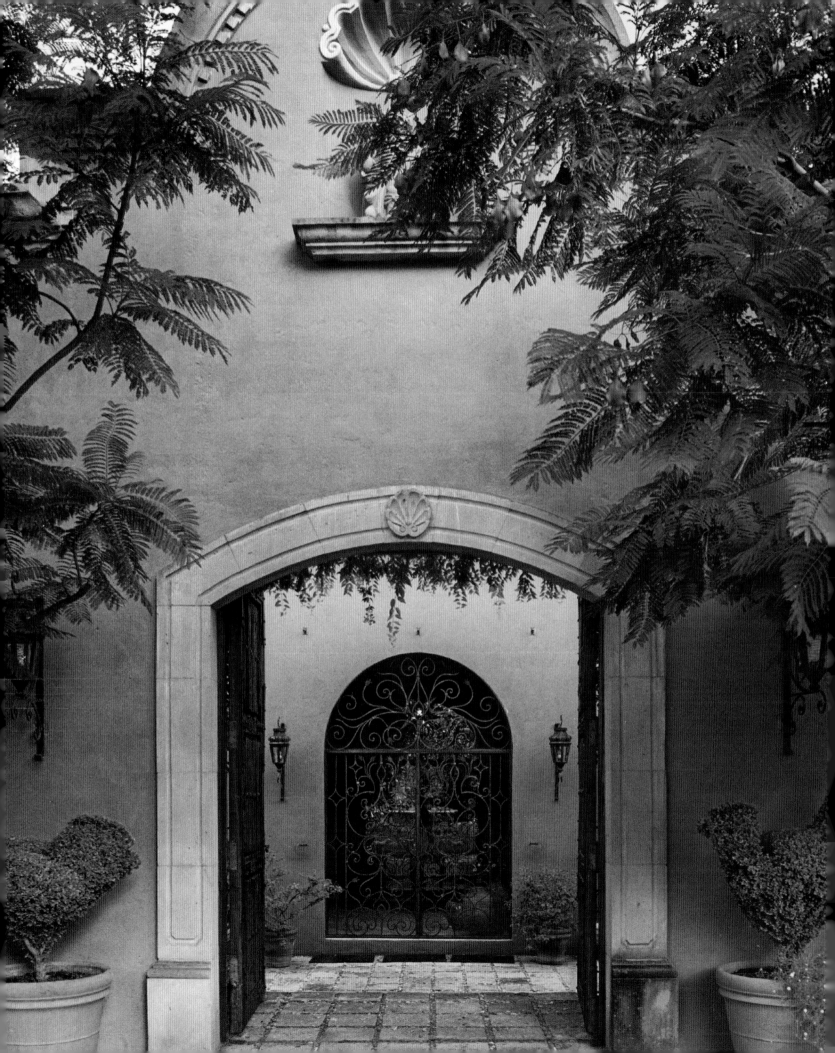

Hacienda del Angel

OWNERS: Alexa Fullerton and Dr. Eugenio Canales

ARCHITECT: Juan Carlos Valdez

PHOTOGRAPHER: Ricardo Vidargas Photography

The Hacienda del Angel is named for a collection Alexa Fullerton has of angels and archangels that appear in and around the house. There is an Archangel San Miguel over the street door entry, an Archangel San Rafael in the fishpond, and more San Miguels in the living room and bedroom. Alexa finds that San Miguel is especially powerful and helpful when one needs an angel. There are angels in the architecture, too. Alexa and her husband, Dr. Eugenio Canales, built the house behind an enormous traditional wall, where the entrance to the house is at the corner of an intersection.

The owners took inspiration from their stables and equestrian center and decided that hacienda style is what they wanted. They selected their architect because of his willingness to build an adobe, solar, recycled-water-use house. They planned spaces for three years, and it was another three years before the hacienda was finished. The building materials used were local, due to the owners' practice of supporting local

OPPOSITE: Bird topiaries welcome guests at the front gate. ABOVE: Dedicated equestrians, the owners have made horses a motif. BELOW LEFT: The loggia opens onto the landscaped gardens and the pool. BELOW RIGHT: The delicate tracery of iron gates gives a glimpse of the interior courtyard fountain.

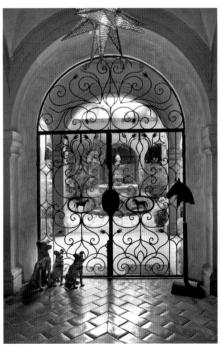

artisans. The adobe came from Queretaro, the cantera stone from Marfil, the tiles from Dolores Hidalgo. The ironwork, cement work, woodwork, and brickwork were all done in San Miguel. The pine, a renewable resource, came from Michoacan. All plants and trees in the landscape are indigenous. The four sides of the house are bordered by formal gardens and a swimming pool. Behind them, in hacienda style, are the orchards, vegetable gardens, herbs, and flowers. At the end of the property are a gardener's cottage, a barn, and a garage for carriages and horse trailers.

Dr. Canales's favorite room in this exquisite home is his office, which has a separate entrance on the street. The office also has a small utility kitchen and a half bath. The adjoining great room has family portraits and a large fireplace. It is here that Dr. Canales hosts lecture series and meetings for local and national equine practitioners. It is also the room he uses when he has the guys over to smoke cigars and watch soccer. Alexa prefers to be stretched out on the couch in the living room, peacefully reading a book while looking at the fishpond. The living room, dining room, and music room are all built of adobe, and because of this the temperature is always just right, whether it is freezing outside or boiling hot. Alexa's favorite room is the master suite, located right next door to the kitchen. If they are the only two people in residence, it is an efficient spatial layout. The master suite

overlooks two different garden areas and the central fountain for soothing sounds. French doors lead to the magical world of Alexa's gardens.

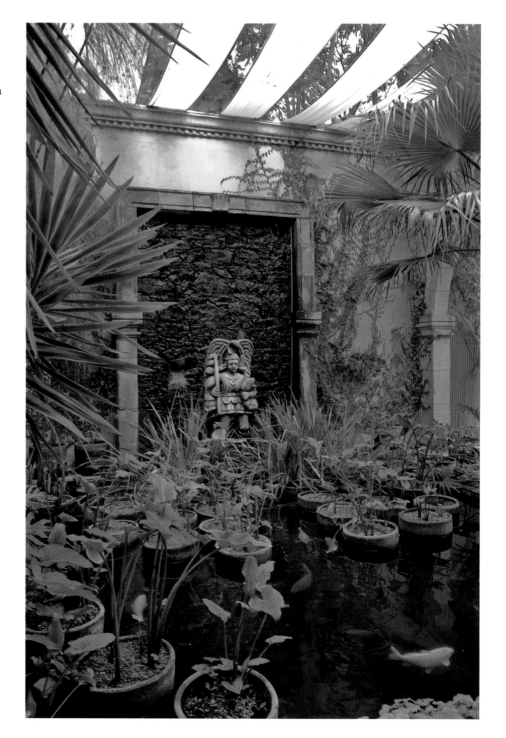

BELOW: A distinctive koi pond with exotic water plantings shares a backdrop of sculpture and a weeping wall framed in carved stone.

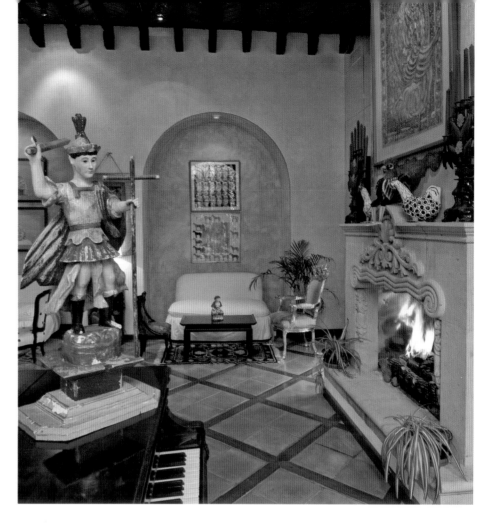

RIGHT: An intimate conversation niche is next to a fireplace and Alexa's great-grandfather's grand piano. BELOW: At the end of the living room is space for dining, sharing tea, playing music, and enjoying the fireplace.

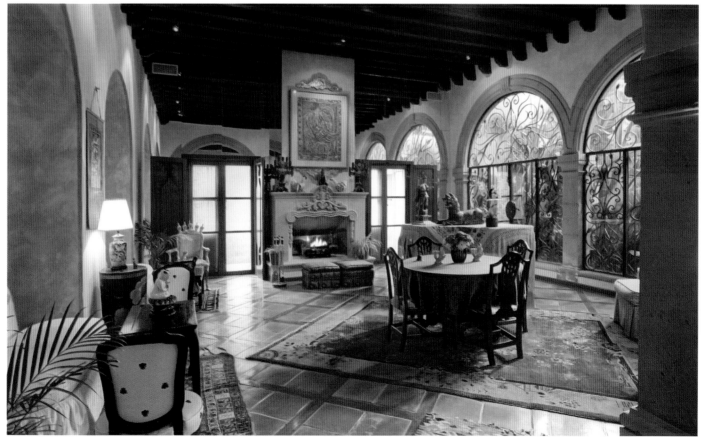

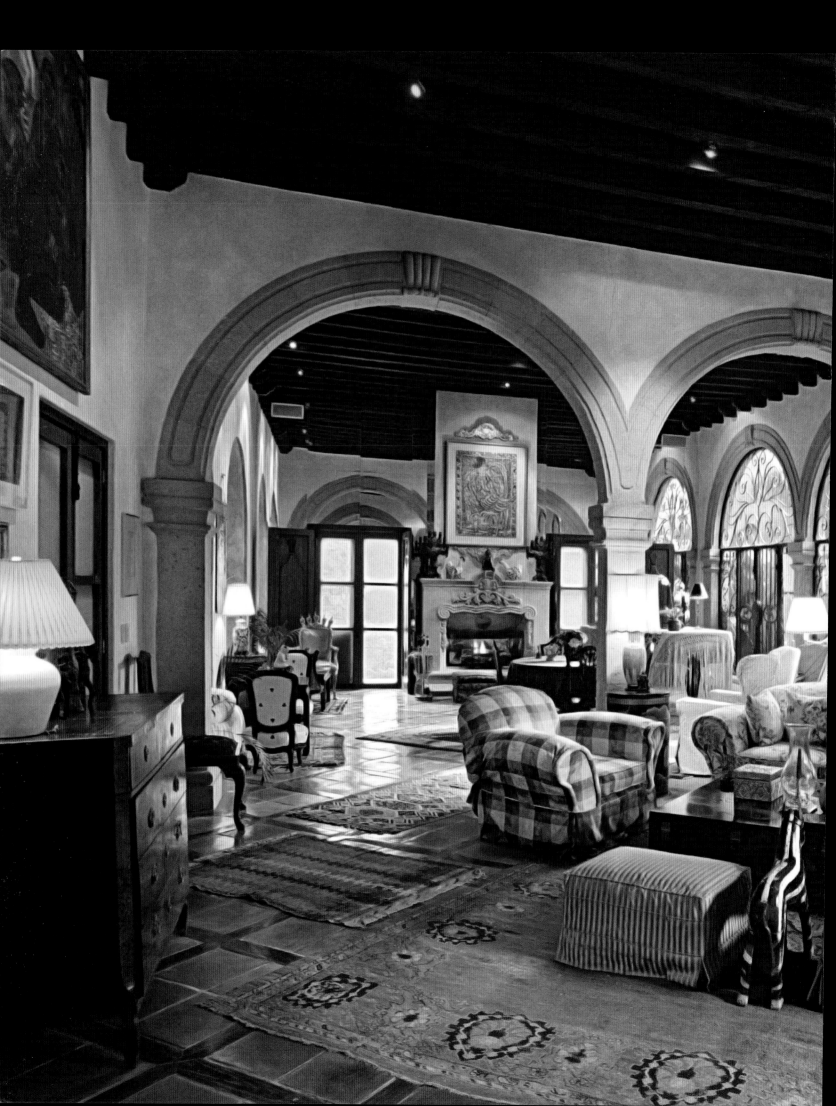

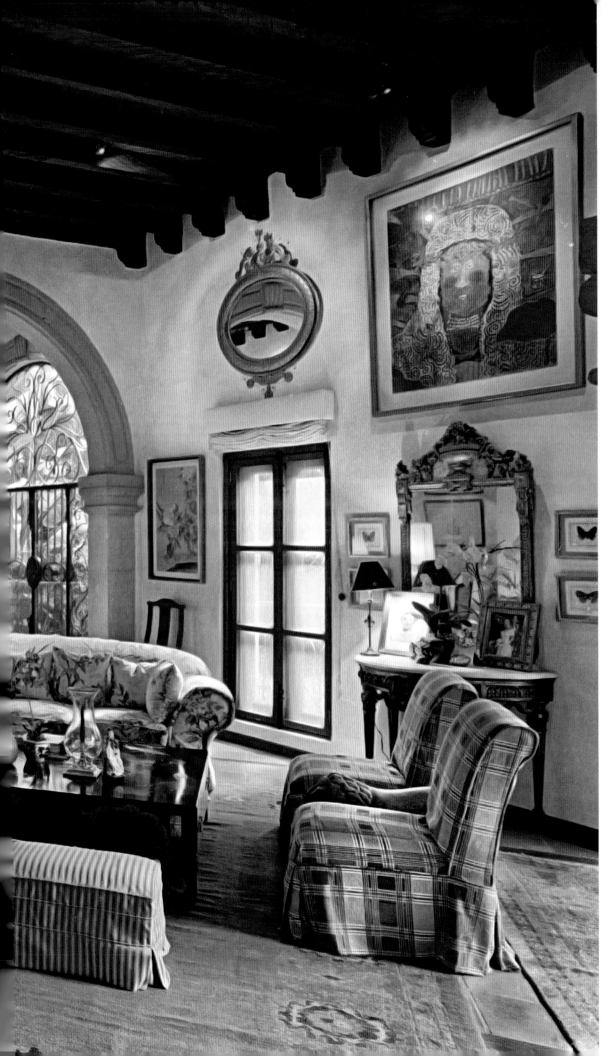

The large living room is separated by two arches, creating a space for a large gathering and areas for smaller, intimate conversations. The oriental rugs belonged to Alexa's mother and both of her grandmothers.

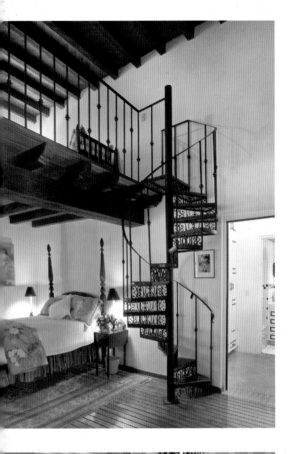

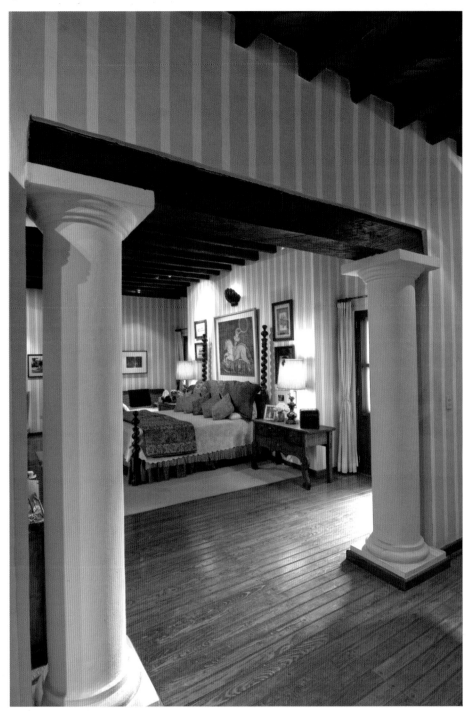

ABOVE LEFT: A guest bedroom has a spiral staircase to the reading loft.
BELOW LEFT: A personal collection of pre-Columbian artifacts and figurines sits above a beautifully carved desk.

ABOVE: The sleeping area of the master suite features Alexa's great-grandmother's matrimonial bed. RIGHT: An Asian cabinet blends with the colors of India and Mexico.

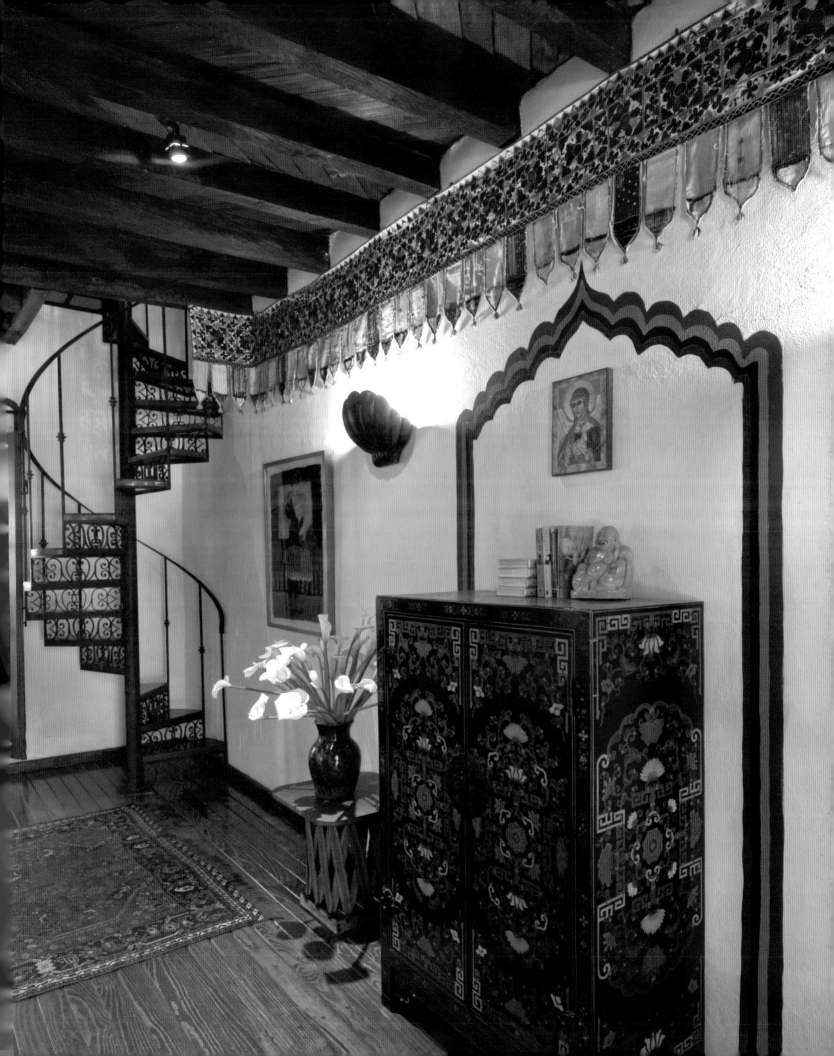

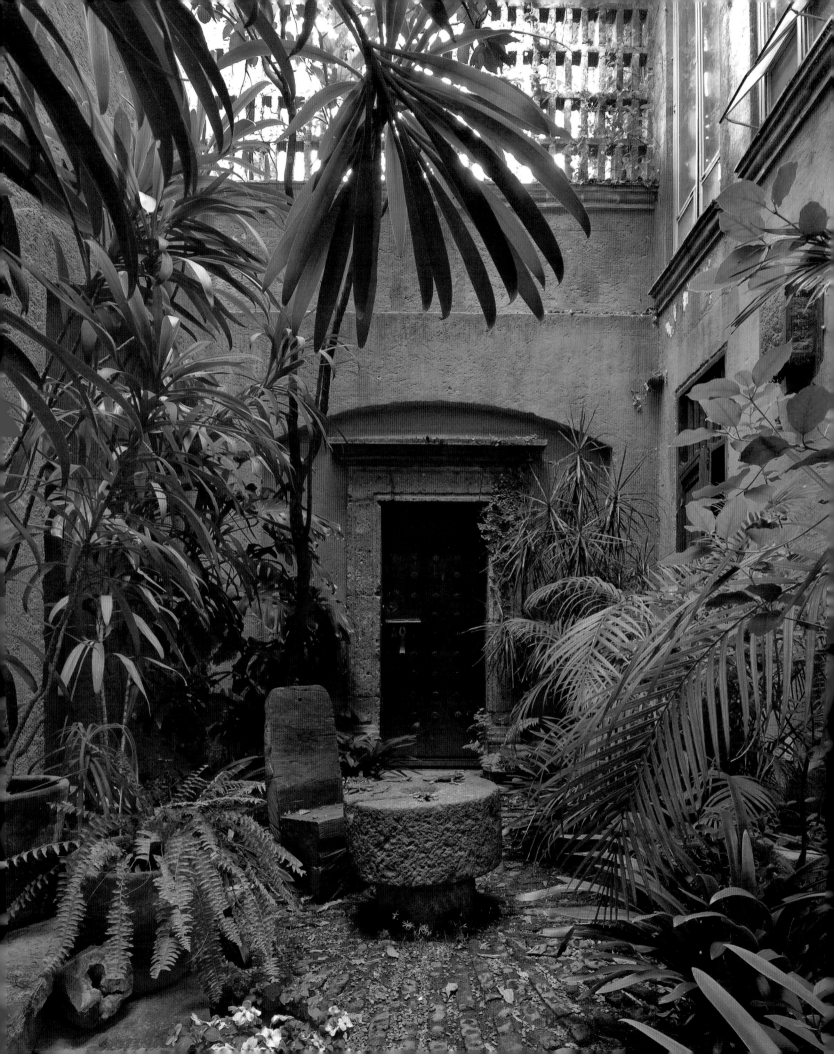

Hacienda Malena

OWNERS: Ingeborg Skatun and Tim Wachter

ARCHITECT: Tim Wachter

PHOTOGRAPHER: Ricardo Vidargas Photography

The greenery and charm of this location was the attraction for Malena and Timoteo to build their home here, near San Miguel. Palms, ferns, swordferns, and grasses—including tropical *Nephrolepis exaltata* and large philodendrons of the *Americas* climbing aroid family—cool their courtyard entrance with lavish green colors and rise up into the center of the building. Among the plants, the brick-paved courtyard nearly conceals a small table made of an ancient grinding wheel. A simple, carved teak chair rests quietly next to the wheel in solitude, waiting for the lady of the house to come rest for a while with her novella. Beyond, metal studs create a formal pattern on the carved entry door, which itself has a lovely carved stone surround, set into a larger niche. The heavy iron bolt completes a sense of monastic security for this entrance. Ivy clings to walls, climbs, and surrounds pieces of meditative art. The entrance corrédor

OPPOSITE: A view of the exterior entry courtyard shows an ancient grinding stone table and a carved wood chair among tropical plantings and a brick patio. ABOVE: A stone niche with a waterfall. BELOW LEFT: The interior courtyard has a tile waterfall niche with koi. BELOW RIGHT: The galleried hallway has a brick vaulted ceiling.

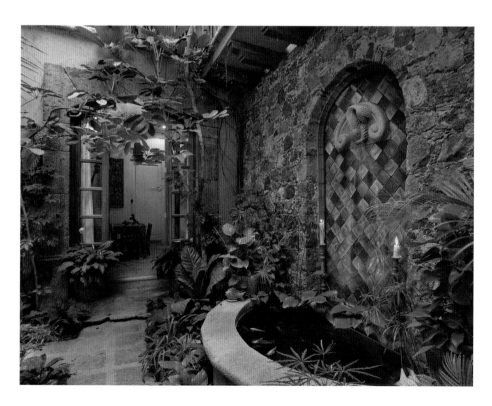

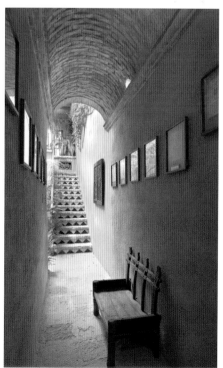

has stone flooring, and a gallery with a lush brick-vaulted ceiling leads to stone and tile stairs, which open to the upper floor. The second floor above surrounds the courtyard; this is the center of daily life and many activities.

At one end of the second floor, domesticity appears in the dining pavilion and the food preparation area. Seating for eight is easy at the long, wide, natural wood table. Warmed with ferns and ivy, the dining loft has stone floors and a beamed ceiling. At one end, the

buffet counters are made of stacked tile and a grill. A place for storing wood is below. The details of every room in the house are exceptional. A painting of two gorgeously colored fish above the grill signifies several themes that are important in the Mexican household. A large wooden mantle is above the painting, serving as a small alter with candles, offerings, and a simple wood crucifix.

Swinging double doors spring open to reveal a second area for cooking, bathed in blue with chicken sculptures here and

RIGHT: Dining among candles and saints inspires joyful events. The kitchen can be seen adjacent to the dining room and balcony. BELOW LEFT: Dining on the balcony overlooking the courtyard is enhanced by fresh air, palms, and vines. BELOW RIGHT: Ceiling beams and paintings on the door panels warm the stone flooring and create a special space between the dining room and the kitchen.

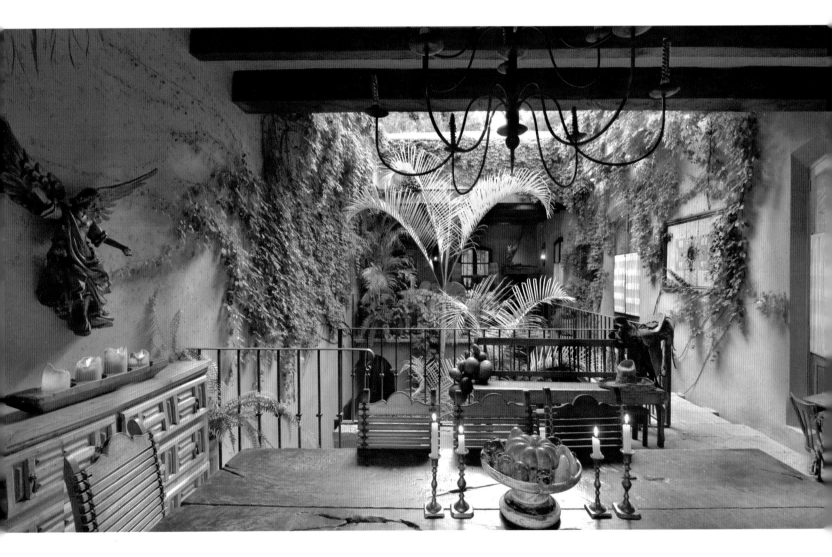

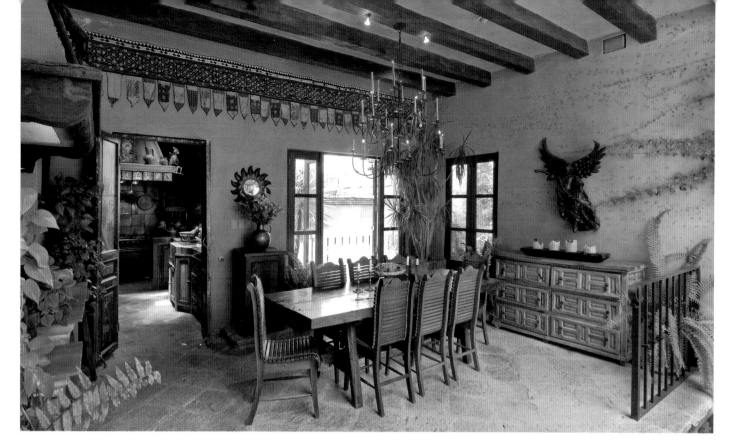

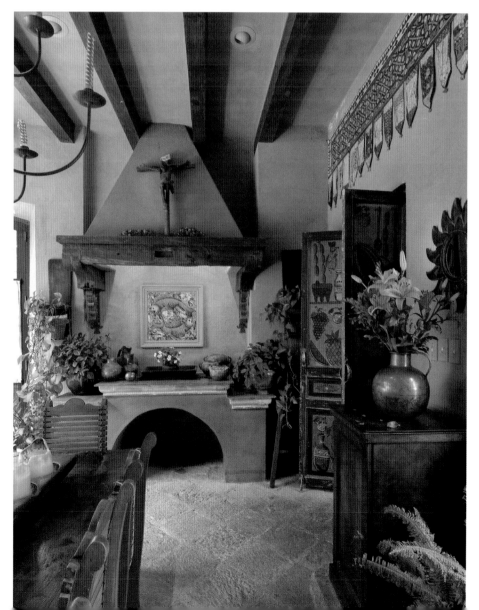

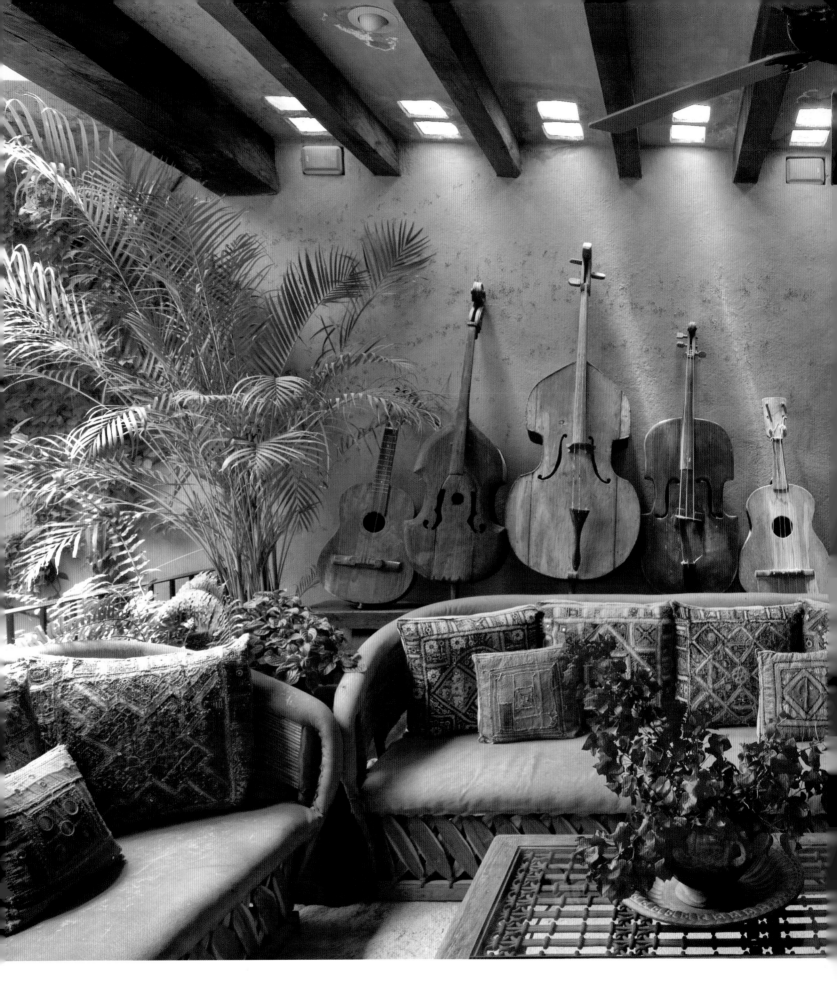

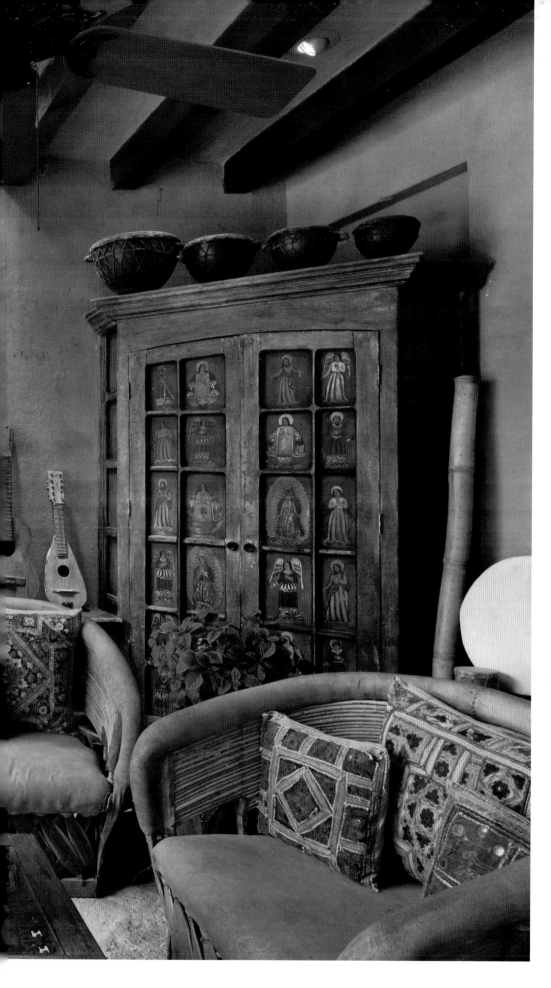

A more convivial room could not exist. The cherished collection of wood instruments is a lively backdrop to the cozy leather and cedar equipale furniture and the painted saint panels of the antique cabinet.

there to keep everyone smiling. The doors are painted with fruits and sausages, decanters and ladles, melons and a stone mortar and pestle to celebrate the wonders of bounty.

At the other end of the second floor is the living room. It doubles as a music room—a gathering spot for the musicians and friends who play. Here Tim and Malena's collection of antique furniture and instruments from Guatemala, including strings, percussion, and a gramophone, set the tone for evenings of pure laughter and music.

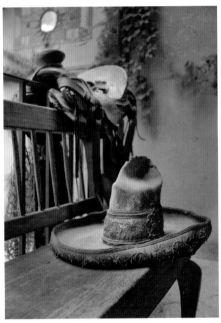

RIGHT: Carved wood furnishings add warmth and comfort to the master bedroom, a few steps down into the cool rooms of the hacienda. The bed fits perfectly into a niche. Stone is used as flooring and caps on the stairs. ABOVE TOP: Details of painted saints adorn the antique wood cabinet. ABOVE BOTTOM: An embroidered sombrero and leather saddle sit on a wood bench.

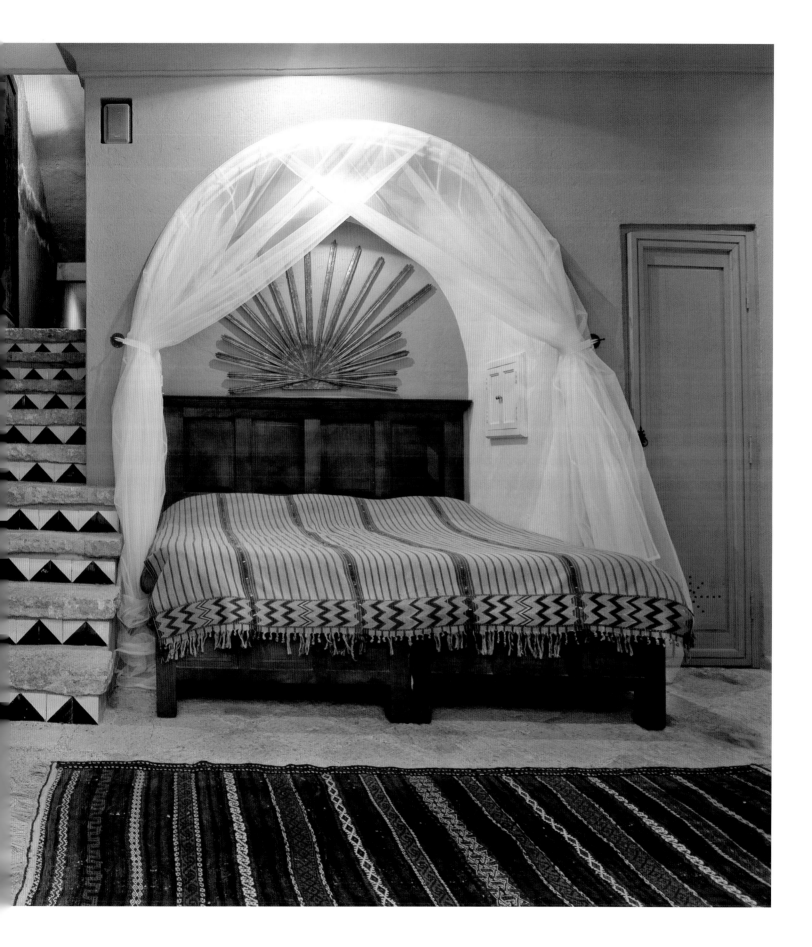

Casa Destino

PHOTOGRAPHER: Ricardo Vidargas

A lack of urgency might well be the all-inclusive enticement to live in Mexico. There is inevitably much to learn about another way of life, one that is intimate and perceptive, and driven by a joy for living it. It is much more than a variation on a theme, in the way that music, linguistics, and architecture are thought to be. When an architect identifies her special building material as "a lack of urgency," we know we have arrived in a new land.

This gorgeous project began in 1993, and due to the owner/architect's infinite attention to details in every room and niche, it was ten years in the making, resulting in a virtue of design that is rarely found. "Patience is the key word for this home," says the owner. She works as an art director in the film business and would often leave Mexico to do a film, make money, and return to spend "absolutely all" of it on the construction of her home. Then off she would go, beelike, again.

The owner found the property when she was was traveling with her parents,

who were looking to buy in Mexico. They were all staying at a small hotel across the street from an open space. Jogging one morning, she got a closer look at the space, jumped the fence, and made inquiries that led her to discover that it had become available that day. She bought it. "Destiny," she said, " is a wonderful force."

The main entrance heads west, directly onto the street, and faces a park, which from the second level of the house

LEFT: The stone and timber of the loggia show their best patina in the warm light of the iron and glass sconces and pendulum lanterns. RIGHT: One end of the loggia is a vignette of antique children's chairs with a low table and a wood plank bench.

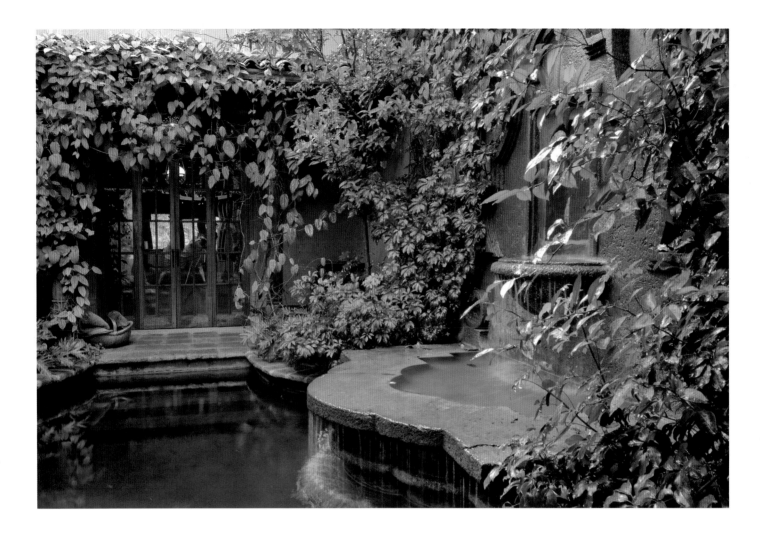

looks just like an extension of the house and garden. The living room, too, is faced toward the park, and its freshness is quite enjoyable when all the French doors are open to the foliage and fresh air. When the owner was a child, her father would take the family on weekend outings to many small towns in Mexico, were they would always end up going to the local village church. The vaulted church ceilings became an important influence in the architecture of her home. The high, beautifully coffered ceiling in the kitchen is a replica of a Guatemala (Antiqua) kitchen, where the actual building plans for the room

were found at the local museum. The tiled kitchen fireplace mantel is adorned with wooden sculptures made by a very old woman who has been selling her work in the town for sixty years. This is a favorite local source for the owner, who frequently stops there to see which new little saint has been carved.

The courtyard pool and fountain are a tour de force. A passion for water led the owner to design the fountain and the pool together to bring the emotion and movement of water into the courtyard itself. The kitchen, dining room, and bedrooms open onto the water-filled oasis, with just

enough surround for small vignettes of patio furniture. Finally, the house is blessed by a sculpture of Mary. The piece has a "halo" of hearts, called "miracles," made by the owner—another lasting detail.

ABOVE: A step out of the living room and into the pool. RIGHT: French doors open on each side to allow free-flowing breezes through the large, vaulted living spaces.

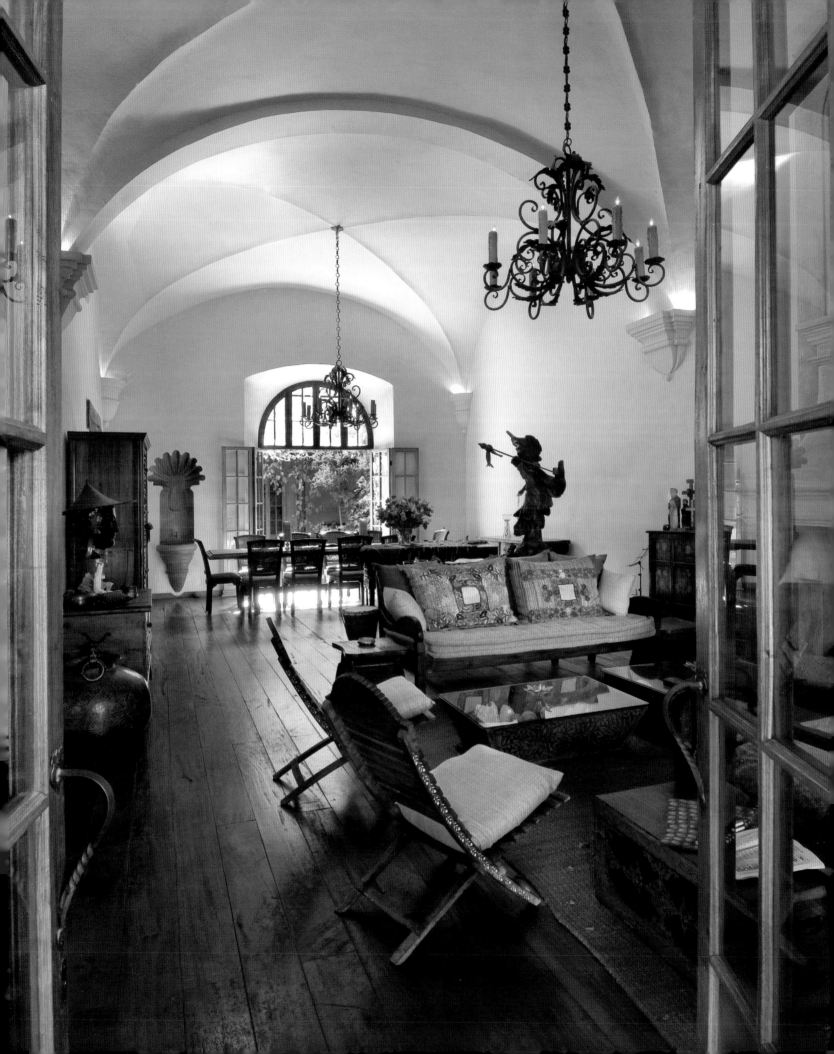

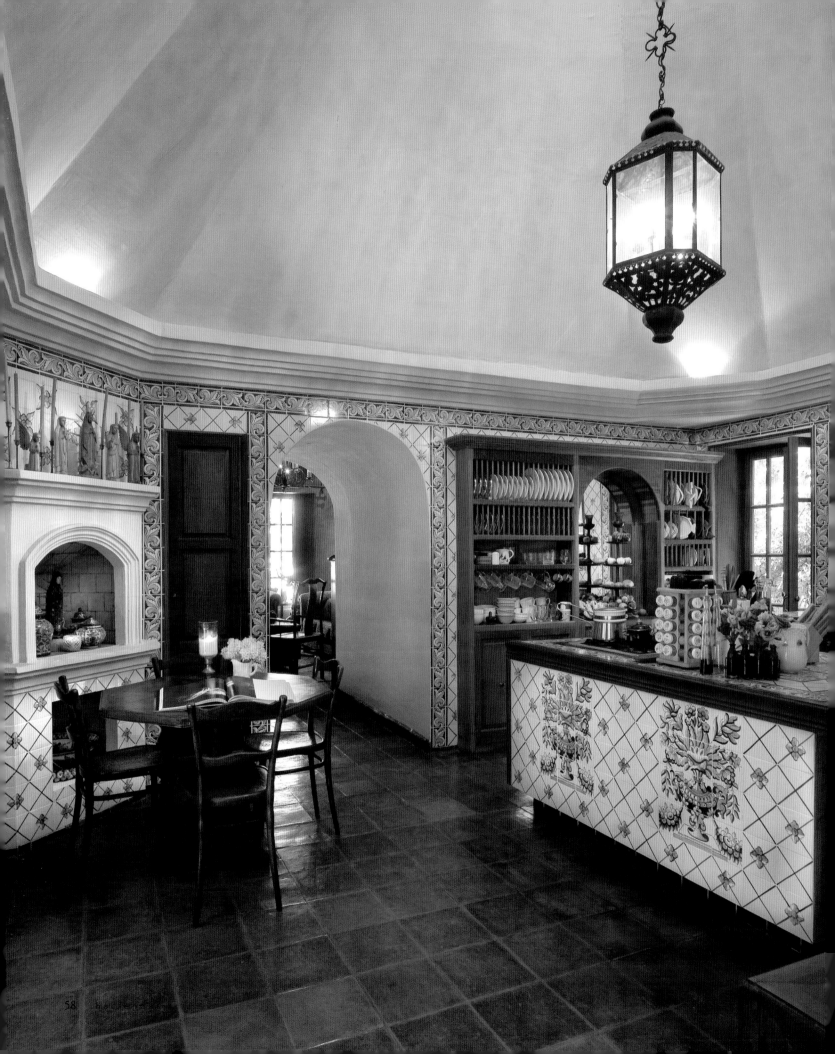

LEFT: A *cocina* for the heart—blue and white tile walls and island under the large, vaulted ceiling, which was based on the design of a Guatemala (Antiqua) kitchen. The plans were found in a local museum. The antique breakfast table and chairs, with wood cabinets and flooring, help create a welcoming and workable space. RIGHT: The dining room opens to the vegetation and waterfall of the courtyard pool.

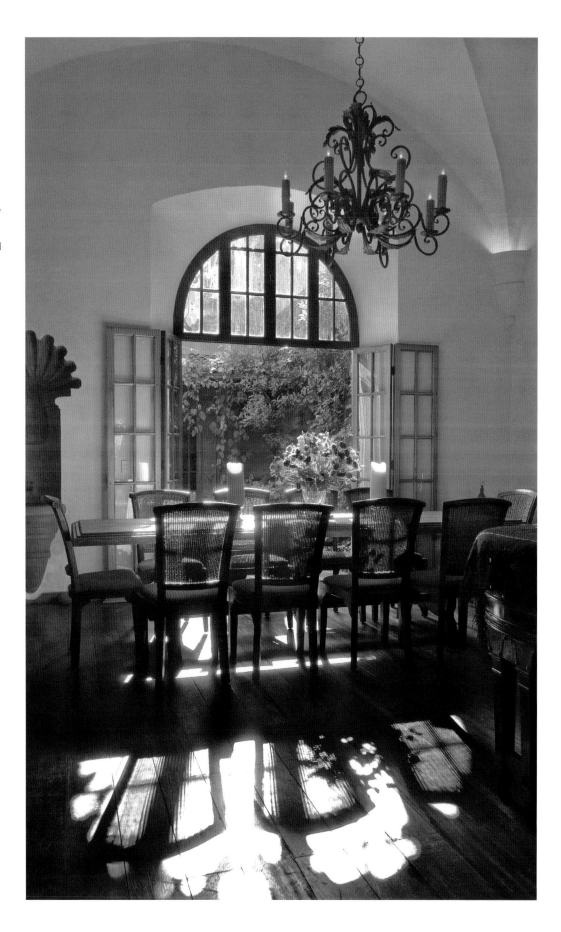

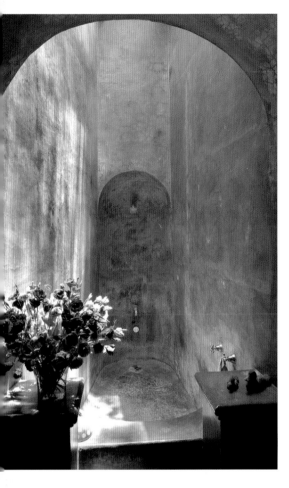

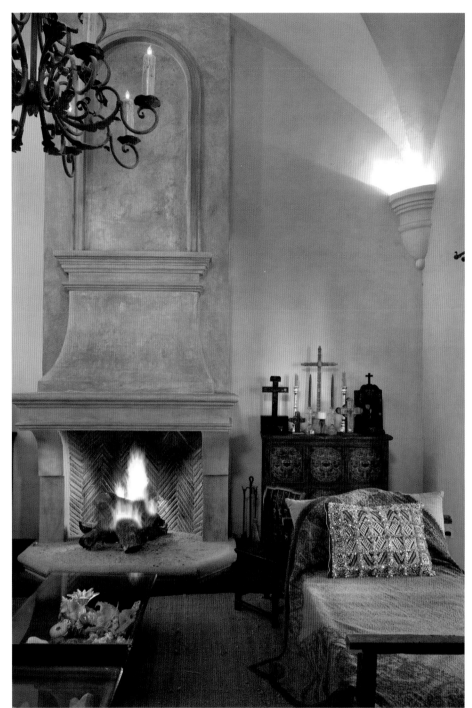

ABOVE LEFT: A sanctuary of stone for bathing. A high stone arch is the entrance to a bath with a shower in the niche beyond. Canyon walls rise to allow natural light to flood the space. BELOW LEFT: The house is blessed with a sculpture of Mary. The piece has a halo of hearts, called "miracles," made by the owner.

ABOVE: The "squinch" in the corner of the vaulted living room ceiling gradually widens and projects concentric arches across the interior, forming the circular half-drum shape as a transition from one part of the room to the next. RIGHT: The owners' collection of textiles is effectively displayed to arouse the emotions.

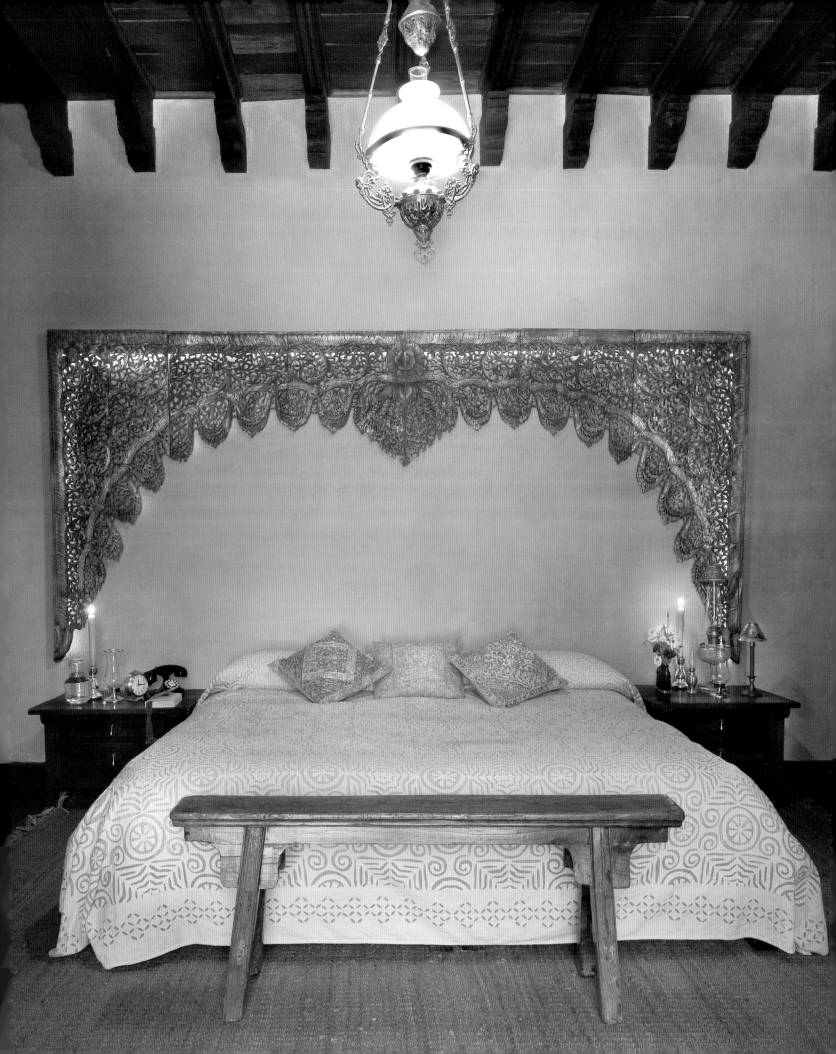

ABOVE: Flowers on a tiny tea table, the colors of the equipale leather, and the reflections of the pool in the glass brighten the day.
RIGHT: A view from the bedroom to the living room across the pool captures the flora and sunlight.

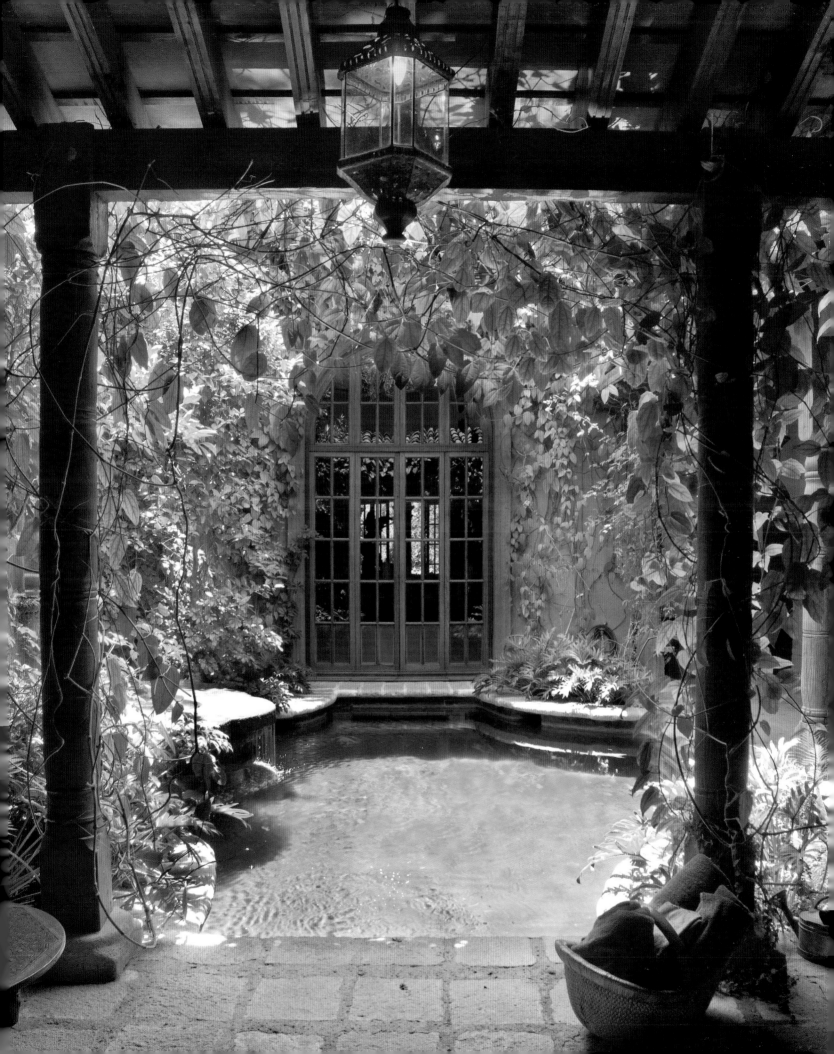

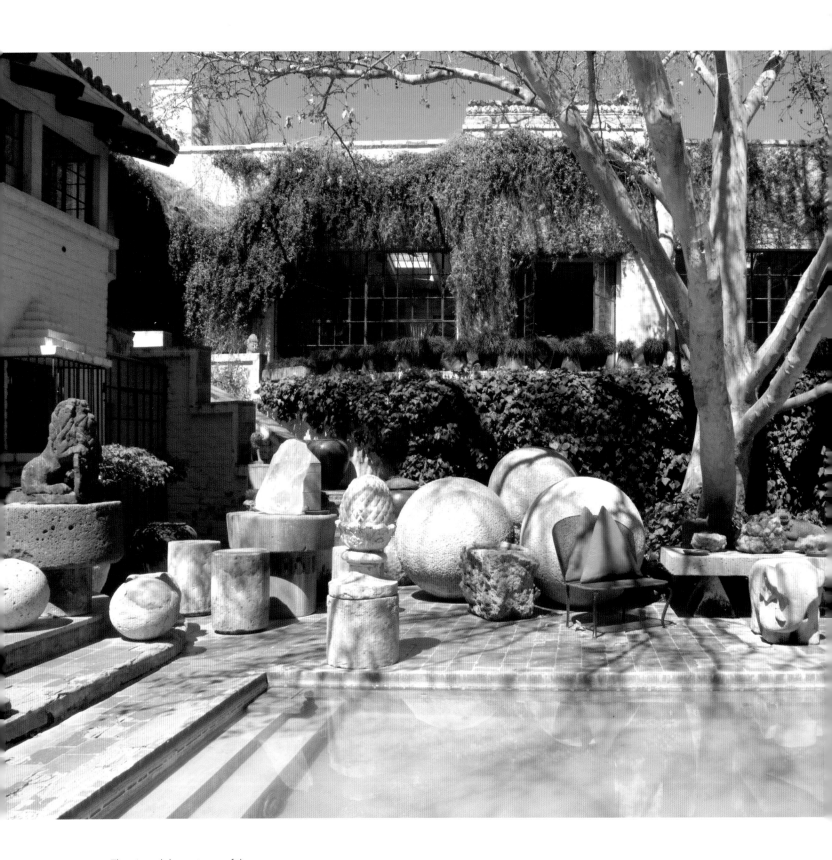

ABOVE: The air and the vastness of the desert are mediated by an unsurpassed collection of artifacts.

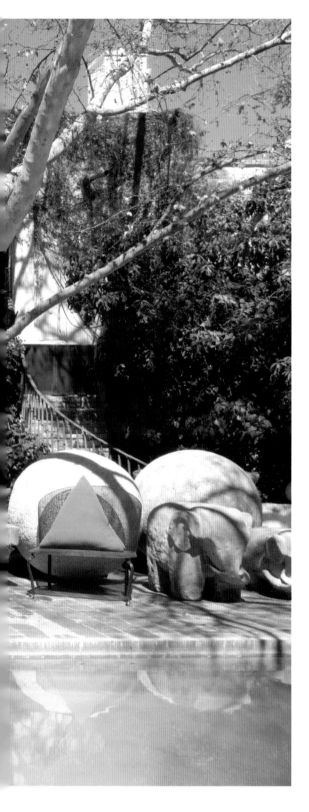

Holler & Saunders

OWNERS: Edward Holler and Samuel Saunders

ARCHITECTS: Edward Holler and Samuel Saunders

PHOTOGRAPHER: François Robert

Edward Holler's great-grandfather homesteaded the Arizona border in the 1890s. He braved a land where, "you may be alone without necessarily being lonesome. And everyone rides here with the feeling that he is the first one that ever broke into this unknown land, that he is the original discoverer; and that this new world belongs to him by right of original exploration and conquest. Life becomes simplified from necessity. It begins all over again starting at the primitive stage. There is a reversion to the savage. Civilization, the race, history, philosophy, art, how very far away and how very useless, even contemptible, they seem. What have they to do with the air and the sunlight and the vastness of the plateau!"[1]

A house was built, a "fusion of Spanish-Mexican and American traditions. Gabled, hipped, or pyramid roofs built over older roofs or on new buildings. Doors and sash windows, some bay windows with trim, were added, and wood floors. Rooms were added on, new roofing materials such as metal were incorporated."[2]

Soon the land was fenced, and a straight road to Mexico ran out the front door. Today the homesteaded residence is in the center of the city of Nogales. In many ways, it is still a world of wonder unto itself. Owners Edward Holler and Samuel Saunders, both lusty and vigorous interior designers, have created a home within a gallery, and many galleries within. They are surrounded by precious artifacts and complementary contemporary pieces. Their prized collections glorify every room, patio, and terrace. The principal patio is their favorite place to relax. The

[1] John C. Van Dyke, *The Desert* (Gibbs Smith Publisher, 1901), 200.
[2] Janet Ann Stewart, *Arizona Ranch Houses, Southern Territorial Style, 1867–1900* (The Arizona Historical Society, 1974), 7.

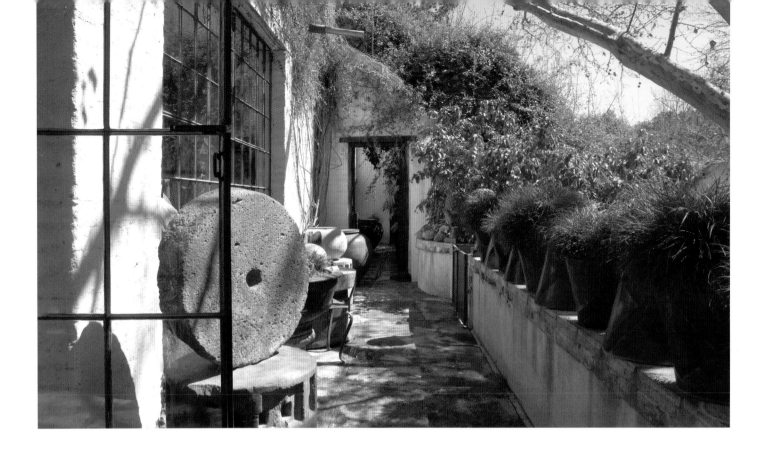

patio and pool area are populated with animals—elephants, snails, Chinese lions, and reptiles, all of stone. The animals become "animated" in the voluptuousness of green foliage around the pool; long ivy vines drape the higher walls. Large ceramic containers extend sword plants, and a border of greenery covers a balcony rail in blue and green planted pots. An old and treasured tree in the pool patio spreads its limbs to eliminate sun glare. Exterior walls are surrounded by large trees that lean into the patio to create a canopy of green overhead.

Edward and Samuel each have a private interior studio as a contemplative retreat, and their special room for later in the day is a very fine tequila bar. Somewhere on the grounds is a "hidden patio," with a large, shallow pool and a dramatic single stream of water blasting upward in

a shallow fountain—yet another secret retreat. The best feature of the house, in addition to its history, is its collection of interior furnishings. The passion of the owners' collection is evident: stone statues of warriors; carved wooden and painted Spanish *santos*; enormous gilded mirrors that reflect other gilded mirrors and golden chandeliers; chip-carved tables in the Spanish Colonial style; and handmade wood-plank tables from humble kitchens. Crucifix and crystal, fossils with foo dogs, armoires and silver armadillos line up with rare pre-Conquest figurines and utensils. The result is a new sublime, sensing the creative imagination of two amazing people who share a devotion to artifacts.

Great danes laze around the pool with chihuahuas. Peacocks walk the grasses with geese and chickens. It is a masterful private retreat.

ABOVE: The living room/gallery opens to a collection of ancient stone pieces and plantings of mondo grass. The balcony overlooks the pool and collection of stone elephants, snails, lions, and spheres below. OPPOSITE, TOP LEFT: Spanish carved wood forms a vibrant frame hanging above a wood statue of a winged warrior. OPPOSITE, TOP RIGHT: Saints and large ceramic pieces are reflected in a large gilt-framed mirror. OPPOSITE, BELOW: The original ceiling and brick walls of the homestead enclose a small gallery for Christian crucifixes and saints, and a rare collection of pre-Columbian bowls, water jugs, offering plates, and figurines.

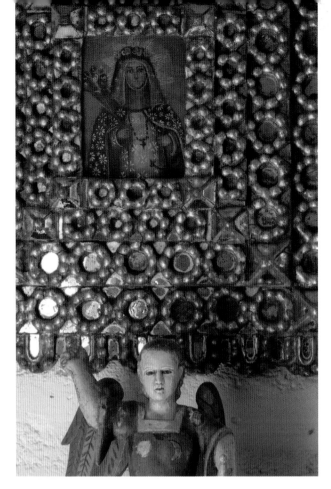

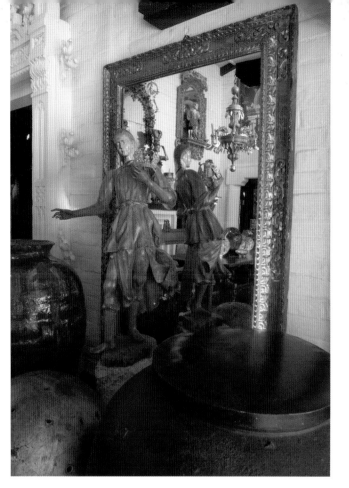

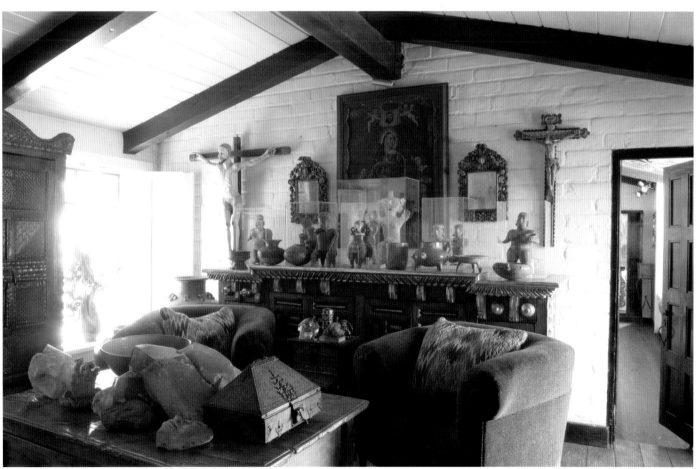

RIGHT: The spacious living room is flooded with natural light and shimmering reflections from the pool below. Celadon ceramics topped with thick natural glass are used as individual side tables among the rich tones of teal, wood, and gold.

BELOW: Living room doors open onto a balcony above the pool and terrace.

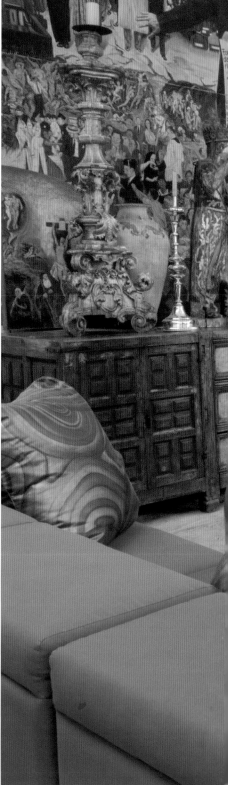

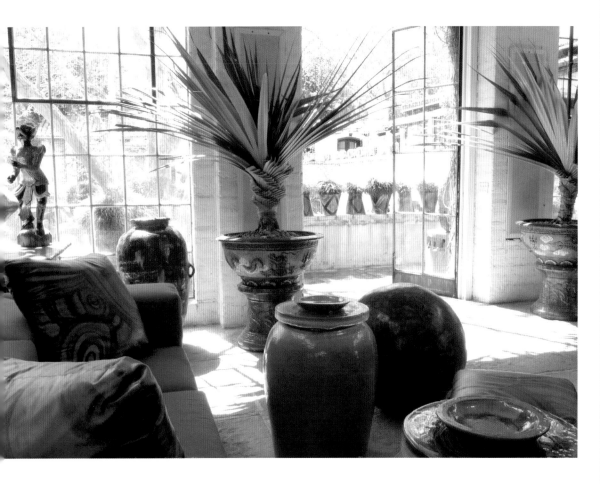

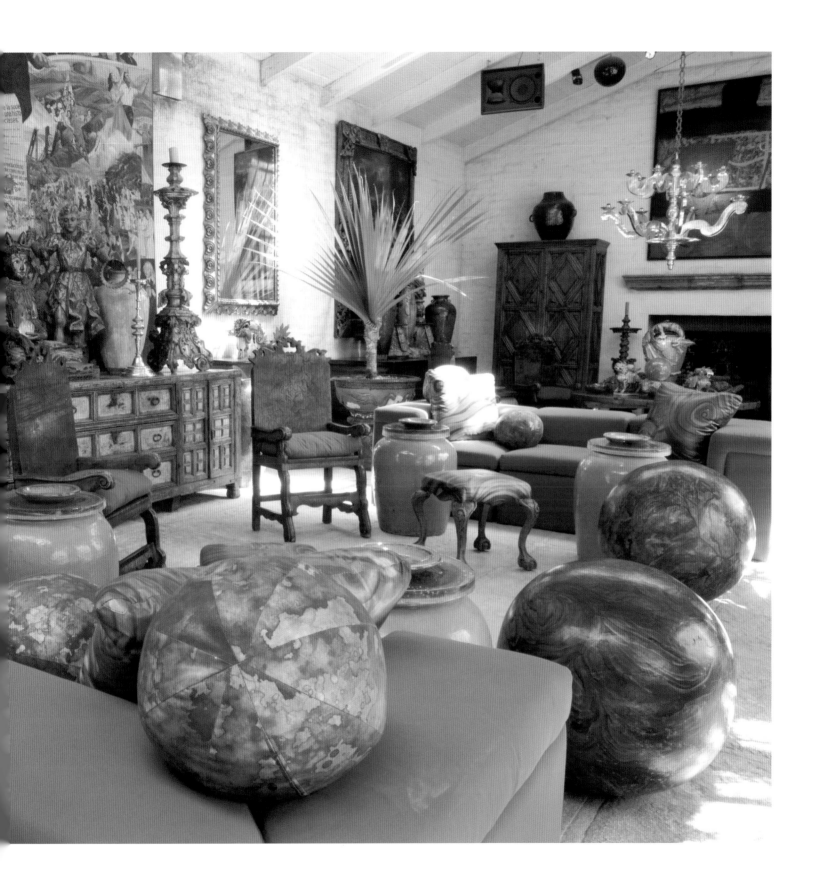

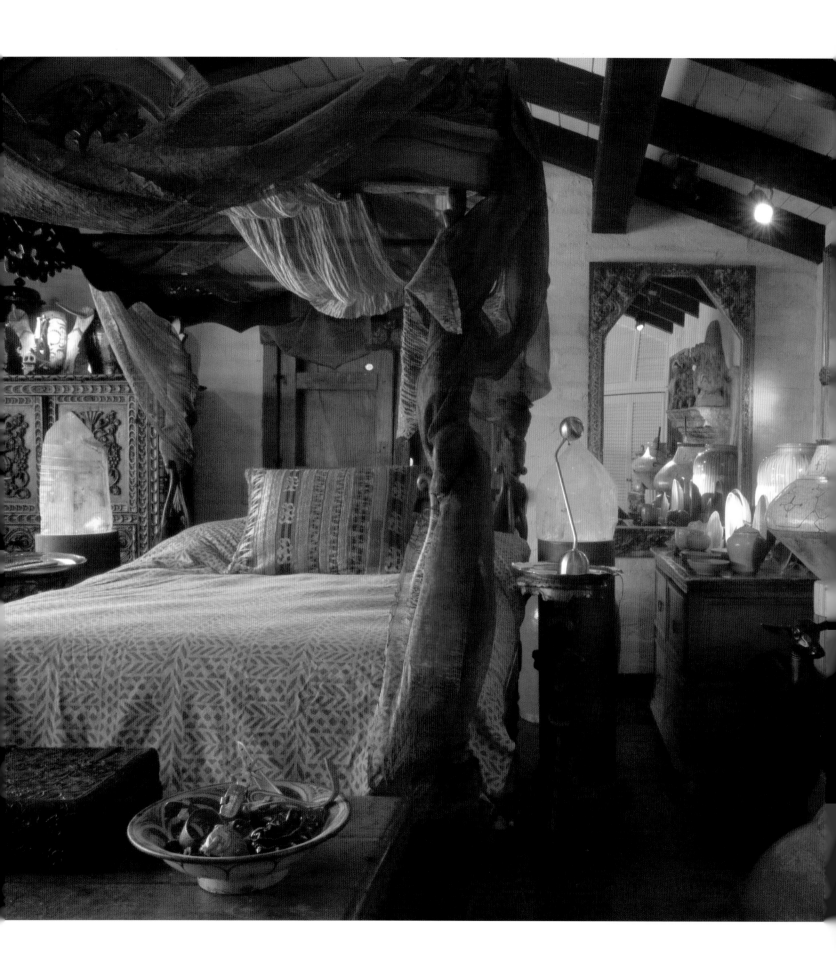

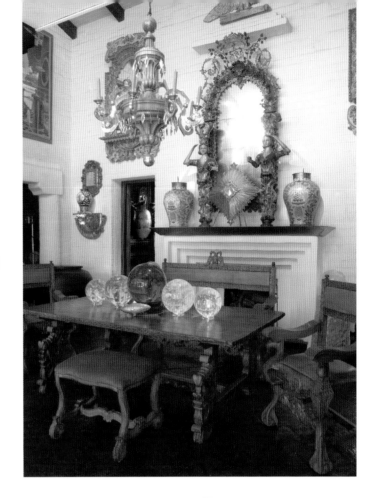

LEFT: A guest bedroom is illuminated by enormously energetic crystal lamps. Textiles soften the center of the room where artifacts reside. RIGHT: Traditional Spanish dining furniture features intricate carvings. BELOW: A Spanish desk and tall-back chair dominate the small office of the master bedroom.

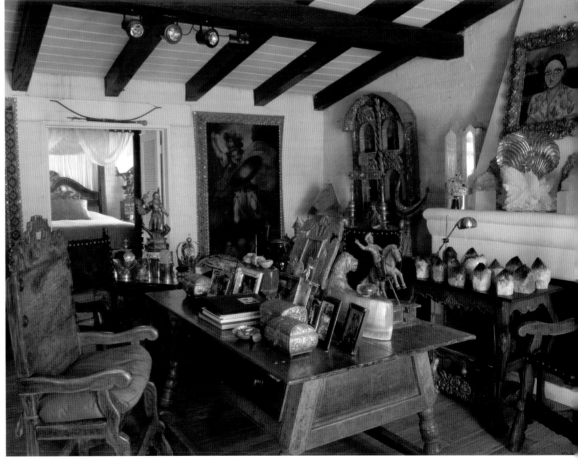

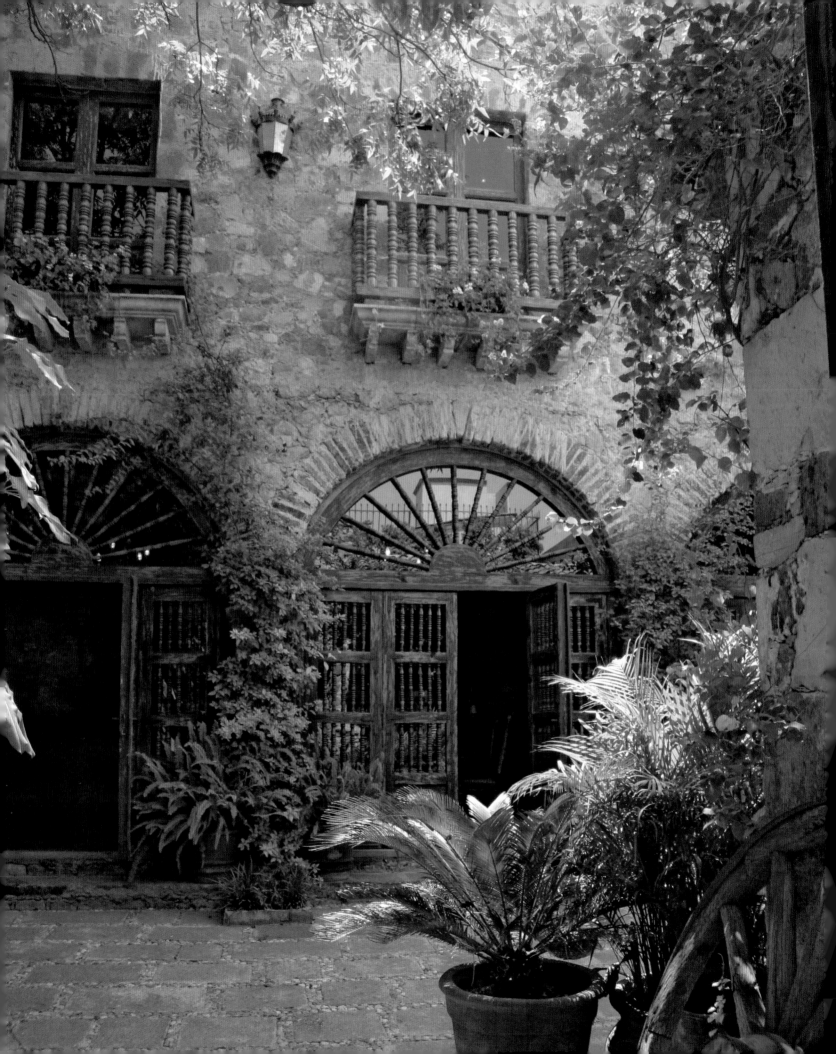

Los Dragones

ARCHITECT: Sebastian Zavala Taylor

DESIGNER: Rachel Horn Interior Designs; Horn and Horn Design

PHOTOGRAPHER: Rachel Horn

This stunning restoration housed the stables for *Dragones de la Reina*, a regiment led by the Spanish officer who lived there. The *Dragones* were the royal guards in the area of the Spanish Royal road, where routine shipments of gold and silver passed en route to ships preparing to set sail for Spain. The grand house was said to be a full San Miguel block from one side to the other, and the stables were in scale with the home. Los Dragones was originally built in 1670 and has experienced many exchanges in the deeds of ownership since then. The house has been divided and had many incarnations, but most of the stables remained in relatively sturdy condition. Many of the stone walls are several hundred years old and are two feet thick.

A recent restoration achieved the magic and atmosphere of the original house by keeping close to its history and drama. New areas were designed to resemble the oldest parts of the house. All the furniture was designed with a specific patina to give guests the sensation of having stepped back in time. The renovated living room, dining room, and kitchen were original stables, so they are quite small. The designer worked meticulously to keep the original three arched openings from the courtyard to these rooms. The ceilings of the three rooms were made with exactly the same techniques and materials that would have been used three hundred years ago. Mud, straw, and paint, with a special new sealer for protection, look genuine and masterful. The architect and builder is local and comes from a traditional San Miguel family. His background and expertise in construction and historical context allowed ancient materials, some from salvaged historic sites, to be

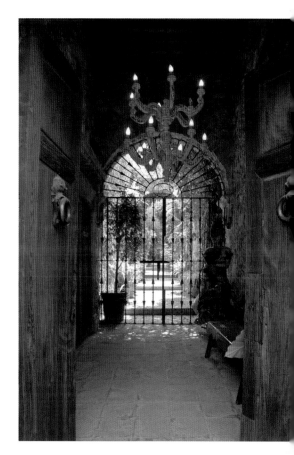

OPPOSITE: Spindle double doors open to a small living room, once a horse stall, from the central courtyard. LEFT: The small corner of the garden can be used for a private, tree-shaded *sala*. ABOVE: Antique double doors open to a stone passage to the central gated courtyard.

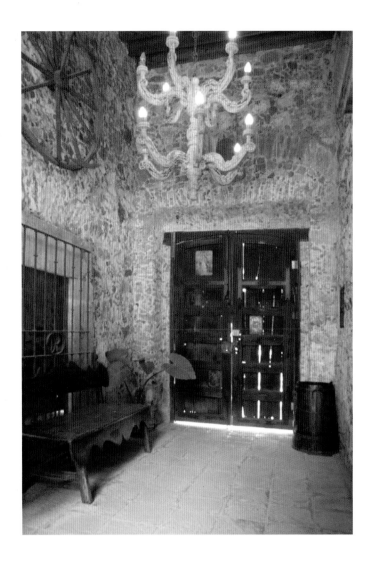

used. Carved cantera stone is used for fireplace and door surrounds. Brick pavers and tile flooring are used throughout the interiors, while exterior spaces are clad with stone. Wood doors with copper and wrought-iron fixtures are used as gates, door handles, and chandeliers. Interior walls made of stone gathered from several locations were handcrafted, one stone at a time: smaller stones line the lower portion of the wall; larger stones climb upward to meet a beautifully tinted frescoed interior wall or a lush, irregular border atop the courtyard walls. The courtyard is a

ABOVE: The stone passage, or *zaguan*, is a place to pause when going from courtyard to exterior. RIGHT: The living room off the courtyard. Stone walls and an arched entrance are warmed by rusted iron sconces, candles, and a gilded chandelier.

pinnacle of serenity, with a "crying wall" fountain. The magnificent efforts of architect and designer have never been better expressed or resulted in a more enchanting completion.

Here the echoes of the horses can still be heard.

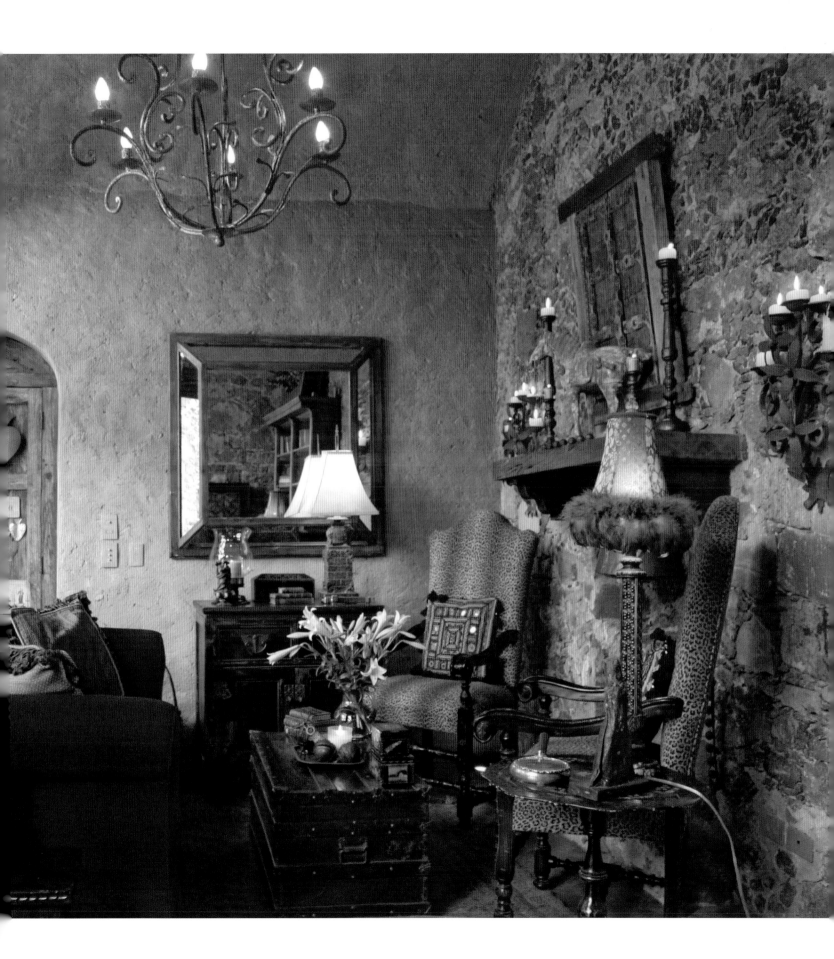

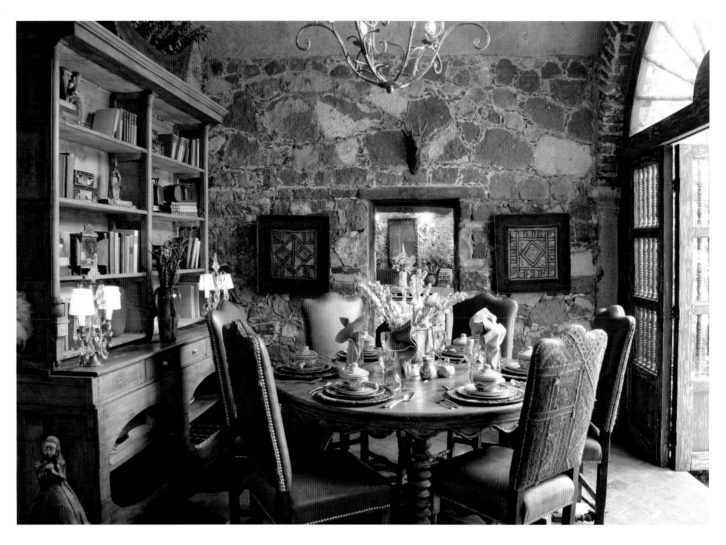

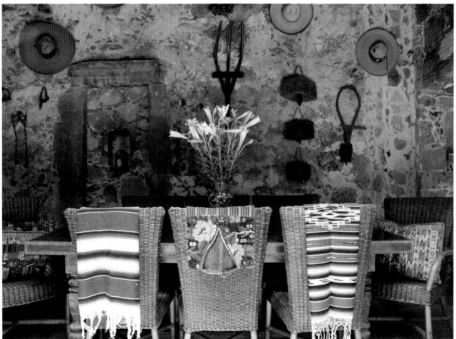

ABOVE: Each arched doorway once led to a horse stall. This delightful and cozy dining area is adjacent to the living room. LEFT: Textiles, color, and fresh flowers bring the stone niche of the outdoor *sala* to life. The large table has a unique copper surface. RIGHT: This large, redesigned horse stall is now a sensual and enjoyable *cocina*, lively with a soft citrus color on the vaulted ceiling.

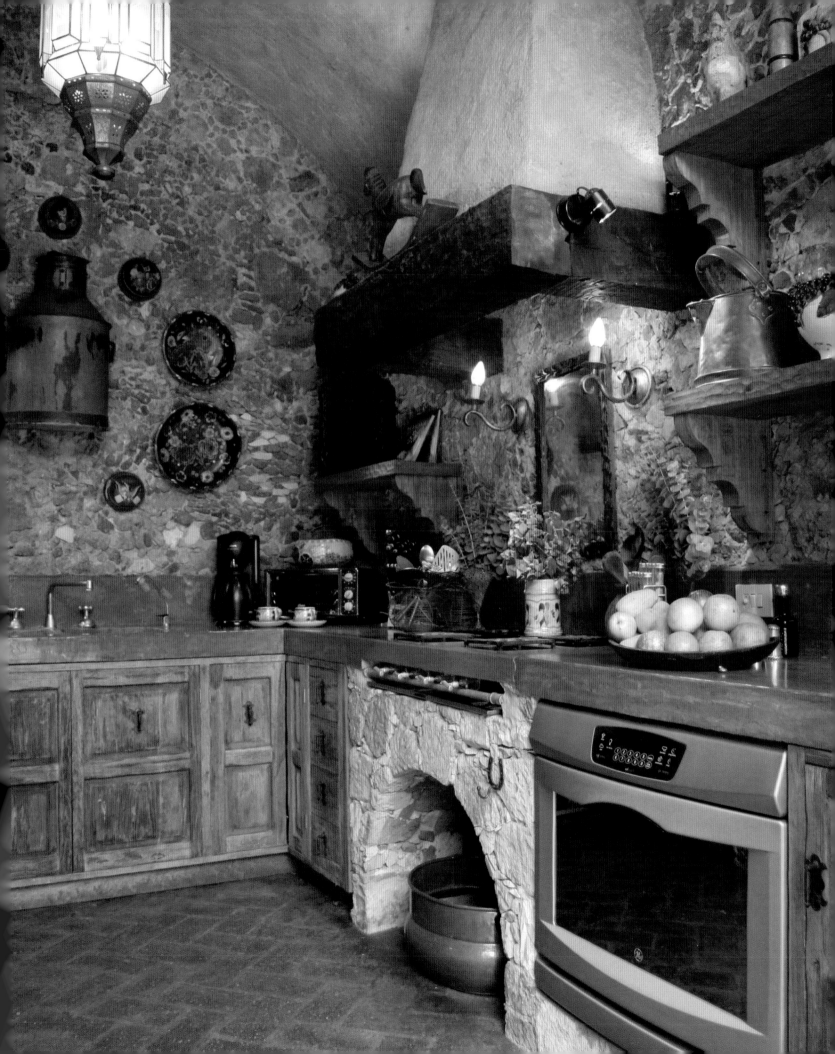

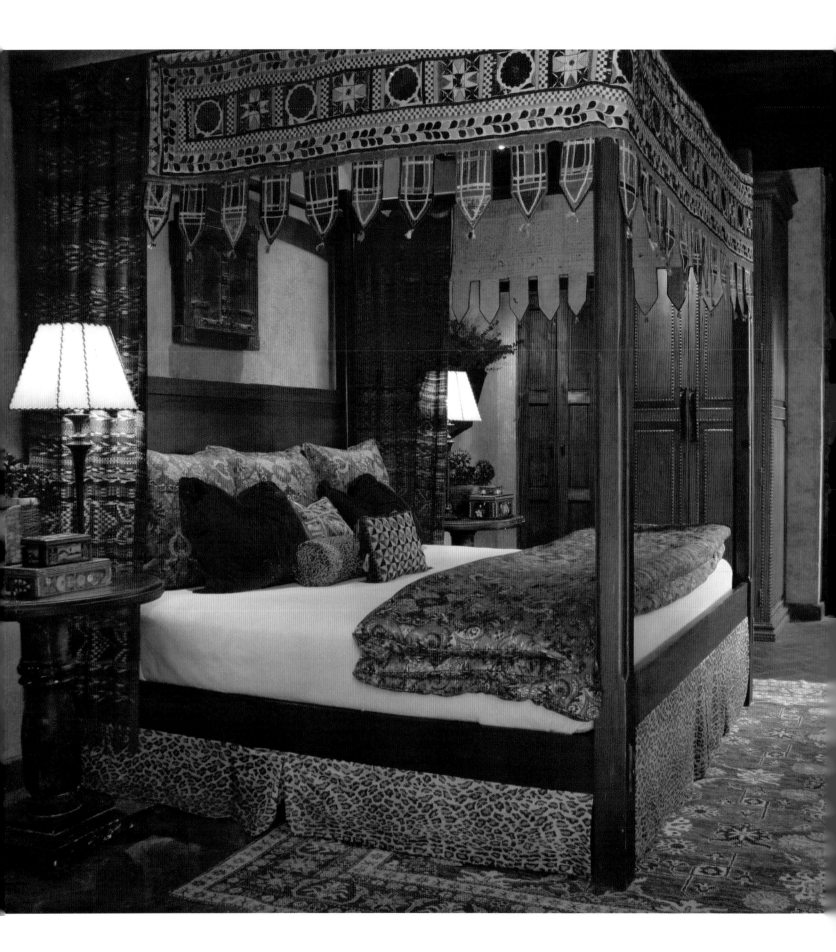

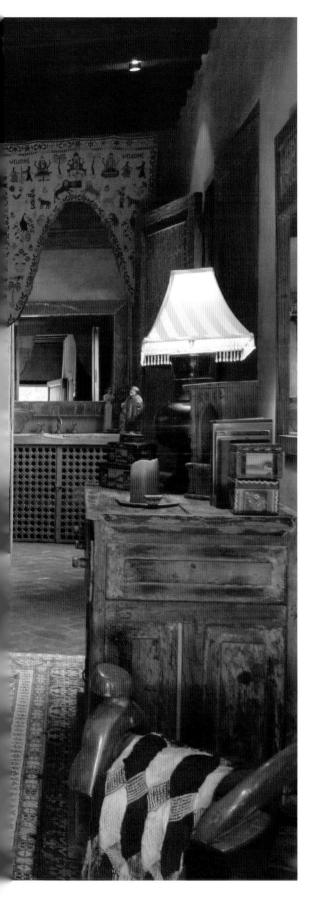

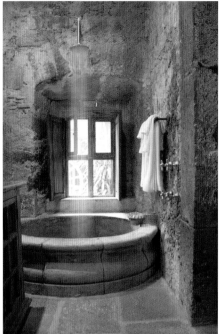

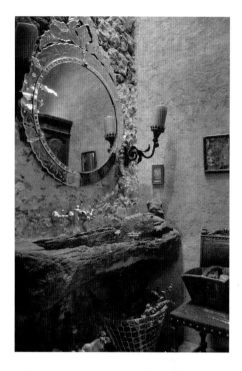

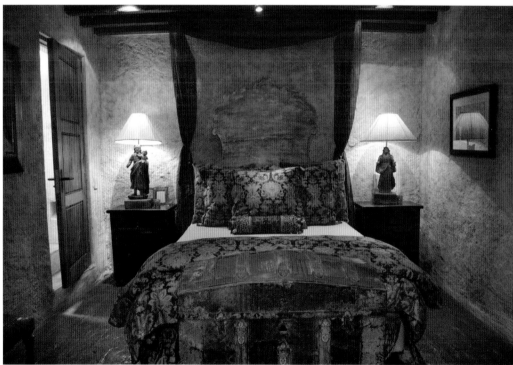

LEFT: The master bedroom has a four-poster bed and armoir with nailhead molding. A lattice-carved cabinet animates the adjacent bath. ABOVE LEFT: The round stone spa-sized tub has a "rain" shower. The windows let fresh breezes and bird songs become part of the bathing ritual. ABOVE RIGHT: The powder room features a stone basin and large, ornate mirror. ABOVE: The guest bedroom has an antique trunk and bed. Overhead is a dressing loft.

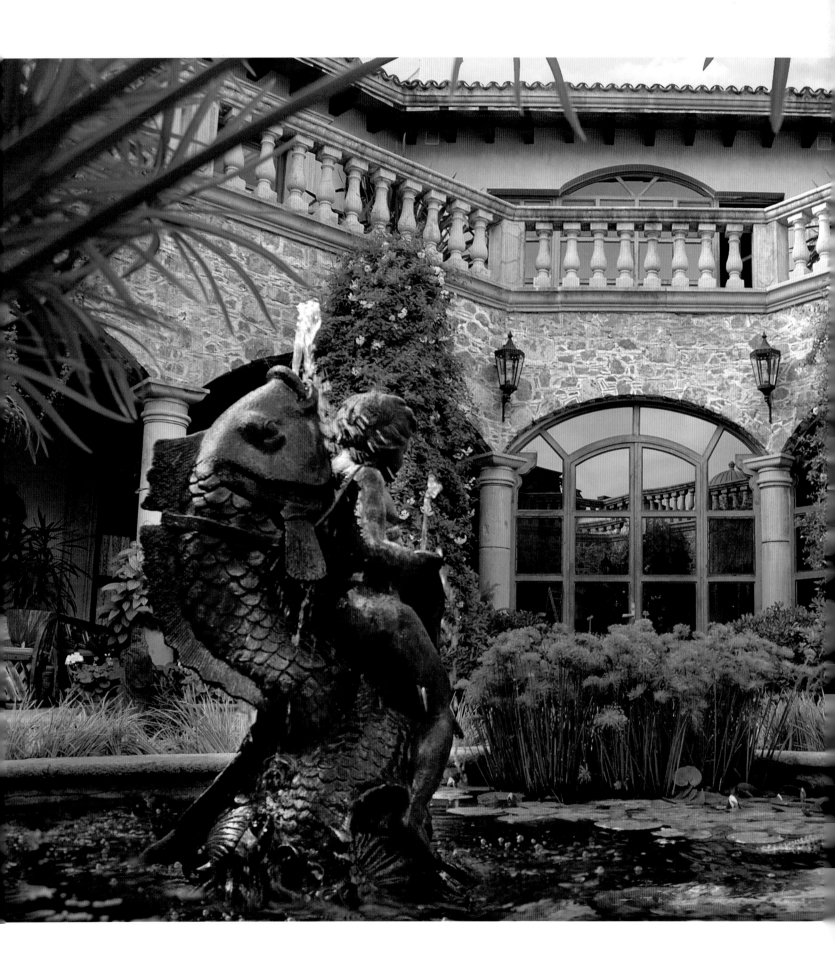

La Casa de las Fiestas

OWNERS: Mary and Tom Ambrose

ARCHITECT: Allan Wilkerson

INTERIOR DESIGNER: Sandra Menendez

PHOTOGRAPHER: Ricardo Vidargas

The hacienda is a potential dreamscape labyrinth. Visitors can be certain they have been in every room and garden, then suddenly find themselves in a place they have not been before. It is aural and mysterious; music is always playing. Its beauty cannot be entirely beheld: it may exist in letters sent to London or Africa; in groves of avocados or fruit; in layer upon layer of stone, laid between histories and secrets.

La Casa de las Fiestas is a new house. Mary and Tom Ambrose began the project with their architect, Allan Wilkerson, in 1995. The architect's mother was a famous local architect. Growing up, Allan worked side by side with his mother on residences. Later he was educated as an architect and engineer in Mexico City. Allan turned to many of the artisans who had worked with his mother and asked for their expertise and talents to create a sense of grace and authenticity while designing and building this new house. Their talents are rare in the modern marketplace, where new techniques are substituted for old. They would, for example, mix concrete in the old, traditional way, in which mounds of concrete and sand were piled on the

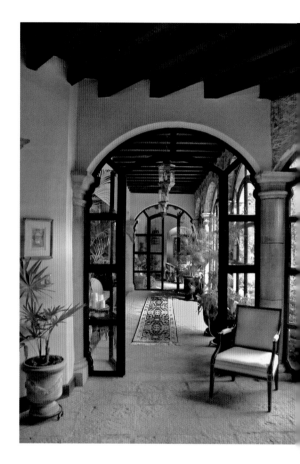

OPPOSITE: A koi sculpture is the focal point of the large fountain and pond at the center of life at La Casa de las Fiestas.
ABOVE: This elegant passage with large arches has French doors facing the court.

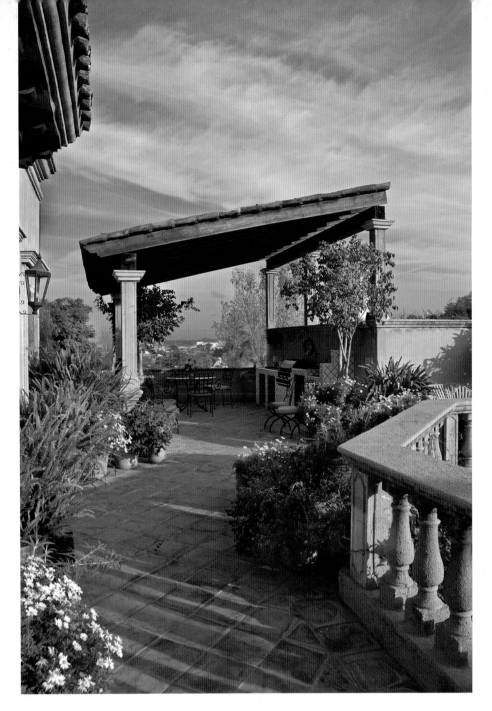

ran up the less-than-two-foot-wide plank to where the mix was needed, sometimes on the second floor.

The ceilings in some rooms are wood beam and *tajamanil*: short strips of a green wood placed against each other in a pattern covering the entire area between the beams. The luxurious design is found in many old colonial homes, adding warmth and charm to the rooms. On the second floor, the slanted *tajamanil* ceilings support a roof of antique tile. The *conchas*, or shells, over the niches are made from concrete that is carved freehand. Elevations and dimensions are unnecessary to the artisans. The iron railing on the staircase was made from a picture in a magazine— nothing more was needed. To create a roof or rail, a simple hose was used to establish the "level." The workers "fill a hose line with water, hold one end at the height they see, then watch where the water bubbles from the other end to determine a level: fascinating, and accurate." [1]

Tom and Mary's favorite place is the master bedroom. A friend of theirs is known to have remarked, "Why would anyone want to leave this room. It has a place to eat, a place to sleep, and a place

ground and a channel was dug, starting at the peak of the mound and winding around downward until it reached the bottom of the mound. Water was then poured into the top of the channel, flowing down and around the mound until it reached the end of the channel, where it was blocked. Two or three men then started at the bottom, turning the water and concrete mixture over and over with shovels until all was mixed to the proper consistency. The concrete would be shoveled into something that resembled an oversized olive oil can of about two cubic feet. These cans were hoisted onto a shoulder and rapidly carried, using only a steep board ramp with crude cross strips of wood nailed to it for foot traction, as each man walked or

[1] Tony Cohan, *On Mexican Time* (New York: Broadway Books, 2001), 254.

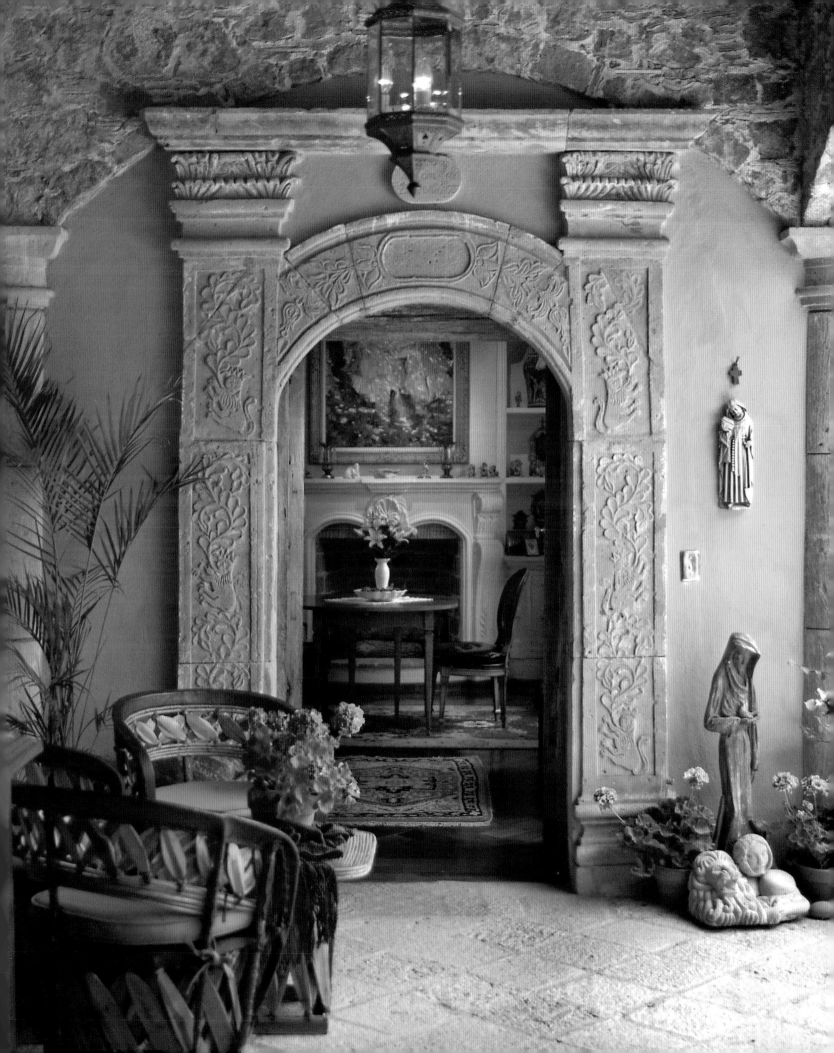

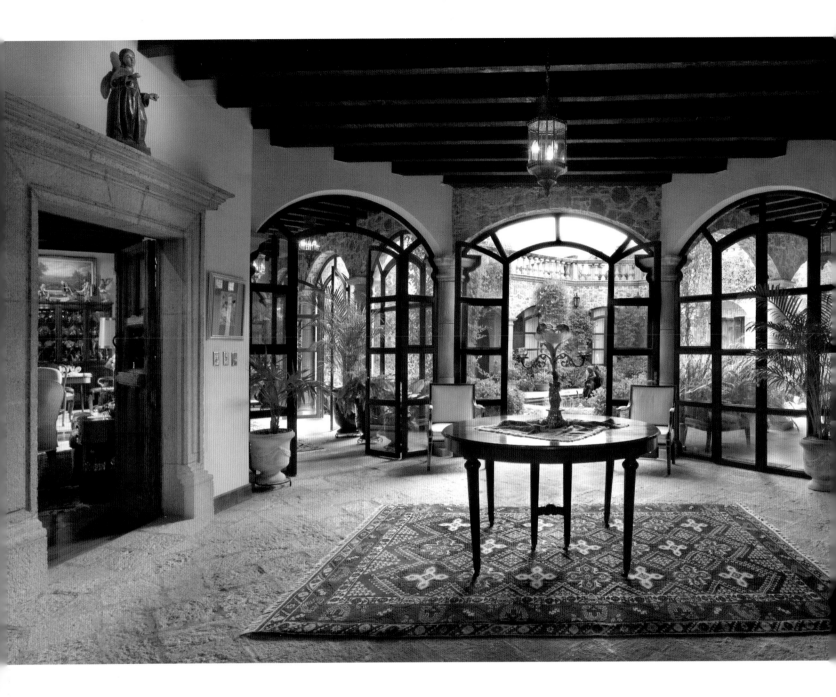

to read." It is thought to be a perfect suite, with all the luxuries of a private retreat. On chilly mornings, breakfast in the bedroom in front of the fireplace is the rule. Noon meals are occasionally taken in a passage outside the kitchen or bedroom.

The home is spacious with easy circulation, and lends itself to entertaining.

Mary and Tom's favorite charities are those that benefit children, animals, victims of domestic abuse, and care for the elderly. One organization, *Patronato Pro Niños*, pays the medical costs for children from poor local families in surrounding villages. Thus, the home has become known as "La Casa de las Fiestas"; to their neighbors, the House of Parties, benefits, and fundraisers.

The home was completed in 1997. Mary claims that if she'd known ahead of time that it was going to take so long to build, she wouldn't have done it. Although now, when friends suggest that the house must be three hundred years old, Mary is delighted that the work of her architect and her designer has earned the compliment, and the time is appreciated.

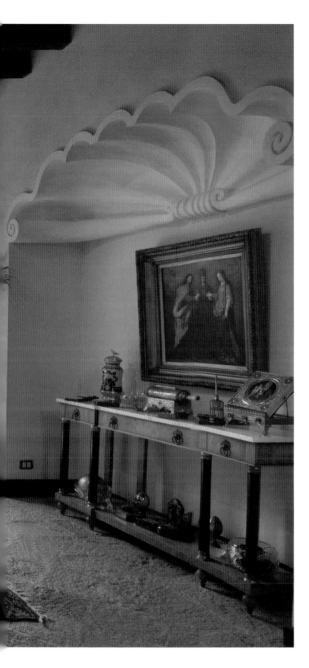

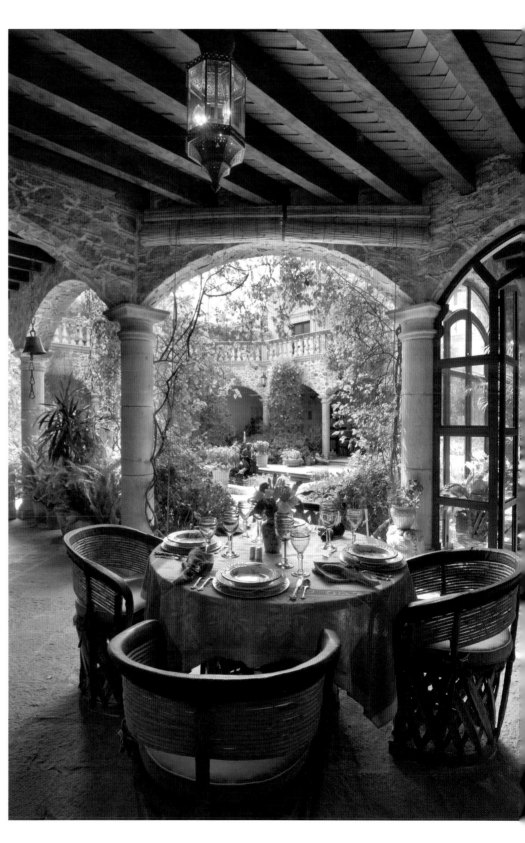

ABOVE: A large front hall serves as an introduction to all rooms and gardens.
RIGHT: One of several dining areas of the loggia has a quiet corner that enjoys sounds from the fountain.

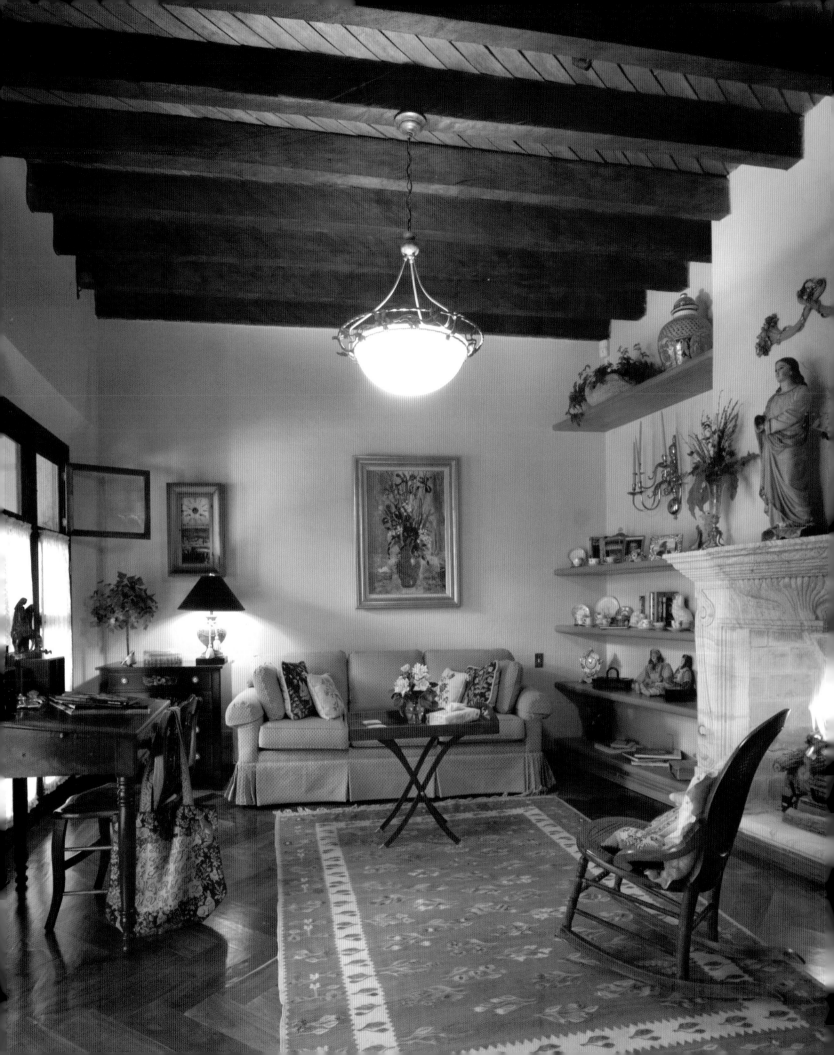

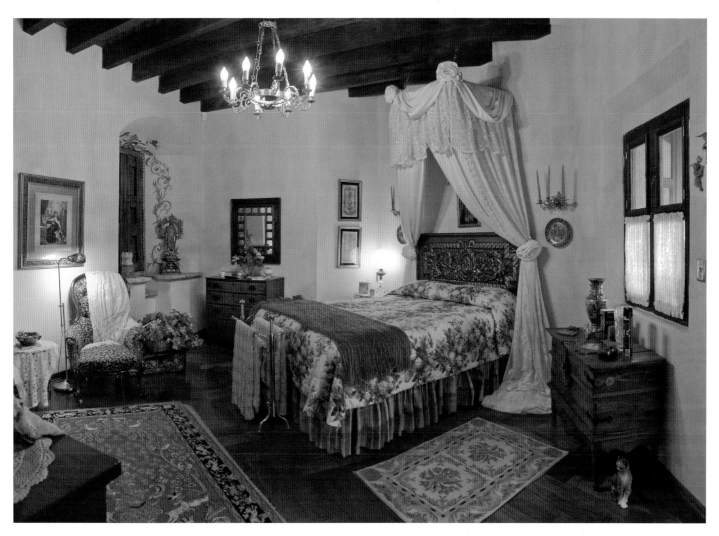

LEFT: This room is perfect for writing or reading, with the warmth of the fire and a secluded peacefulness. ABOVE: A guest bedroom is furnished with treasures from world travels. RIGHT: The master bedroom suite is a world unto itself.

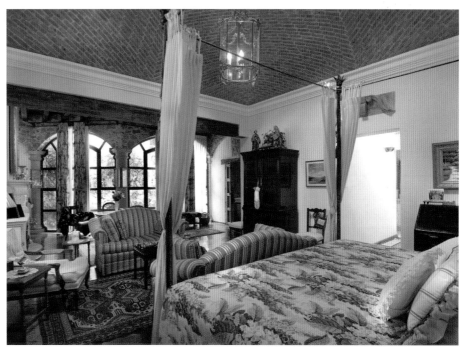

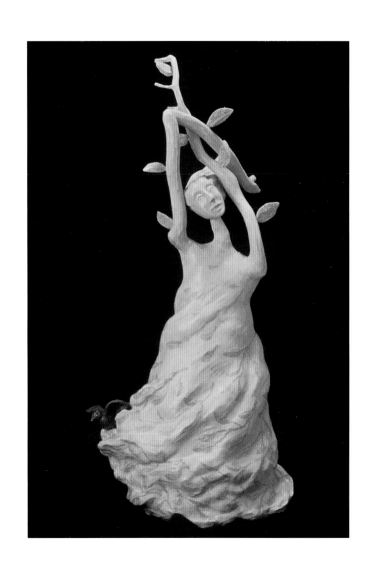

PART III

The pure and simple balances and lines create the look of a centuries-old home. The foyer and three-corner rooms each have a bovéda ceiling—an ancient and unique art form. A high and delicate vaulted interior is constructed of brick, using no mold, form, or frame. Two men begin at ceiling height at opposite corners. The craftsmen continue to work opposite each other, putting up brick by brick, working in circles around the ceiling. Each brick is balanced and shaped perfectly to turn a corner or make just the right curve to form the glorious final dome.

—Mary Ambrose
La Casa de las Fiestas

NON L'HO NOTATO L'HO PROPIO VISTO
Margarita Leon
Clay, wood, eggshells, copper sheeting, patinas
44"h x 20"w x 16"d.

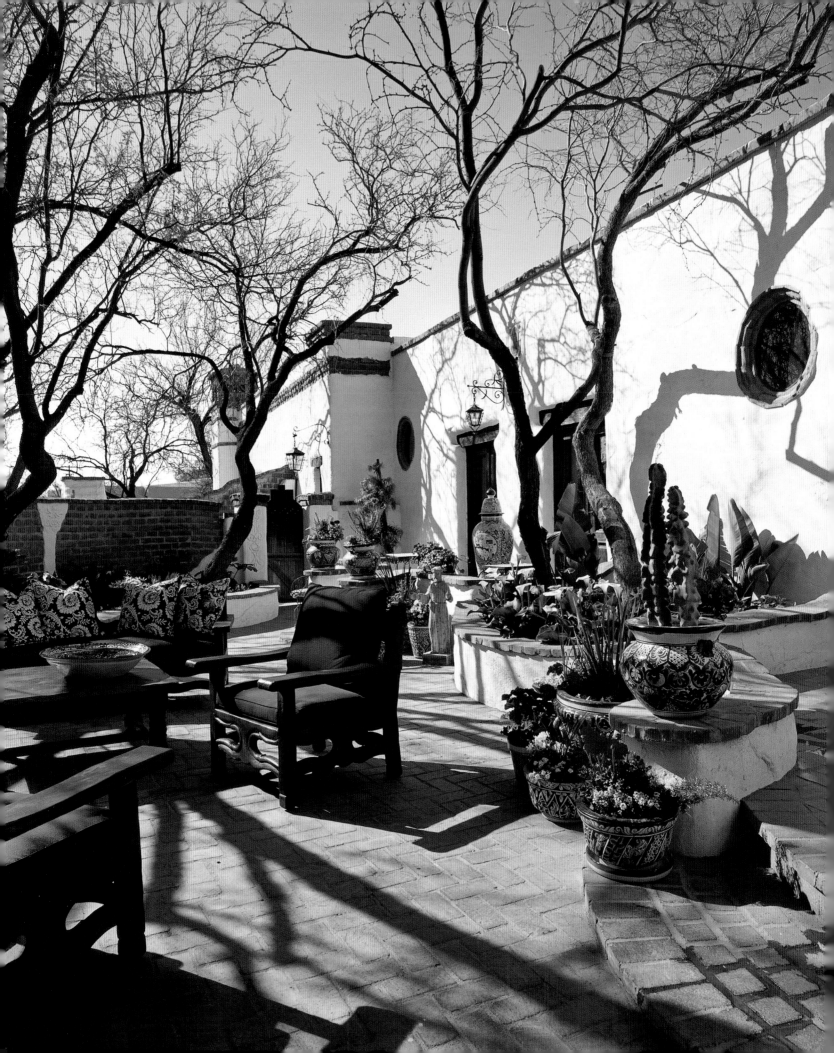

Casa del Oso el Bosque

OWNERS: Julie and John Taber

ARCHITECTS: Julie and John Taber

INTERIORS: Bouton & Foley Interiors, Inc.

PHOTOGRAPHER: Werner Segarra

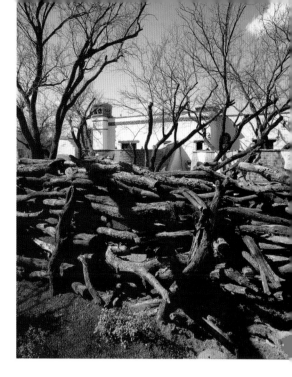

If there is one feature in Casa del Oso el Bosque that is perhaps most representative of this home, it is the white stucco scrollwork. A white bird against the brick entry might be missed by visitors entering the front door. Above it and just below the roofline are vines, roses, and scrolls of raised stucco that add a touch of grace to the finished brickwork. It is subtle: scrolls appear in a corner of the kitchen and above the French doors in the dining room; a rose is glimpsed above a kitchen window, a hummingbird above the master bedroom door, and a bunny above the eldest daughter's room. The stuccowork speaks of the history of the place; that it has been rebuilt by the owners, by their hands and the hands of craftspeople, with love and determination. It is a house, Julie Taber says, "that was not patterned after one place. It was influenced by houses and hotels we saw in Mexico, Santa Barbara, and even old areas of Phoenix and Tucson." Bear myths and magic may be a large part of the re-creation of this marvelous Arizona-style hacienda, but the loving hand of homeowners has rarely been more satisfyingly accomplished.

Following a flood in 1999, when the house and everything in it was lost, the Tabers began their plan of renewal. Materials were collected by friends, architects, and the Tabers themselves. Stones for exterior walls and driveways were provided by a friend. Tiles, mesquite, and ponderosa pine were salvaged and stored. The bark beetle, in search of water, is devastating the pines in northern Arizona, so John milled pine trees before the insects would destroy them completely. The couple collected vintage building materials to replicate

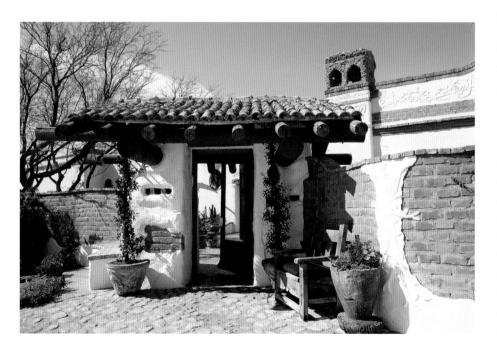

OPPOSITE: A beautifully detailed enclosed courtyard combusts with lively energy. Colors of the earth and the deep-blue sky appear on the Talavera pots, occasional pillows, and furniture cushions. ABOVE: A fence was made from the branches of reclaimed mesquite. LEFT: A rustic entry leads to the courtyard and main entrance. Materials salvaged for the reconstruction of the house included cobbled stones.

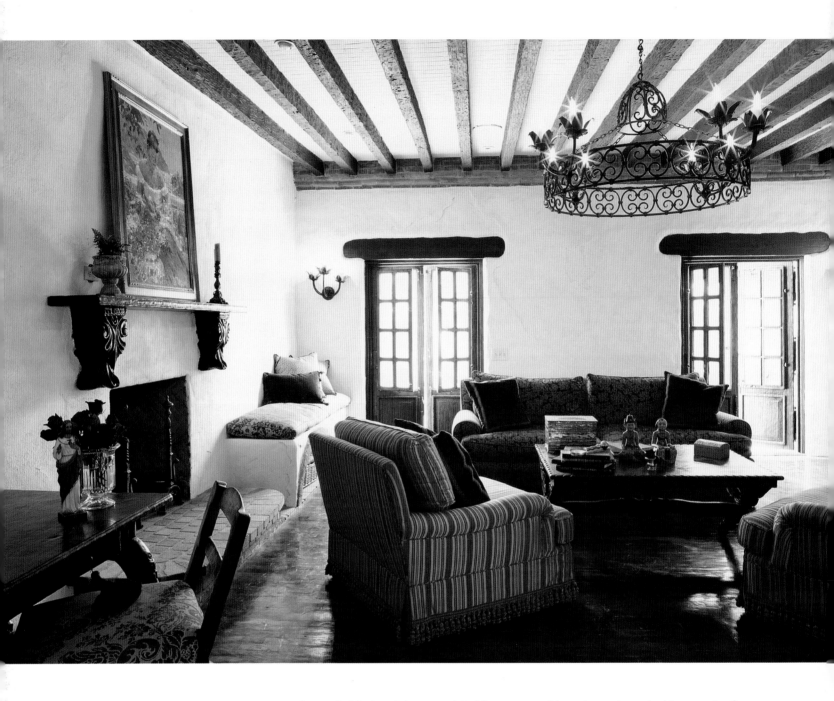

ABOVE: The reclaimed soft wood flooring, wooden lintels above the French doors, and overhead beams create the perfect setting for the chandelier designed and fabricated by the owners' design business, Taber & Co. OPPOSITE: Period and antique furnishings are reproduction pieces from the Taber & Co. design studio.

homes in Mexico, Arizona, and California. The construction techniques used in the home were labor intensive and from another era. The craftsmen and -women who worked with Julie and John created a full range of interior furnishings, including wrought-iron chandeliers, sconces, door clasps and locks, carved furniture, leather upholstered dining chairs, and

refrigeration units tucked into a pair of carved Mexican colonial armoires. The craftspeople work for the Tabers at their custom furnishings house, Taber & Co. Each piece is expressive of its history and its creator—each of whom Julie and John consider family. Their furniture, architectural elements, and millwork are well known, and their work is in high demand

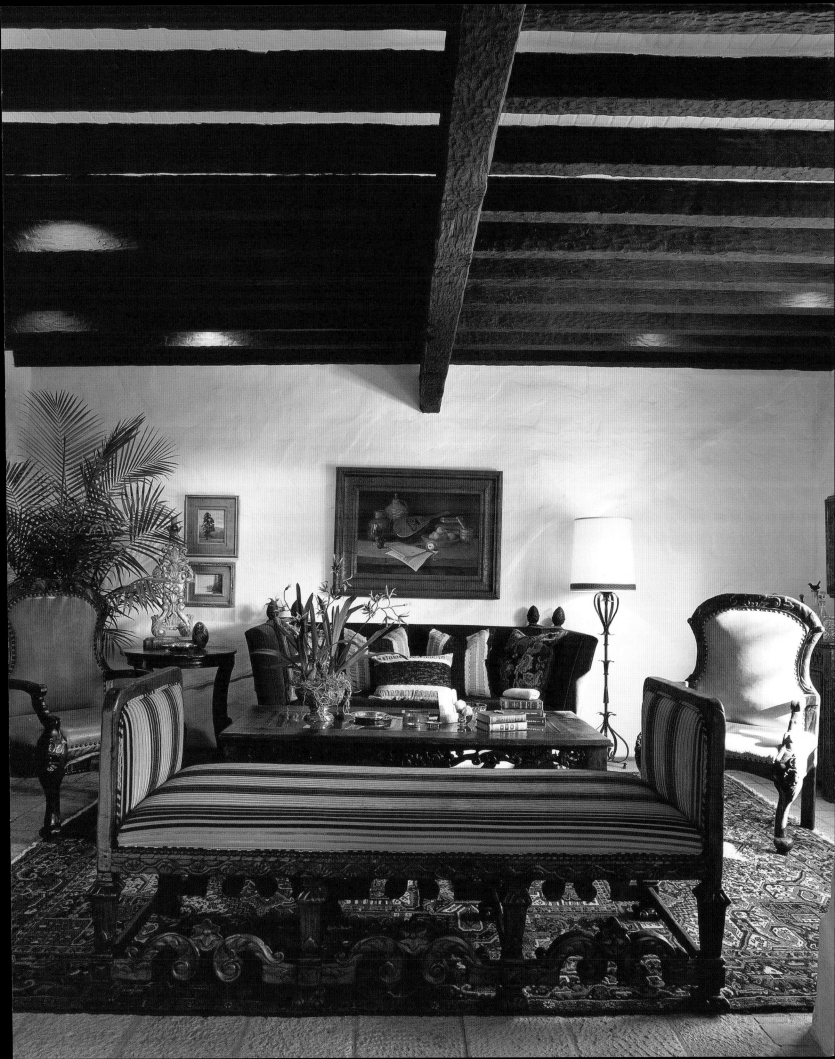

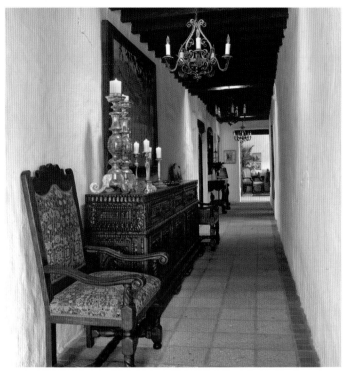

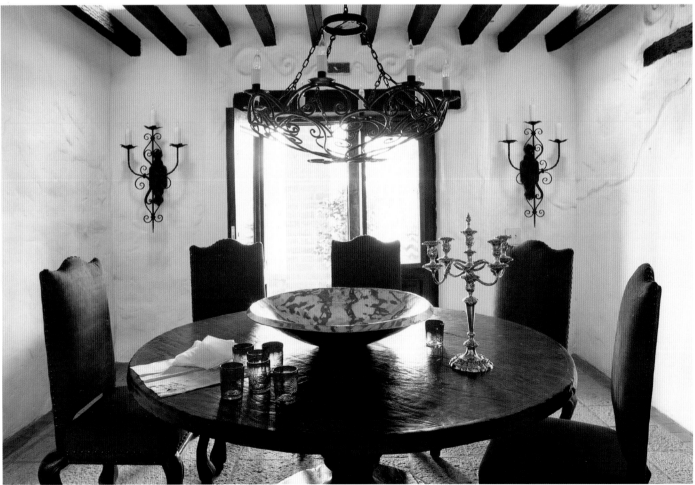

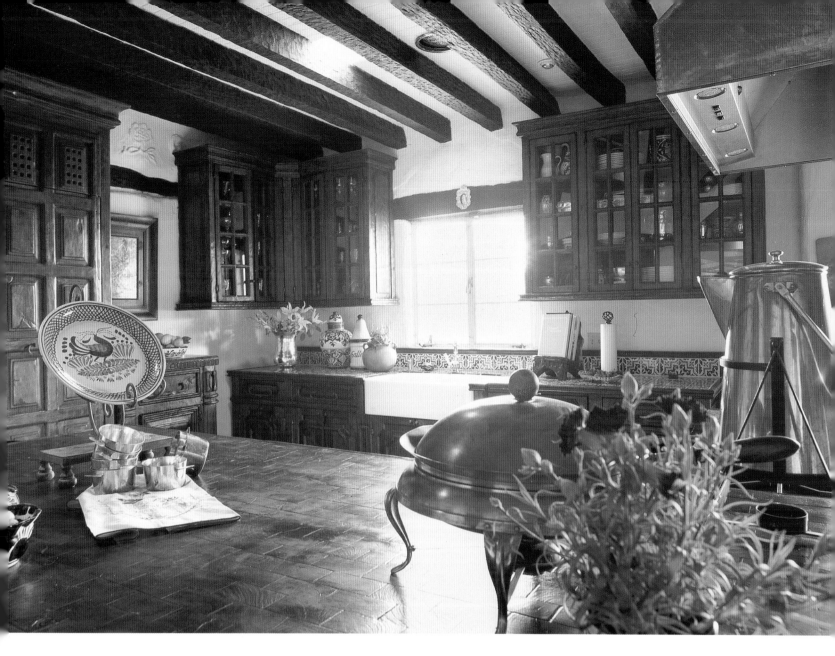

for its superior quality and considerable detailing, preserved to perfection by their own recipes for stains and waxes.

The neighborhood is their joy. Julie and John love taking walks with their kids and dogs. Their favorite loop is through the ranches where miniature horses are raised. Texas Longhorns graze in pastures, and cowboys rope cattle in their arenas. Roosters and peacocks can be heard. Back in the Tabers' courtyard, the mesquite trees emerge from corners of the garden patio. Gate columns topped in brick and covered with stucco or stucco fragments each bare their own quiet story; there is no evidence of the flood.

ABOVE: A spacious kitchen features end-grain mesquite for the island top. Glass-fronted cabinets and carved-wood cabinetry are complemented by the blue and white accents of Talavera backsplashes, vases, bowls, and platters. OPPOSITE, ABOVE LEFT: A Talavera-tiled sink and ceiling tiles accentuate the Taber & Co. armoir. Note the plaster scrollwork above the doorway. OPPOSITE, ABOVE RIGHT: An open-beamed passage in the bedroom wing is furnished with hand-carved Taber & Co. pieces. OPPOSITE, BELOW: Plaster scrollwork above the door lintel is an echo of the chandelier above the round dining table. Red leather chairs add drama.

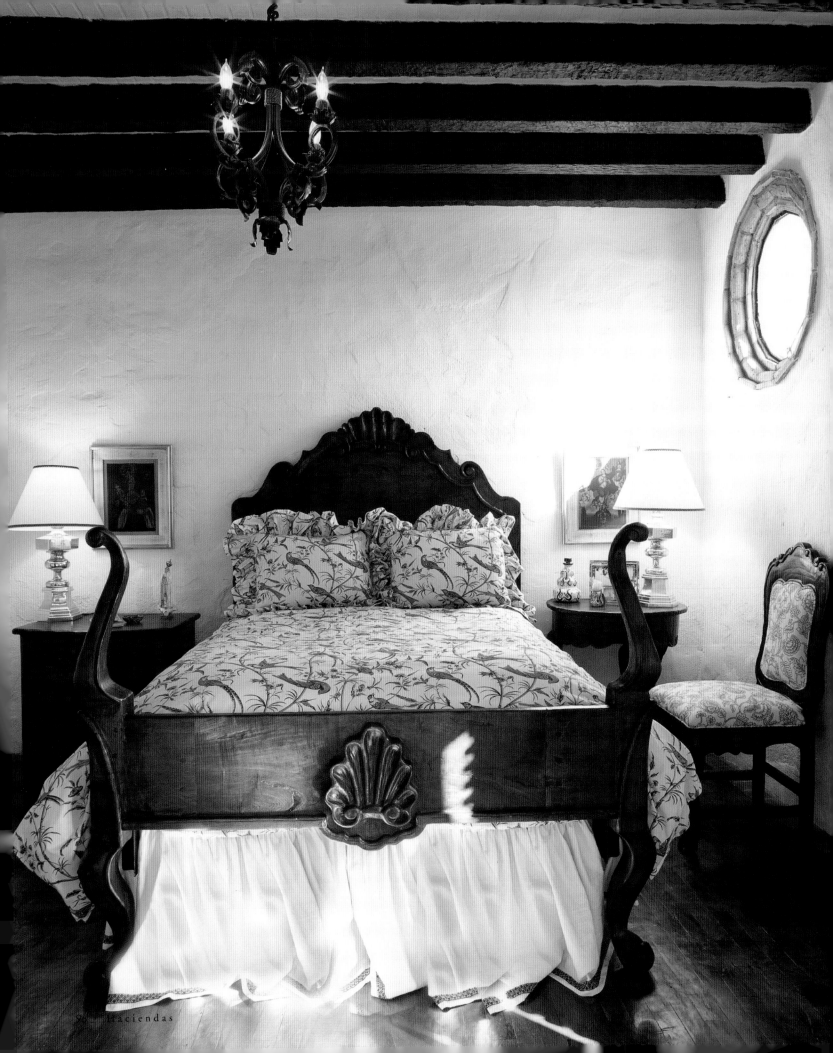

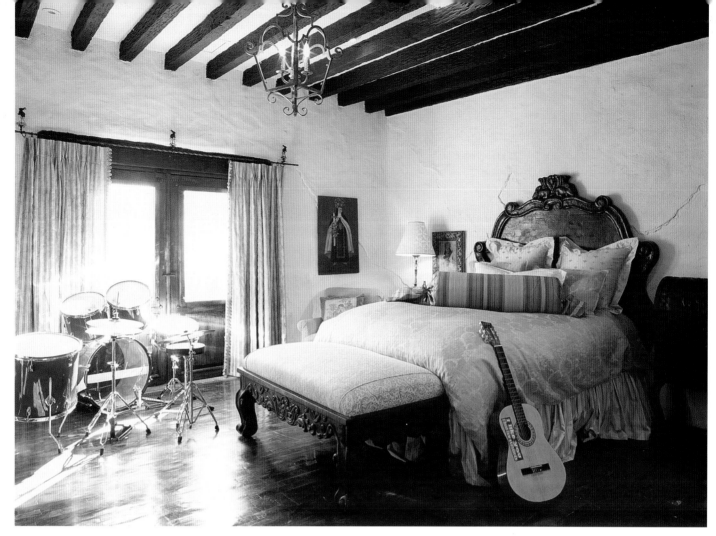

LEFT: A guest bedroom has a traditional Mexican circular window. The antique reproduction bed, with shell design, is a Taber & Co. piece. ABOVE: Wrought-iron rabbits dance on the curtain rod and are carved into the headboard of the bed. RIGHT: Behind the arched wood doors, tiled wainscoting surrounds the bath.

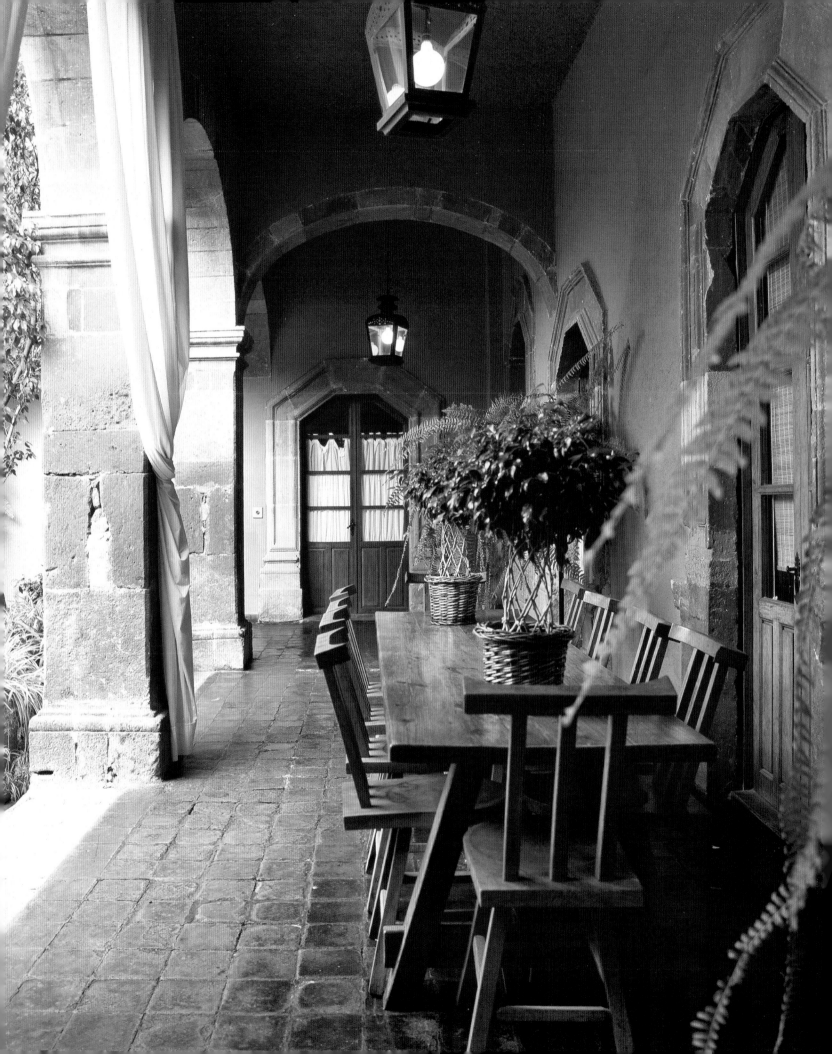

Halpert Residence

OWNERS: Billie and Luis Halpert

ARCHITECTS: Billie Halpert & David LaBrada

PHOTOGRAPHER: Christiaan Blok

It is not easy to restore and renovate a three-hundred-year-old building. Many lives and histories have passed through in that time, and the years have left their marks. Billie Halpert's home most recently was a restaurant. It sat across the street from her gallery, and from time to time she dined there. Billie has been a creative person her entire life. When the opportunity came to purchase the historic fourteen-room building in 1987, she knew that she had the talent and follow-through to bring this beautiful old structure back to life and restore it to its original beauty, and perhaps make it a little livelier than it had been since its original days.

Billie also had the benefit of a group of talented artisans and their captain, David LaBrada. "We had no architect, no engineer, no artistic director at all. Between the two of us, we figured it all out. I would just draw him pictures and walk off the lengths I needed. When I would explain something I wanted, he would draw it with his pencil on whatever wall was available. We would discuss, make corrections, and then back to work. I knew what I wanted, and he knew how to do it. Easy as that." One beautifully confident talent recognized another.

Billie and her husband, Luis, spend a month or two a year away from their Mexican home. They look forward to returning to their comfortable courtyard garden, the trees, and their meditative benches. It is the custom of some architectural styles that the facades of buildings reveal nothing of what is to be found inside. And so it is often in Mexico. Billie and Luis's courtyard has a stone patio with an arched colonnade, where they have installed hanging wrought-iron pendulum lanterns. Overhead the courtyard is protected from the sun with draped fabrics that

OPPOSITE: Topiaries of *Ficus Benjamina* set the stage for outdoor dining on the loggia. LEFT: A curtained courtyard and arched *corrédor* screen the sun and move the breezes. A clutch of bottle ferns undulates at the center of the pavers. ABOVE: A collection of antique *pulque* bottles in various sizes. Color was believed to retard spoilage. A dramatic wrought-iron chandelier and antique table furnish the foyer.

move with the flow of breezes and show the shadows of the clouds, while keeping the hot temperatures and glaring sunlight at bay. Carved stone surrounds window casings and doors that lead inside to the kitchen, as well as the living and dining areas.

The interiors, painted in soft colors, are cool. The living room floors are soft wood, stained to a dark, muted shine. The fireplace and furnishings are crisp white with silver accents and, for color, a collection of Talavera pottery. The foyer and bedrooms share salvaged antique terra cotta tiles buffed to a low sheen. The ceilings are eighteen to twenty feet high and emphasize the quiet elegance of the home. The interior spaces maintain a refreshing and renewing feeling, which Billie, with all her certainty, created.

ABOVE: A casual seat for gathering in the kitchen and talking to the chef.
RIGHT: The dining and seating area is near the carved limestone fireplace.

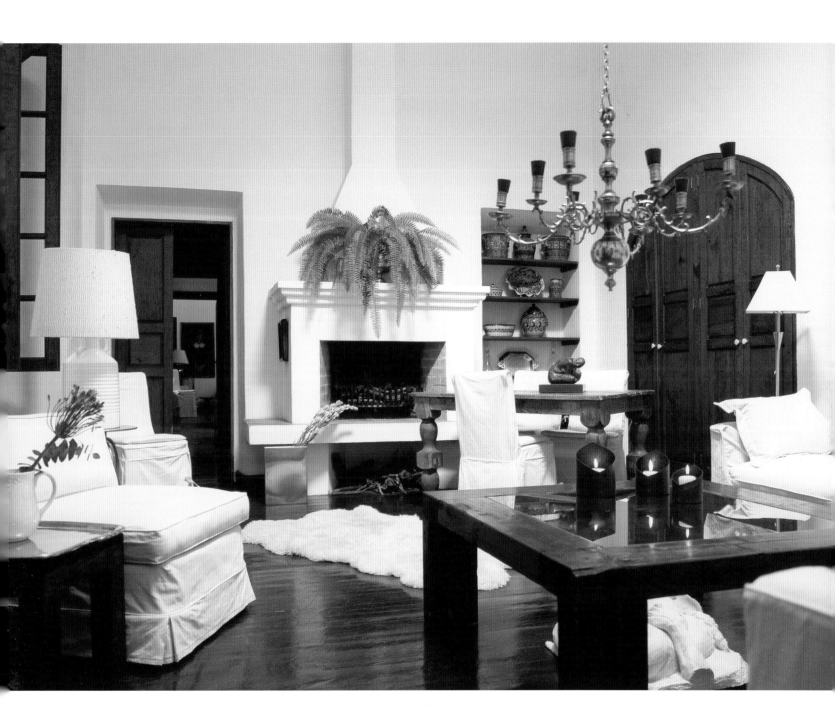

The living room is a contrast of starkness
and warmth, accented with Talavera pottery
and a beautiful silver chandelier.

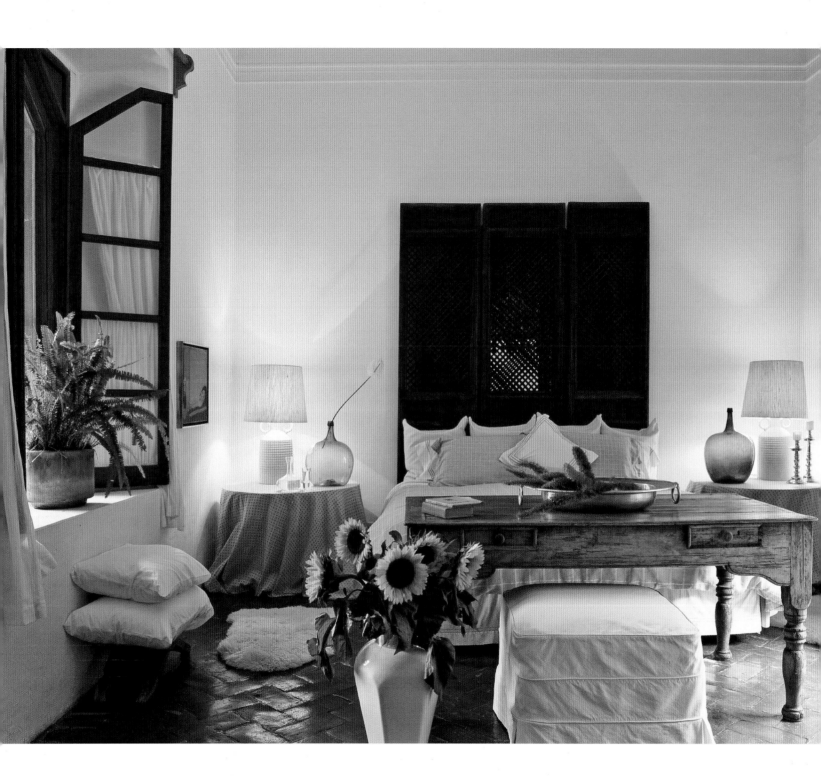

ABOVE: Saltillo tiles make any room feel
fresh and warm. The four-by-six-inch dimen-
sions used here to create a herringbone
pattern generate an added liveliness.

OPPOSITE: The guest bedroom is a swoon
of blue. Carved birds perch on the end of the
bed board, and a cupid holds forth. Airiness
and breezes billow above the canopy of light.

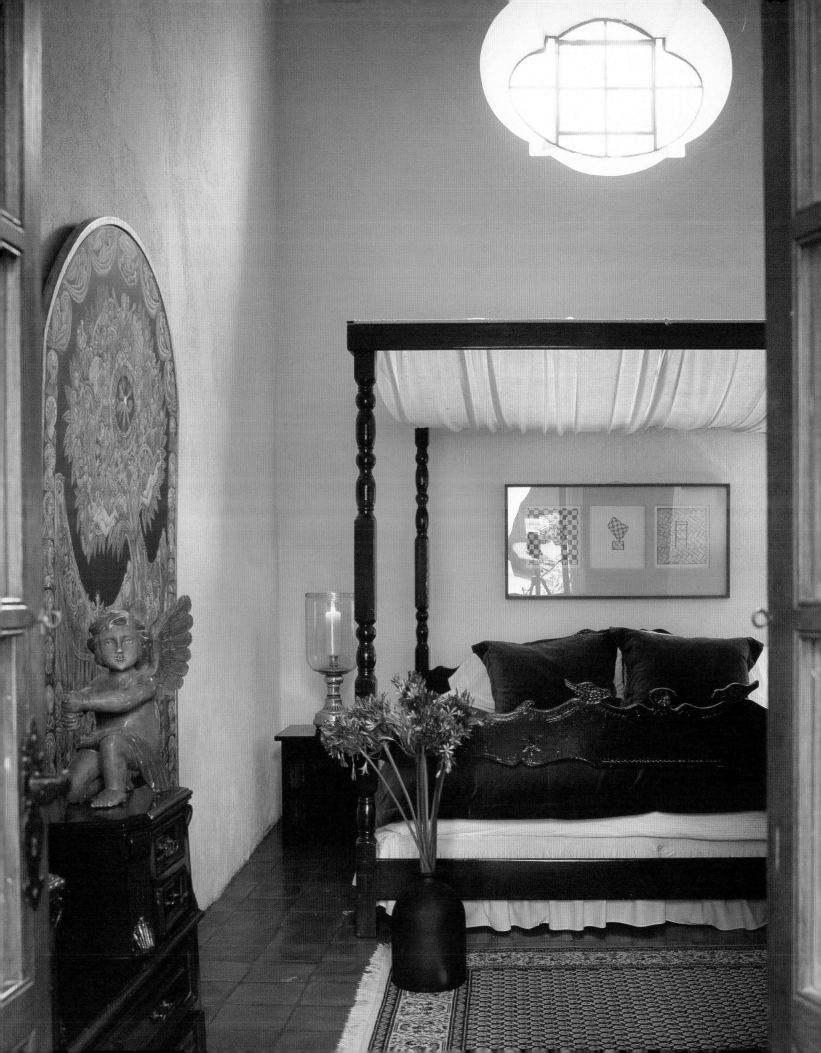

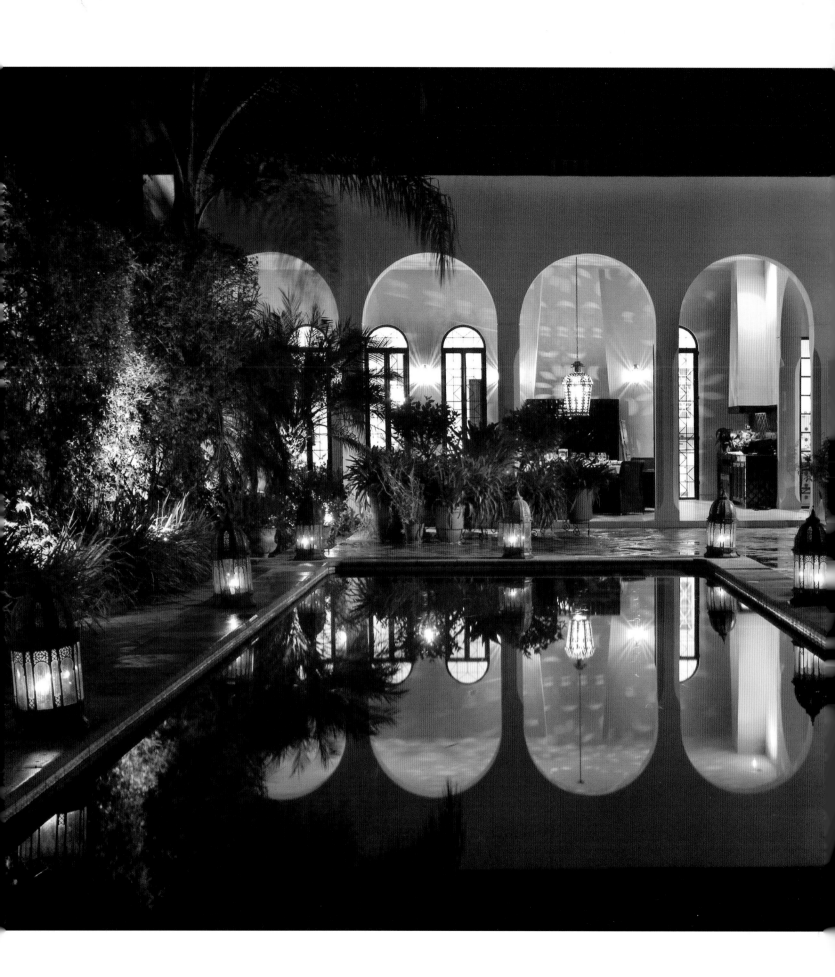

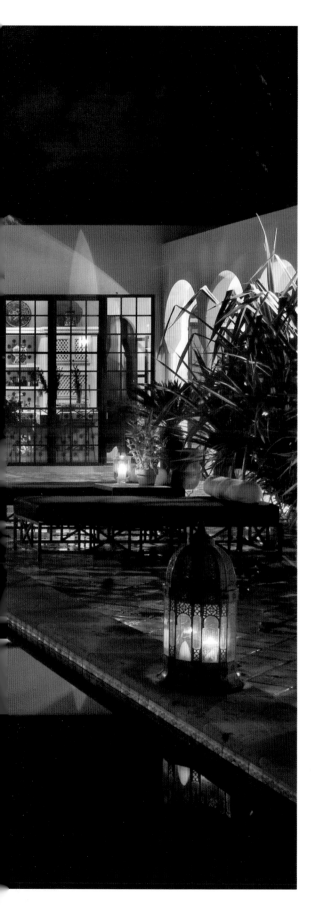

Casa de Los Reyes

OWNERS: John and Norma King

ARCHITECT: John Lee King

PHOTOGRAPHER: Ricardo Vidargas

One illuminated strand of architectural history that is delicately woven through Spanish and Spanish Colonial architecture is the tradition of the Moors in Spain, following their eighth-century conquest of that region. The most lavish example of their architecture is Spain's last Muslim principality, the glorious Alhambra in Granada. Architectural historian Spiro Kostof says the stylistic theme is "sumptuous and insubstantial, its reality is that of illusion; its goals are escapist. Light is courted with, absorbed. No sharp definition of shades is allowed, and a soft languid, liquid atmosphere is created where mass is not entirely a void."[1] The architecture is meant to mesmerize with the sight and the sound of softly bubbling

LEFT: The view from the guest house to the main house on a golden evening in Ajijic. The courtyard and pool are the center of activities for the family. BELOW: There is no better place to set up a drafting table and fall in love with architecture, over and over.

[1] Spiro Kristof, *A History of Architecture, Settings and Rituals* (New York: Oxford University Press, 1985) 398.

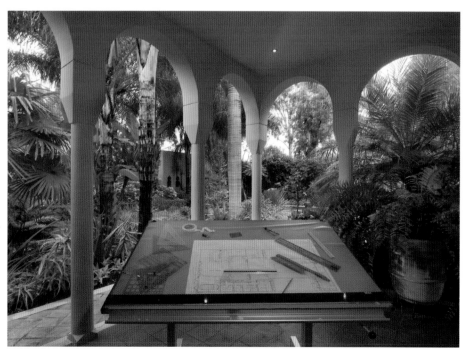

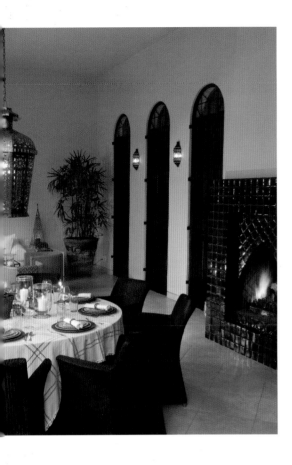

fountains. Light flows inside through window designs that are mediated by tiles or carvings in stone. Window openings are filled with tight textures and lattices that balance light and dark so evenly that the eye is not shocked by a sudden glare of harsh light. The lattice and tile pattern acts as a window shade against the sun. At the Alhambra, the central theme is the *rhiad*, an open space surrounded by architecture. Ancient Indian cultures in early Mexico also created an open space,

the *atria*, as a preface to the architecture of their temples and places for worship and gatherings.

It is little wonder that Norma fell in love with the style and began what her husband refers to as "her Moorish period." John, too, would soon become attracted to the sophisticated and elemental motifs of the style. For him, however, the obsessively detailed flourishes "with carved foliage, abstracted and repetitive, and interlacing designs like stars and lozenges" were too

ABOVE: Black glazed tiles on the surround of the loggia fireplace create a glowing jewel as a backdrop for dining. RIGHT: A conversation and gathering space is tucked into the end of the loggia. The oversized Moroccan mirror with inlaid patterns and the geometric glass tables add exotica to the charm. OPPOSITE: The heroic punctured-tin lantern reduces the scale of the table for eight.

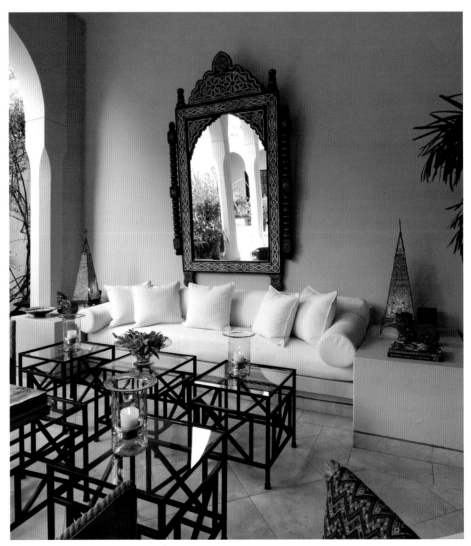

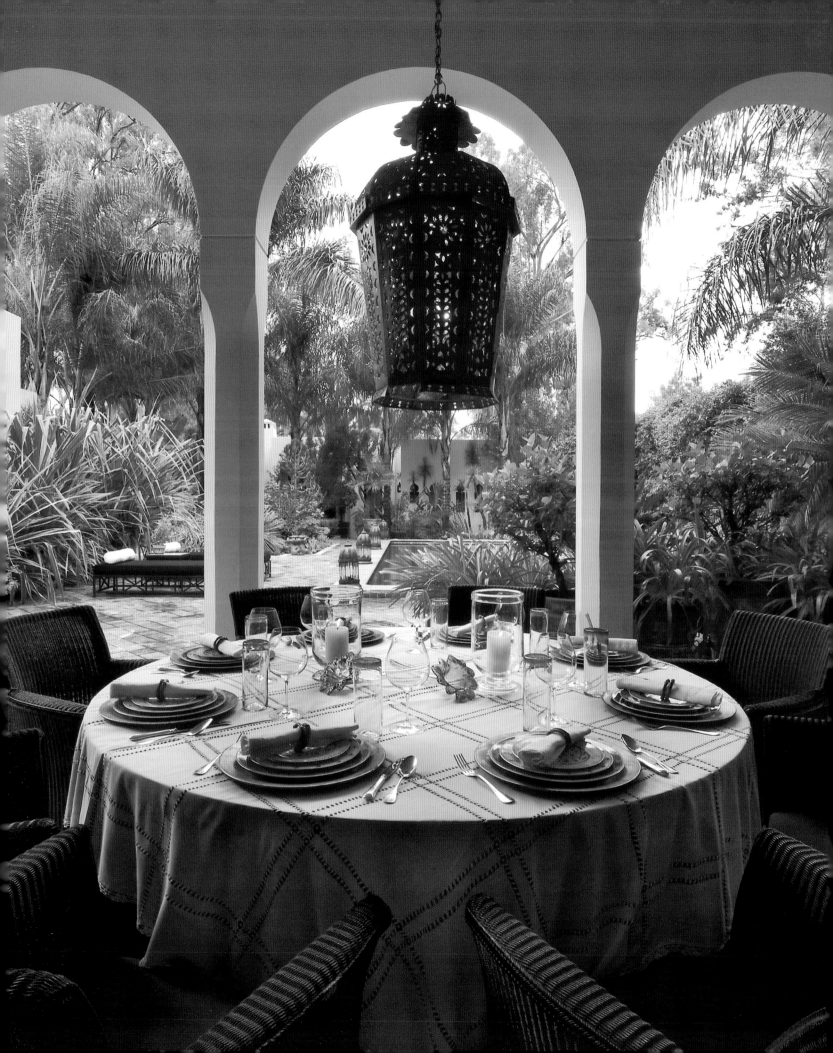

flamboyant. John's expertise was in the style of the Bauhaus, driven during the Walter Gropius and Mies van der Rohe era, when architecture became almost ethereal. Norma and John worked together as architect and designer on a project of their own for the first time, and it was an exhilarating experience for each. That the Moorish elements of ornate poetry met the iron-willed discipline of the Bauhaus and found its prodigious balance in this classic home is a gift to us all.

ABOVE: The view from the vanity in the master bedroom includes the landscape and the architecture of the courtyard. The room opens onto the loggia. RIGHT: The brass dining table is adjacent to the kitchen.

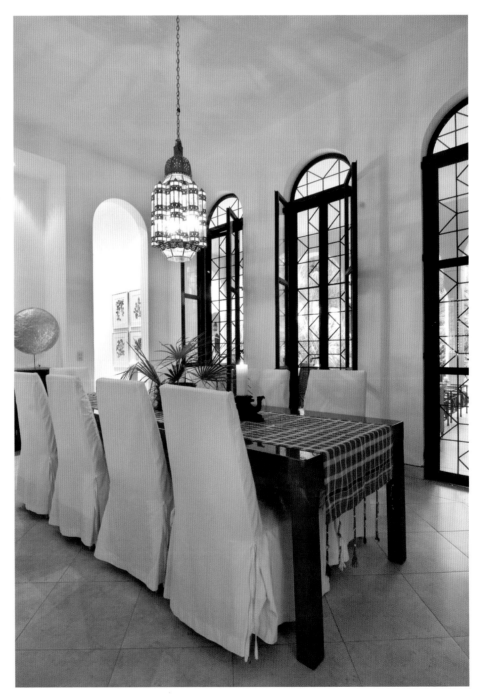

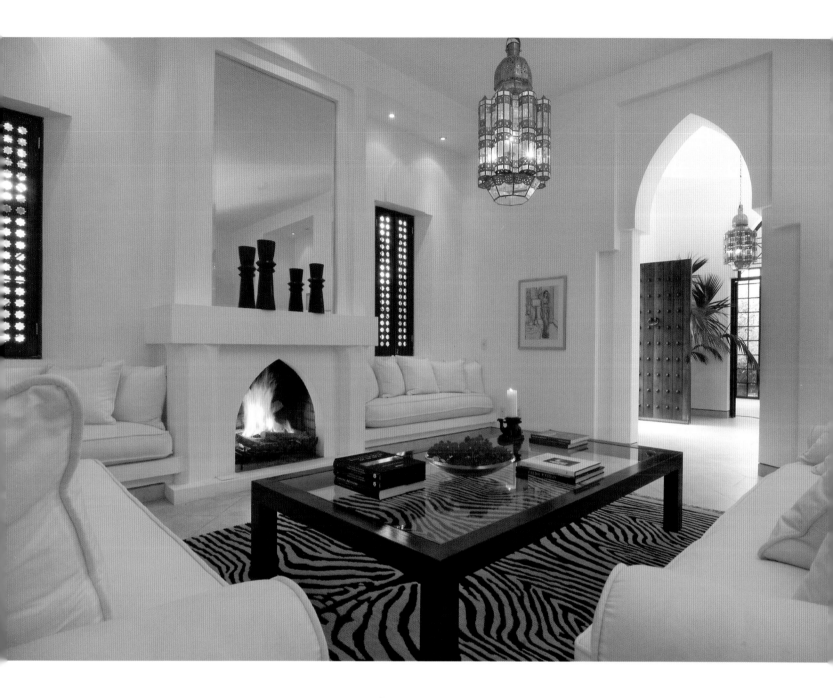

The living room entrance features a Moorish-inspired arched doorway. Star shutter designs, a simple fireplace opening, and a glass and brass lantern accentuate the striking white contemporary lines of the interior.

The perfect blending of cultural histories and architectural styles is a luxury to behold. The interior of this home is one on which nothing has been lost. It is stripped to its Moorish bones, and fragile traces of the culture are graciously incorporated: small tile stars on the kitchen island and leaded-glass Moroccan-style lozenges (a form that also appears on the jade skirt of the Mexican nature goddess Chalchiuhtlicue) in the arches above French doors; arches that are narrow and wide open to the loggia, which is a preface to the *rhiad*. A Moroccan pendulum lamp now and then spreads a yellow glow over it all. The varying forms of the simple fireplace openings give the flavor of the intrigues of Morocco. Walter Gropius would have loved this home.

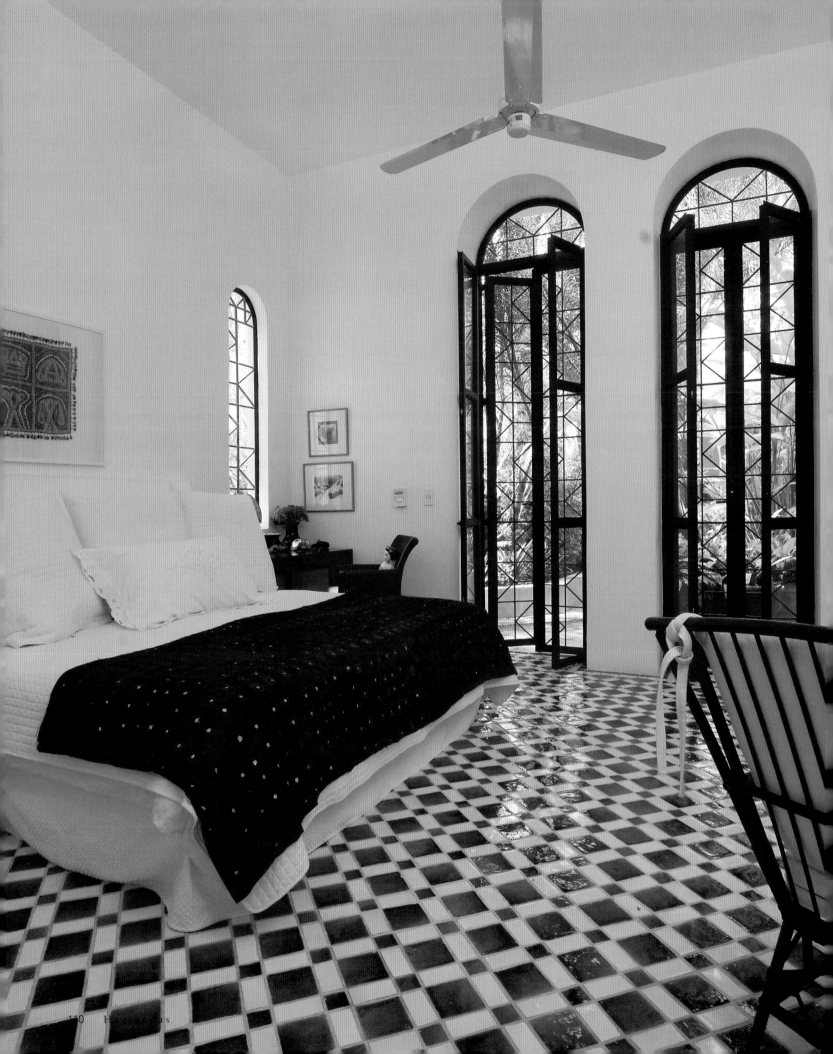

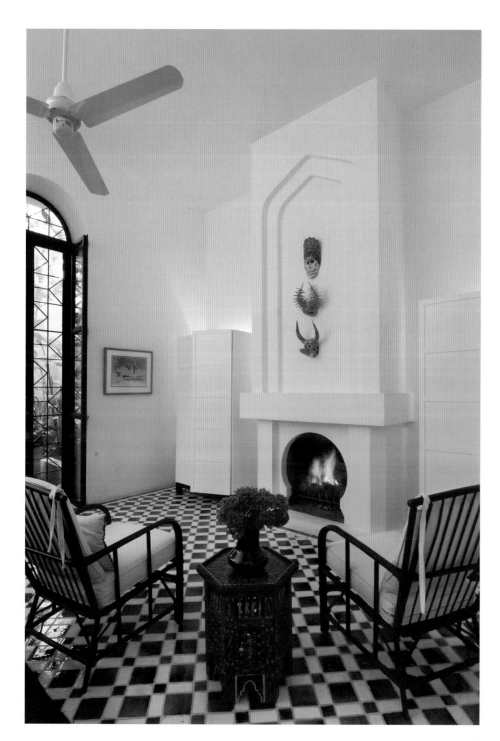

OPPOSITE: The master suite opens to the courtyard with the same high, elegant doors found in the dining room. The floor is a bold pattern of blue and white tile. LEFT: A sitting area with a fireplace is at the opposite end of the bedroom. ABOVE: Moroccan sling chairs in a guest room. The tile pattern is the same as in the master bedroom, but the color is a soft mossy green.

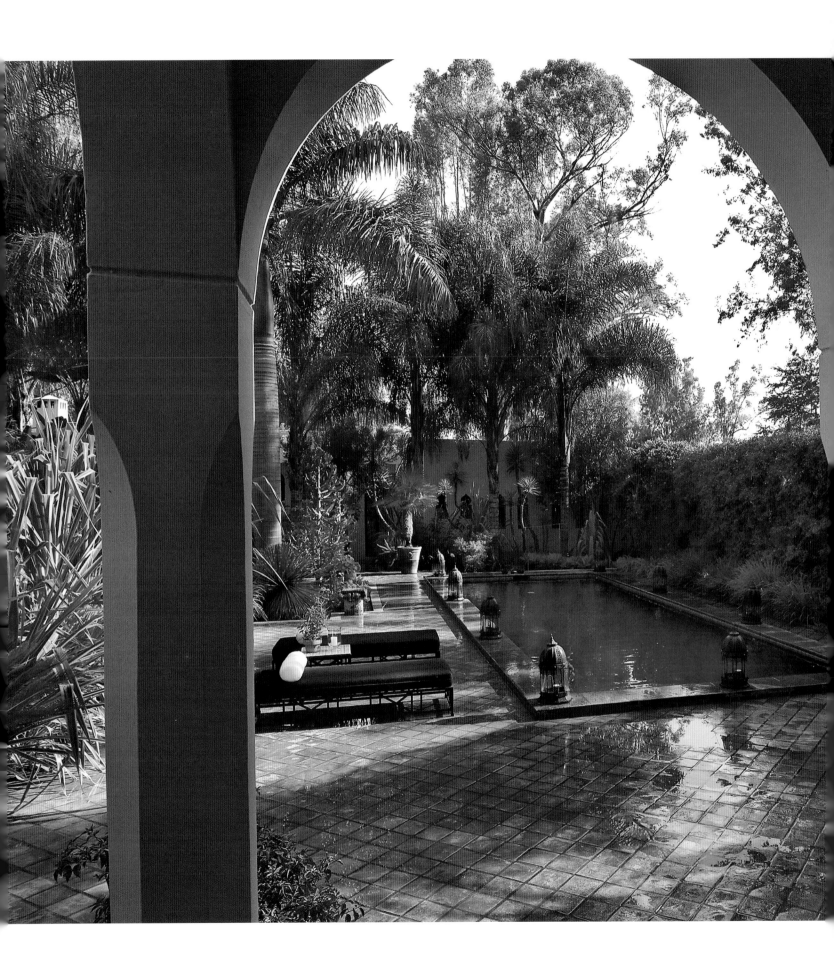

LEFT: Sun and a rain shower pass over in this view through the pool arches.

ABOVE: Every room opens onto the courtyard. Here a tile fountain is discovered through a gate reminiscent of the *Girl at the Gate Watering Doves* from Hacienda San Diego de Jaral de Berrios.

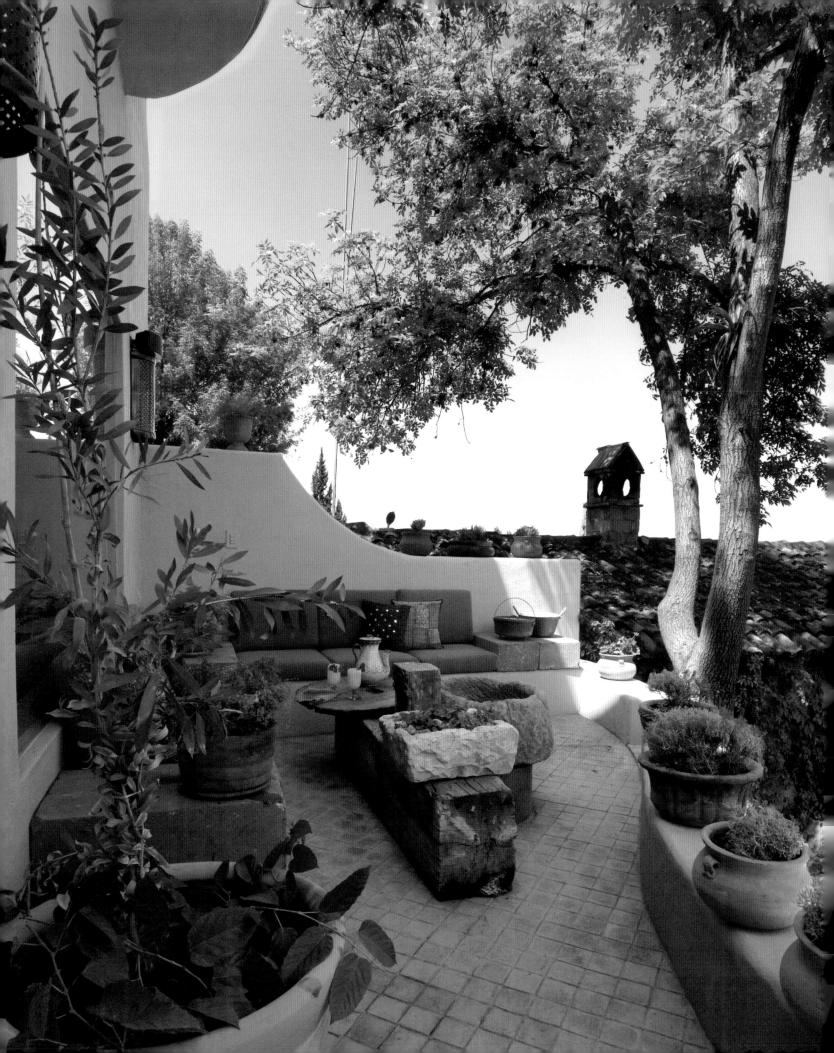

Burillo Residence

OWNER: Roberto Burillo

ARCHITECT: Roberto Burillo

PHOTOGRAPHER: Ricardo Vidargas

Simple, narrow wooden doors open from the street into the minimalist interiors of Roberto's home. The open vaults and repeating forms found in the ancient architecture of such refined structures as the Hacienda San Diego de Jaral de Berrios are instantly and mystically captivating when put to use here. Monastic and Moorish shapes occur off the central axis. Immeasurable stone steps lead up to bridges that float as if in phrases from Borges: "with vast air shafts in between, surrounded by very low railings." A three-foot-thick wall, midway up the steps, anchors a footbridge that crosses to another unseen room, and

one of the free sides leads to a narrow hallway that opens to yet another gallery. The bridges are either passable or structural, but beautiful in their elegant engineering. The stone stairs continue up and up, until they begin to narrow near a half-arch wood door, which is tucked into a petite and quite dark foyer. The half-door opens to a bright upper-level room, guarded on the outside by a small niche of arched wood doors that watch over a silent open advance of tile, adobe, and steel. This is the structure of engaged human thought: a style that in itself stakes its claims. Like at the Hacienda San Diego de Jaral de Berrios, the forms express a sense of what matters, the search for and the statement of a fine truth.

The door opens from the street onto a long, tiled hallway that extends toward a living room. The room is intimate, gracious, and comfortable. Vincent, a faithful and handsome setter, warms himself before an old stone fireplace. A large window lets in natural light through the courtyard trees and foliage.

Roberto lived and worked in Algeria during his early professional years. There, he studied and learned to understand the deep and true roots of colonial Mexican

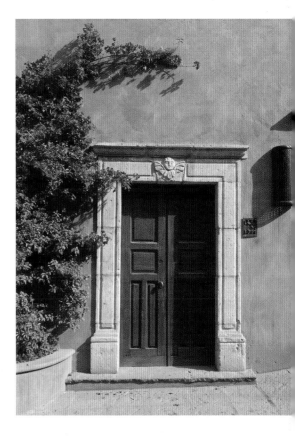

LEFT: A stone fountain on the grounds is embellished with a carved angel.
ABOVE: Facing the street are wood doors and a carved stone surround topped with another angel. OPPOSITE: The treetop roof terrace grants privacy and views of the city.

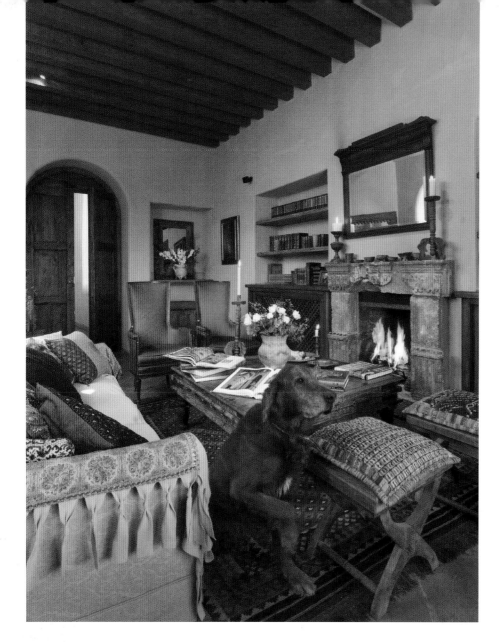

architecture. Since then he has continued to study Islamic architecture and has been influenced by this Arabic legacy. The treasured antiques from the region deepen his appreciation of its domes, vaults, arches, tiles, and latticed iron doors, such as the ones he has placed at the entrance to his wine cellar. There, too, is a Moroccan lantern. Roberto's knowledge and preeminence in architectural history has placed him at the forefront of the very important restoration and renovation of the Hacienda San Diego de Jaral de Berrios. A lifetime of travel and a devotion to architecture, combined with a workspace that has views of the gorgeous Guanajuato state mountain range, is well deserved peace *ab aeterno*.

ABOVE: Stepping into a gracious living room, one finds the fireplace roaring, fresh flowers, architecture books everywhere, and a most wonderful Vincent poised in eager anticipation for his master. RIGHT: Stone stairs curve down to the lower level and the wine room. OPPOSITE: Intimate dinners with candle niches in the stone wall. The draped fabric adds a soft feeling and opens to the courtyard above.

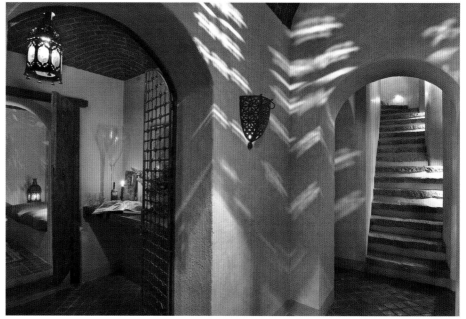

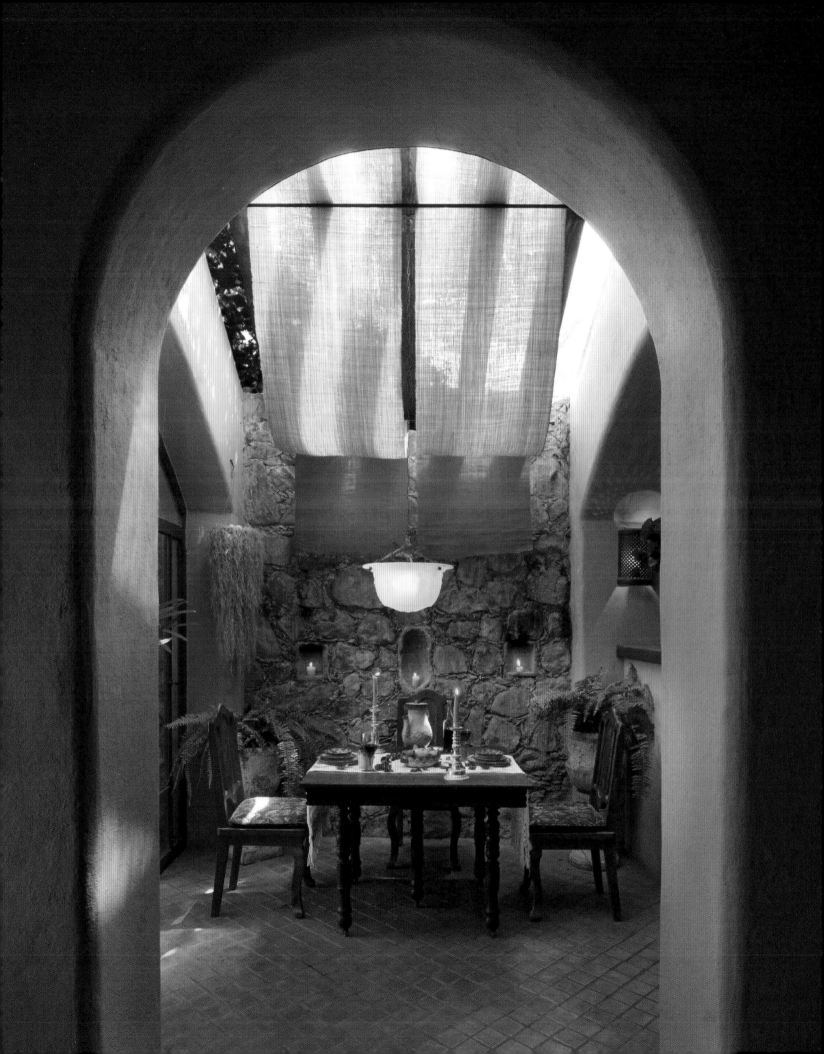

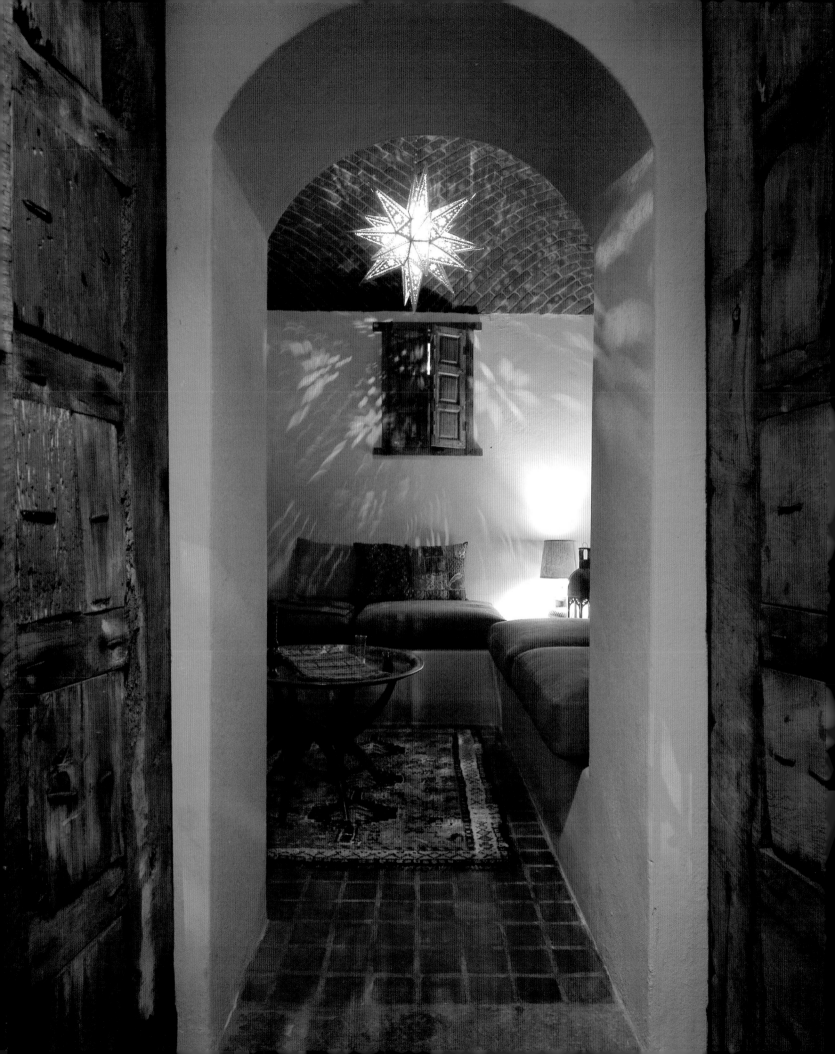

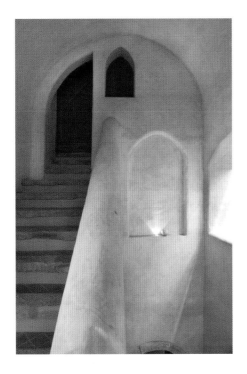

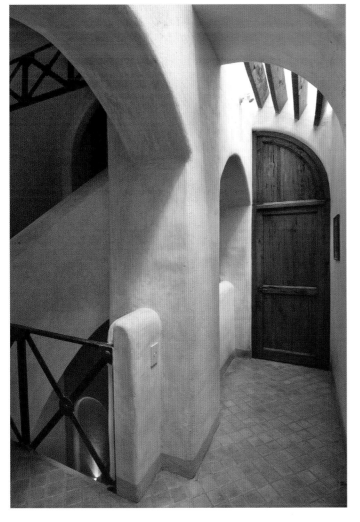

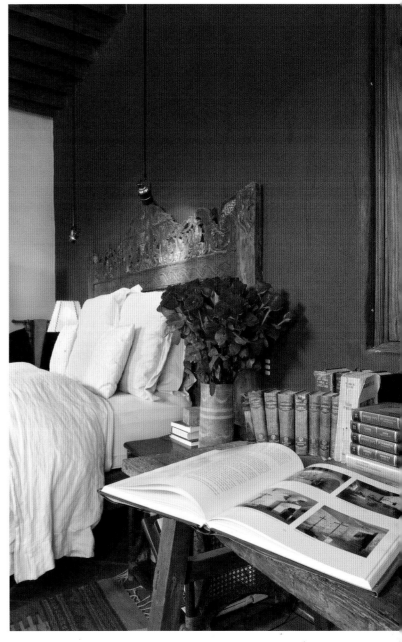

ABOVE LEFT: The intersection of light, space, volume, niches, and mysterious doors and openings. LEFT: Gorgeous geometrics create light and shadow. Deep walls support broad arches and railings of iron. ABOVE: The masterful selection of color, textures, and simplicity of objects captivates the imagination. OPPOSITE: A special lounge near the wine cellar.

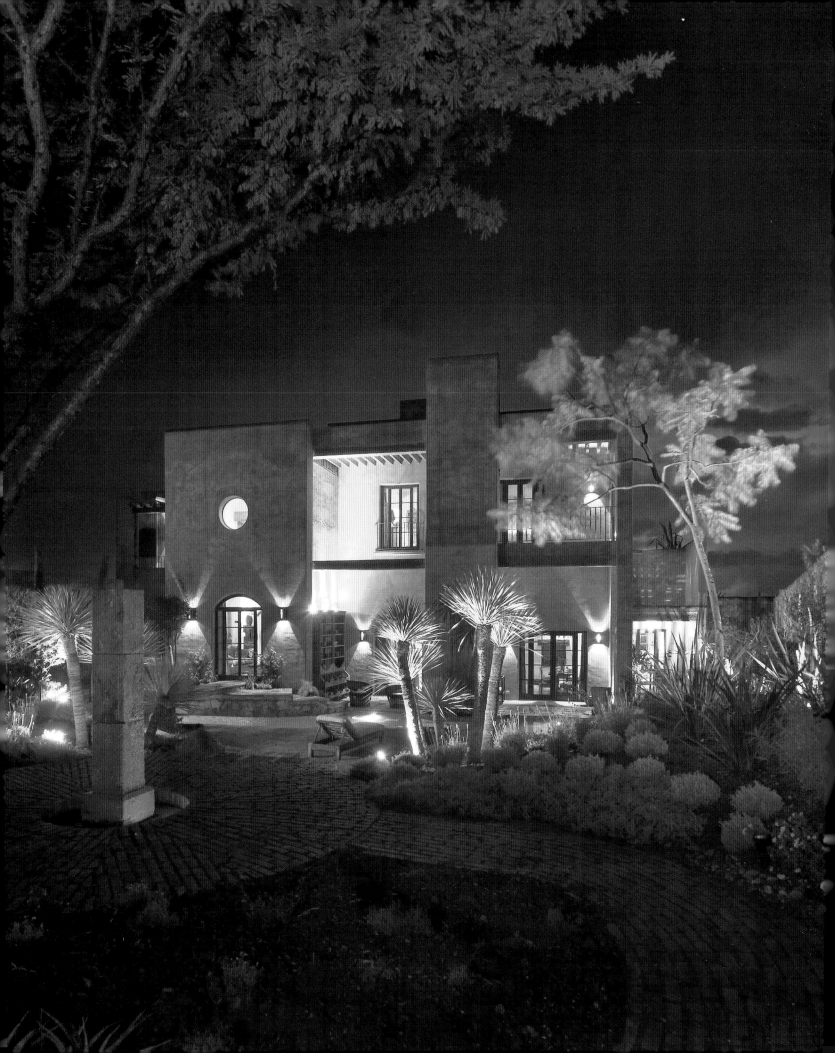

Casa del Camino

OWNERS: Richard and Sylvia Trumbull

ARCHITECT: Roberto Burillo

PHOTOGRAPHER: Ricardo Vidargas

The house was named Casa del Camino following an adventure that Richard and Sylvia had set upon five years ago. They walked the historic eight-hundred-kilometer pilgrimage, the "El Camino de Santiago de las Compostela," across northern Spain. The route (Saint James Way) has centuries-old significance, for it is the name given to the road that people took from as far east as Paris and Arles to reach Spain. There were more than eighteen hundred religious and secular buildings of great historic interest, including hospitals and hotels, that were built to help the pilgrims on their way to the holy city. The oldest description of the journey is from the twelfth century: the *Codex Calixtinus* and the *Kitab Ruyya*, by the Arab author Idrisi. The route played a fundamental role in encouraging cultural exchanges between the Iberian Peninsula and the rest of Europe during the Middle Ages.

Little can be more life enhancing and momentous than walking for over a month. It was during the fourth week of their trek that Richard and Sylvia determined that when they completed their micro-life's journey, they would return to Mexico to build a house. Their house and their city in Mexico became an extension of their pilgrimage. On the northwestern corner of their front wall is a ceramic way marker with a shell representing the scallop-edged conch shell that is the symbol

ABOVE RIGHT: Painted gates open to the main entrance. BELOW RIGHT: Resembling the stairs of the pyramids, these rise to the rooftop terrace. LEFT: A tall, star-patterned gate is at the end of a short passage. OPPOSITE: The house is viewed from the brick-paved courtyard.

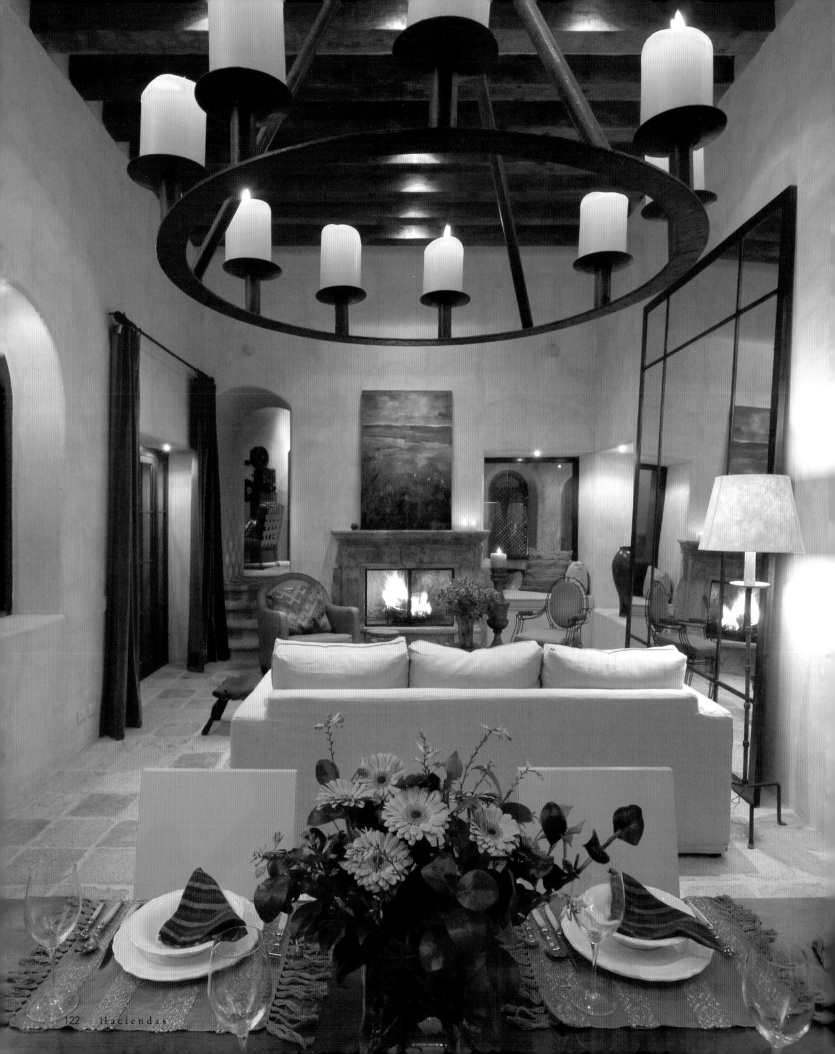

RIGHT: The dining table has a view into another room and out another window. ABOVE: The architect again used light as a design element. LEFT: A very contemporary setting in the living room. The large mirror exaggerates the comforts of the room.

along the Camino de Santiago roads. It was used to dip water from streams on the way. The shell was brought back to Mexico with the anticipation that it would be a meaningful part of their new home.

The Trumbulls were fortunate to work with the prominent architect and architectural historian Roberto Burillo. The plans were drawn, and construction of the house was completed in 2006. Adobe and stone are the significant building materials. The interiors feature a wonderful stone, *adoquin*, over radiant-floor heating in the main living areas of the ground level. Bedrooms and baths were clad in *ladrillo*, Mexican brick, in a herringbone pattern. Stone fireplace surrounds and hearths were carved and styled on the historic hacienda doorways and fireplaces in the area. Salvaged mesquite and cypress doors with their original hardware were put into place. Mosaic tile designed by a local architect and based on a pattern in the floors of St. Mark's Cathedral was used in the kitchen. The artisans and crafts-people who contributed to every detail of the project gave the owners a unique handmade house. Stonecutters, tile layers, ironworkers, and carpenters created one-of-a-kind windows, doors, walls, floors, and most of the furniture and furnishings. The Trumbulls are very grateful and appreciative of their fine craftsmanship.

A new house calls for a bit of finish work and a lot of attention. Sylvia and Richard have spent a great deal of time on furnishings and on their garden. They have discovered that furnishing the house is a "layering" process, one or two objects at a time, one or two rooms at a time. They are collecting in their travels and watching the palette of the surrounding high-desert countryside for their plantings. Fortuitously, the botanical gardens are right next door.

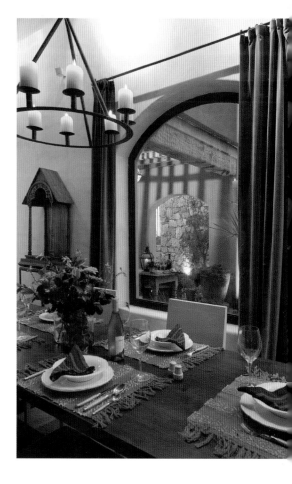

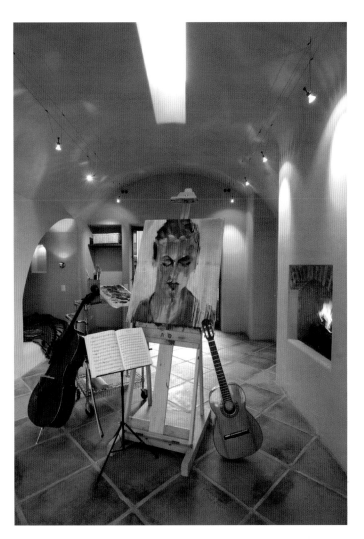

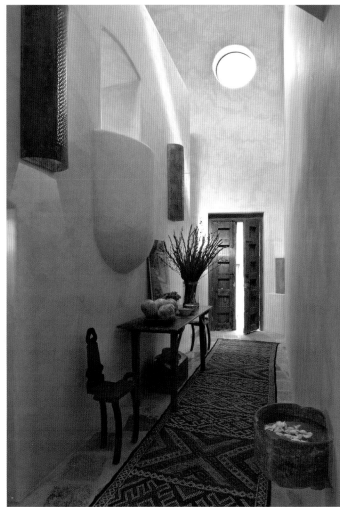

ABOVE LEFT: In the artist's studio, days and nights may merge. ABOVE RIGHT: The entry hall with antique furnishings. Above is a tiny balcony. OPPOSITE: The bedroom has an adjacent sitting room and fireplace.

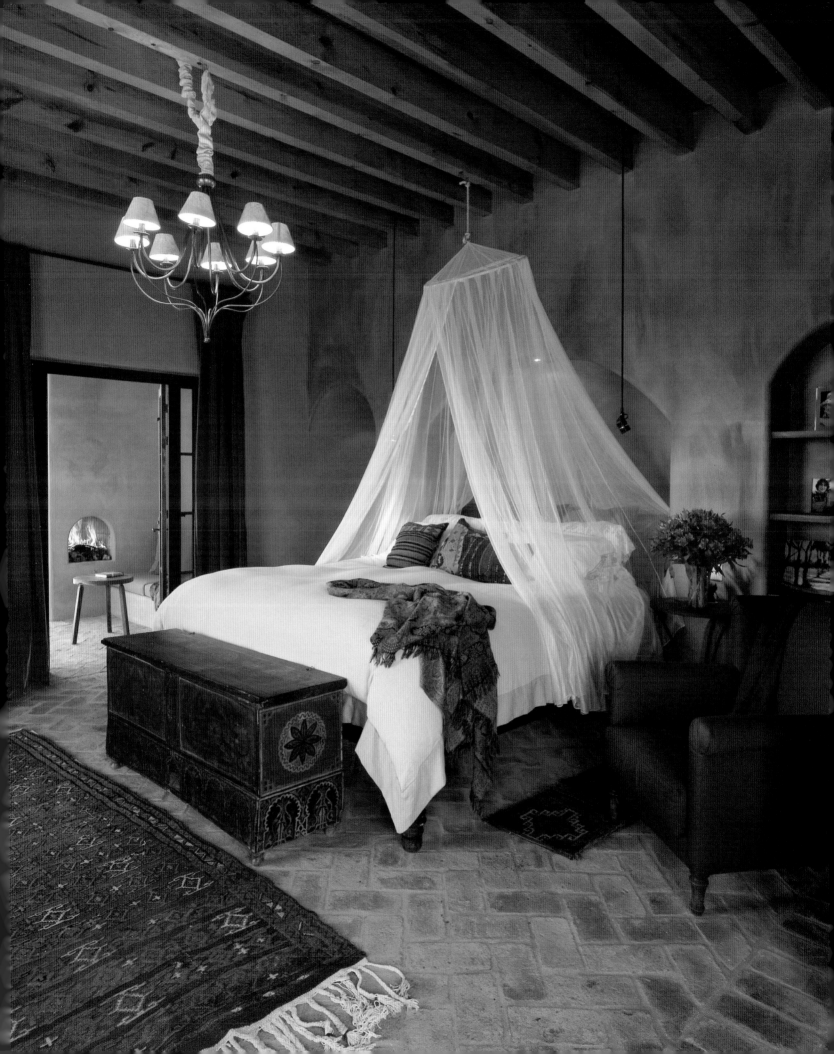

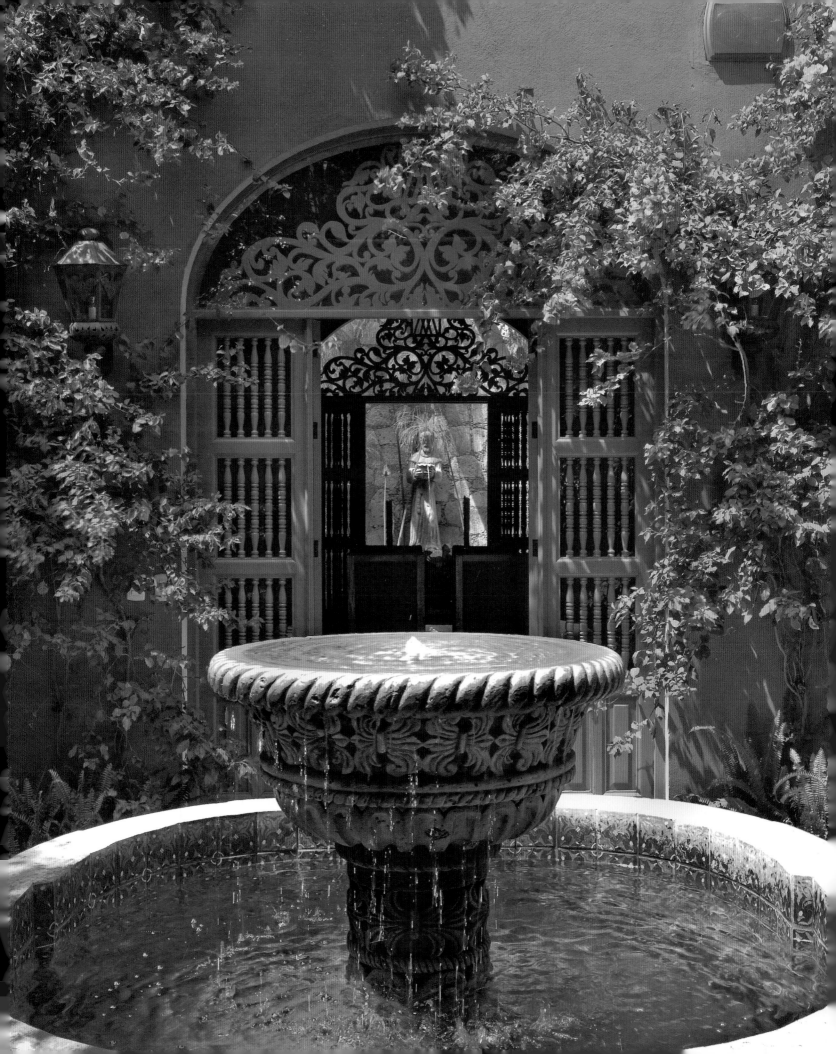

Casa Hypatia

OWNERS: Christian and Patia Finkbeiner
ARCHITECT: Juan Carlos Valdez
PHOTOGRAPHER: Ricardo Vidargas

Walking through the lovely entrance at this home in Mexico is similar to the sensation of arriving in a temple. The ancient hacienda styling infuses itself profoundly through the *zaguán*, entry, corrédor, and garden. Doors of heavy timbers are elaborately designed with undersized panels of beveled and dado patterns; the center of each intersecting edge bears a silver sun ornament. Once inside, the entry invites a restorative moment: candles, cool tile, and saints and friars rendered in stone bolster the divine architecture as it advances to the courtyard fountain sanctuary. A welcome is complete with the toll of an ancient silver bell in an elaborately carved and protective belfry under dark, deep, wood beams overhead.

All rooms have special materials and features: tile from Delores Hidalgo, a front door from China, a living room door from Afghanistan. The decorative shutters in the living room were inspired by an old Franciscan monastery in Zacatecas. Guanajuato stone and wood from Durango, Mexico, contribute to vaulted and domed *bóveda* ceilings made of brick. Some have a tile surface; others have herringbone patterns of wood between the timber beams. Large zigzagging corrédors under the herringbone wood pattern lead through varying levels of rooms. Kitchen cabinets are hand carved by the master artisan Juan David Guerra. Hand-wrought iron graces gates, staircases, and an eight-foot-tall candelabra. Bed canopies and large, delicate chandeliers are a subtle and cohesive element of the decor.

The house was built "from the ground up" for family, friends, and entertaining. The Finkbeiners have traveled throughout Mexico for years. When their youngest

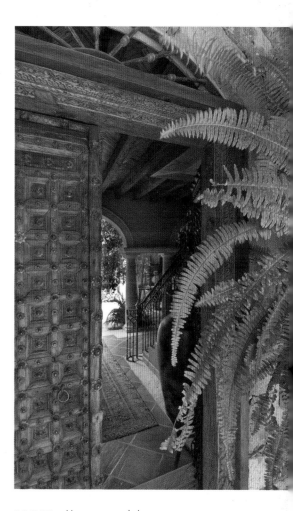

ABOVE: Heavy carved doors open into the large foyer and courtyard.
OPPOSITE: The layering and repetition of patterns, architectural elements, and statuary seem to invite the bougainvillea to bloom and the fountain to splash.

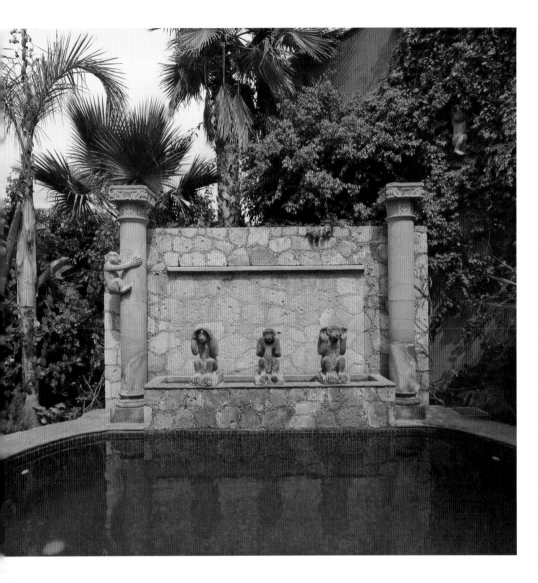

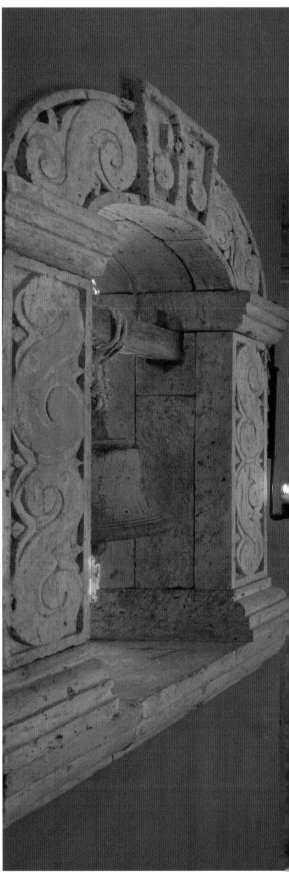

daughter studied ceramics in San Miguel de Allende, they fell in love with the town again. The nearby towns and villages are places to collect pottery, silver, and copper. Hot springs, art galleries, and restaurants are all around to enjoy. The Finkbeiners' passions include Mexican folk art, paintings of local landscapes, architecture, and the work of Frank Gardner. They love Mexico so much they have also built in the countryside—Christian loves the sounds of nature and landscape.

ABOVE: The swimming pool has a backsplash of stone and a tribute to the three monkeys and their lookout.
RIGHT: A traditional *zaguan* has stone statuary, arches, pillars, and a belfry. Chandeliers and tall candlesticks are wrought iron.

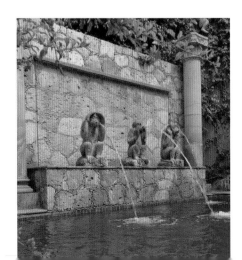

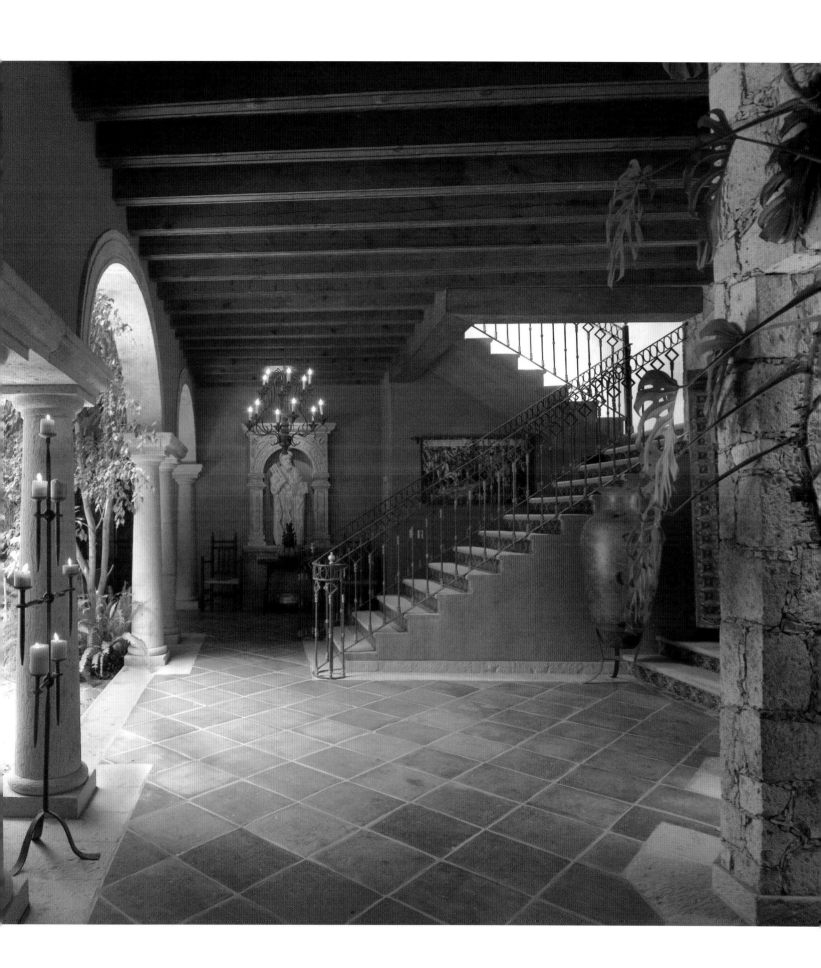

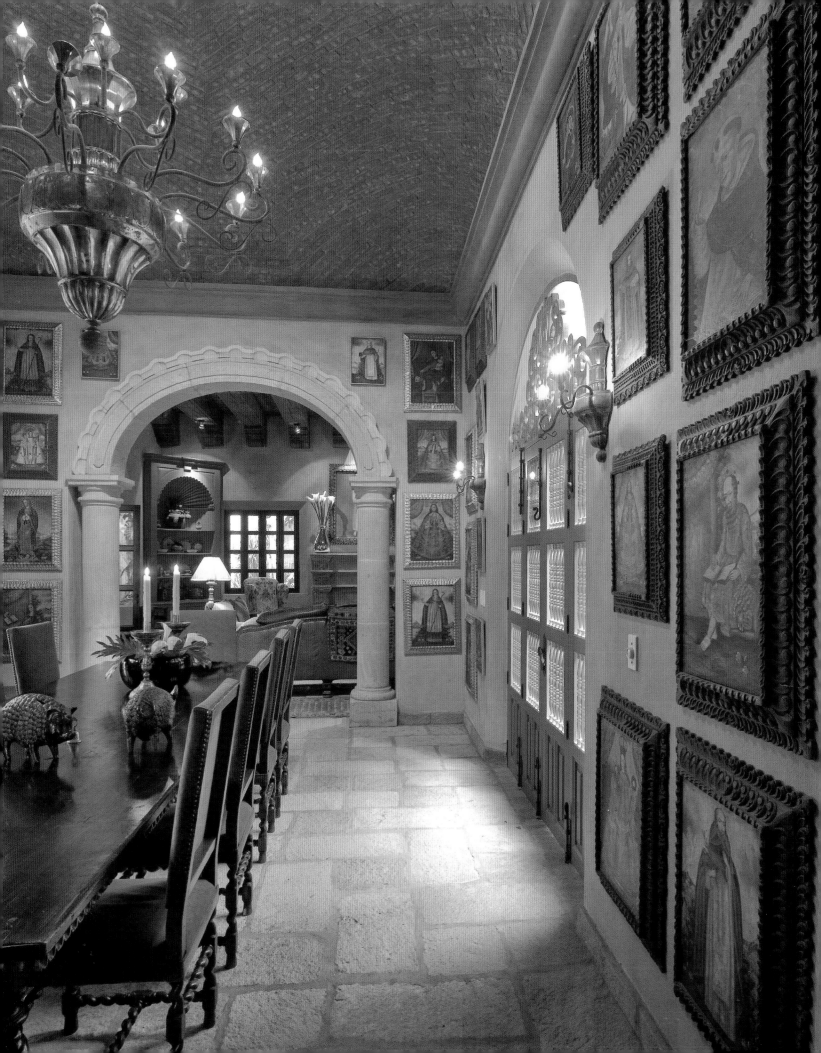

OPPOSITE: The walls of the dining room are clad with antique paintings of saints in carved and gilt frames. Spindle doors with arch windows above open on both sides of the room.

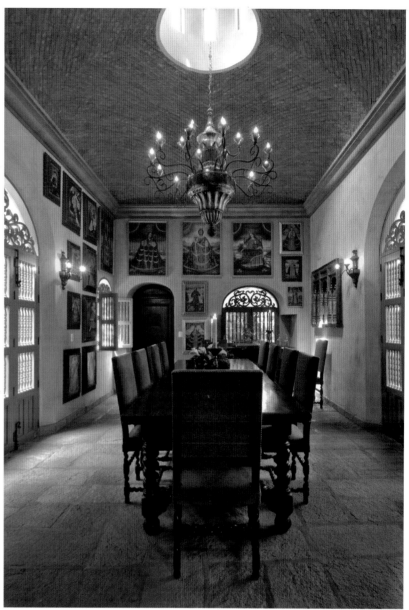

ABOVE: The dining room with an overhead *bovéda* ceiling and oculus anchors an antique mercury and glass chandelier. LEFT: An intricately carved limestone fireplace is below a painting of a child.

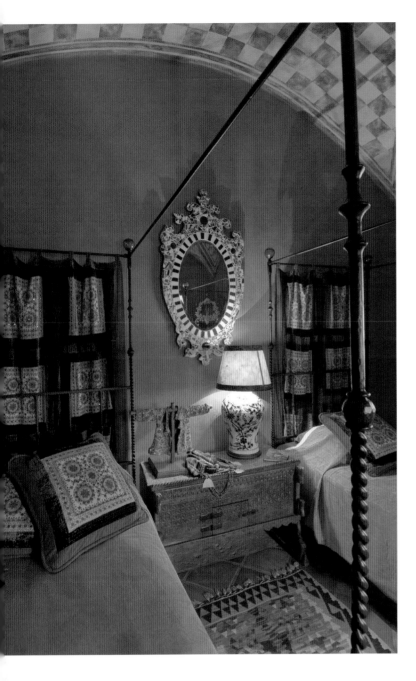

LEFT: The drama in this room is created by the checkerboard pattern and colors of the barrel ceiling. BELOW: A monastic feeling permeates this room until one discovers the gold crowns at the apogee of each bed canopy. OPPOSITE: An iron bed with lattice head- and footboards dominates the bedroom. The doors open to the garden.

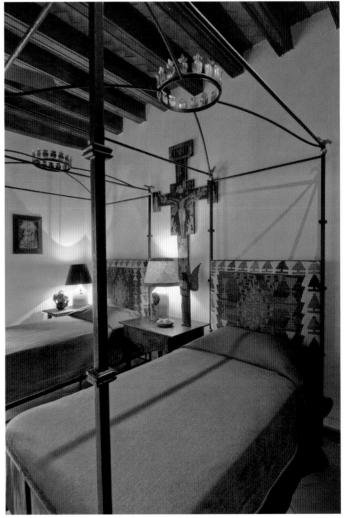

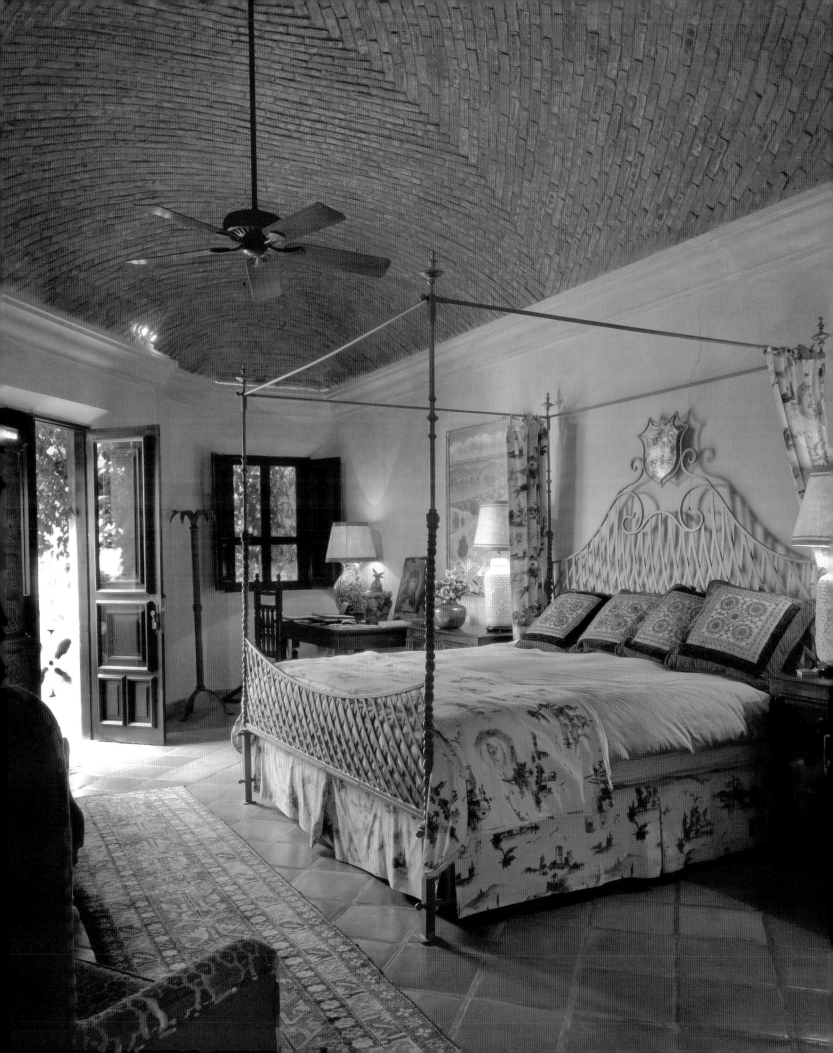

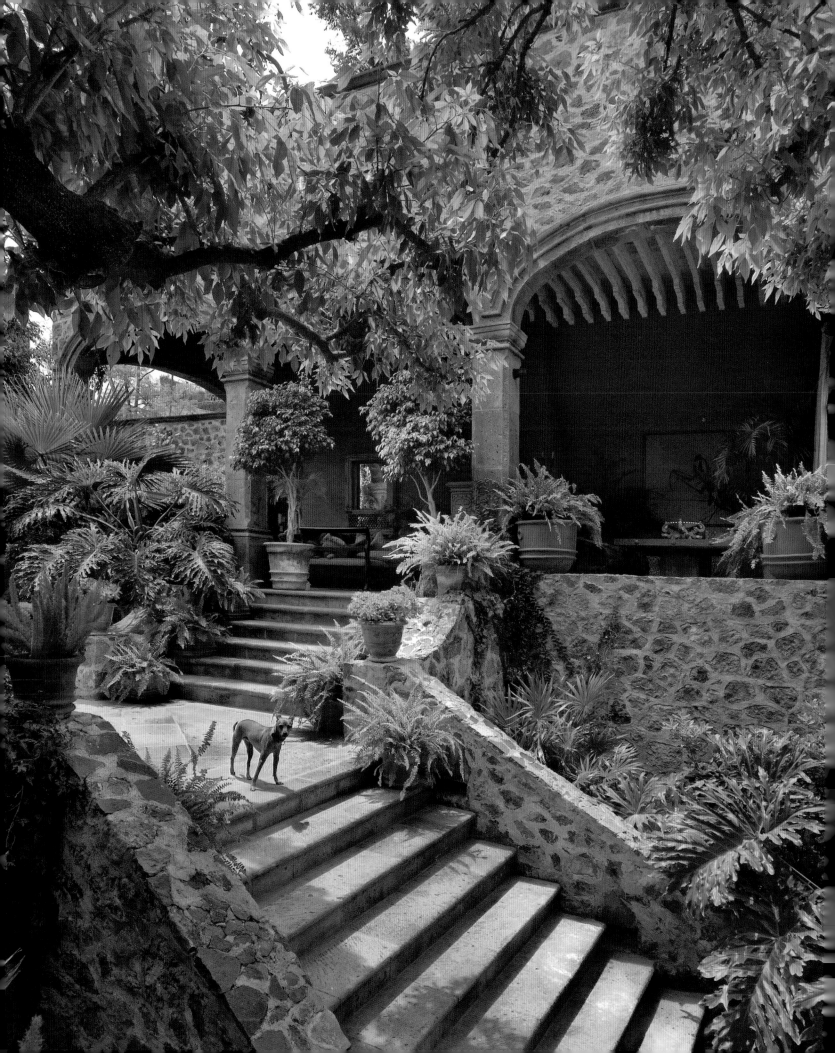

Casa Carolina

OWNERS: Bob and Carol Latta

ARCHITECTS: Nicole Bisgaard and Lis Bisgaard

PHOTOGRAPHER: Ricardo Vidargas

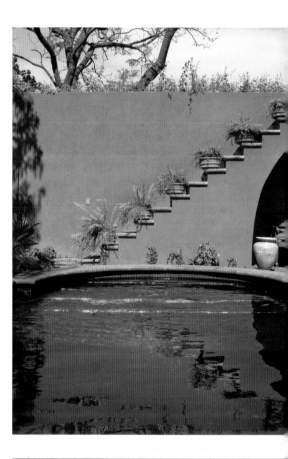

"The highlands of Mexico are really the crown jewel of Mexico. There are many wonderful colonial cities nearby and natural hot springs to swim in. Mexico City is four hours away and always close enough for a culture fix. We are going this weekend to see a special Frieda Kahlo exhibit and to the opera," Carol enthused. She is in love with the new house on Quebrada Street, one she refers to as "an evolutionary process," rather than a building event. She was ready to begin construction on the ramshackle house right away in January 1999. The plan was slowed, however, by

a long wait for a worthy architect. The interim waiting period turned out to be quite useful to Carol, who learned a lot about life in Mexico. The eighteen-month cycle of seasons taught her about building for this unique climate, and how important that is in Mexico.

May of 2000 brought on the demolition of the structure, with the exception of the frontmost wing, which was over one hundred years old. A new entry courtyard was built, as well as a living room, dining room, and kitchen. The master suite was finished, as was the outdoor *sala*. Everything met the expectations and needs of the Lattas until a new grandchild arrived. The year 2006 came, and with it a plan to build a two-bedroom guest house and a pool with new little Benjamin in mind.

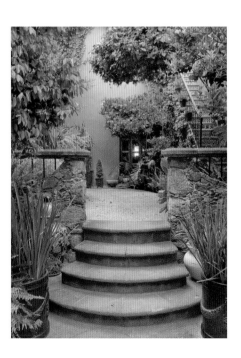

ABOVE RIGHT: Stairs to the pool are reflected in the rippling waters. BELOW RIGHT: Cream-colored pillow-cut tiles resemble a quilted texture. The gates open into a small garden and steps to the other side of the house. LEFT: Steps lead to a terrace and the lower-level rooms; more stairs lead to upper levels. OPPOSITE: The private garden has arcaded loggias, terraces, and pools.

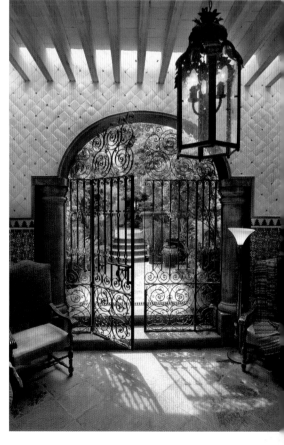

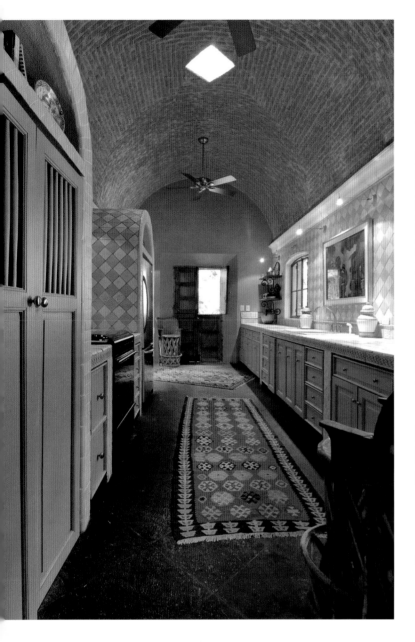

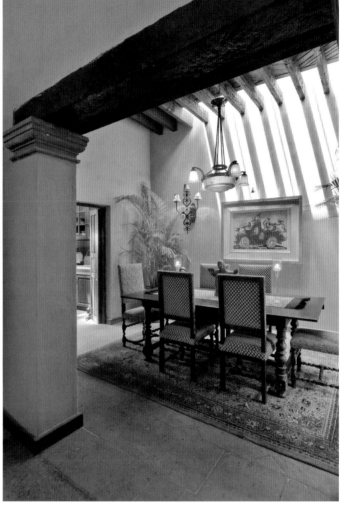

Carol and Bob found that building in stages is a bit crazy. The last project was in the back of the property, so the building materials had to be carried over the top of the house one bucket at a time. They hand dug the pool, which meant all the dirt had to be excavated over the roof one bucket at a time. This second phase was designed and built by Lis Bisgaard, Nicole's sister. Lis once owned a marble quarry and designed marble mosaics. In Carol's guesthouse, Lis designed and installed stunning marble and limestone patterns. A striped white marble and cream limestone bathroom is Carol's favorite, as is the little paisley mosaic above the fireplace.

Building the house "poco a poco" (little by little) is very Mexican and really allows a property to meet the changing needs of its family. All the traditional

ABOVE LEFT: The lengthy and broad workspace in the kitchen has natural light and a beautiful barrel-vaulted brick ceiling. ABOVE RIGHT: The dining room is flooded with natural light from an overhead skylight. OPPOSITE: Outdoor living is more evident than indoor living. Stacked chandeliers and carved ceiling beams are a cause for celebration.

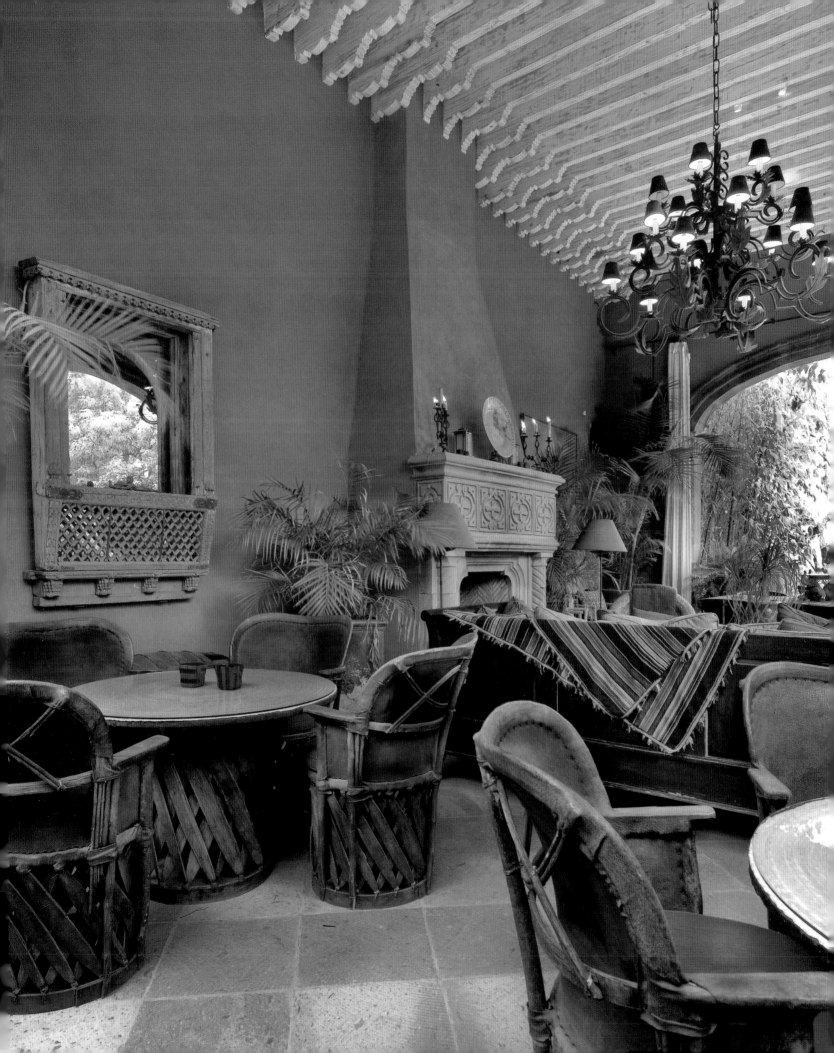

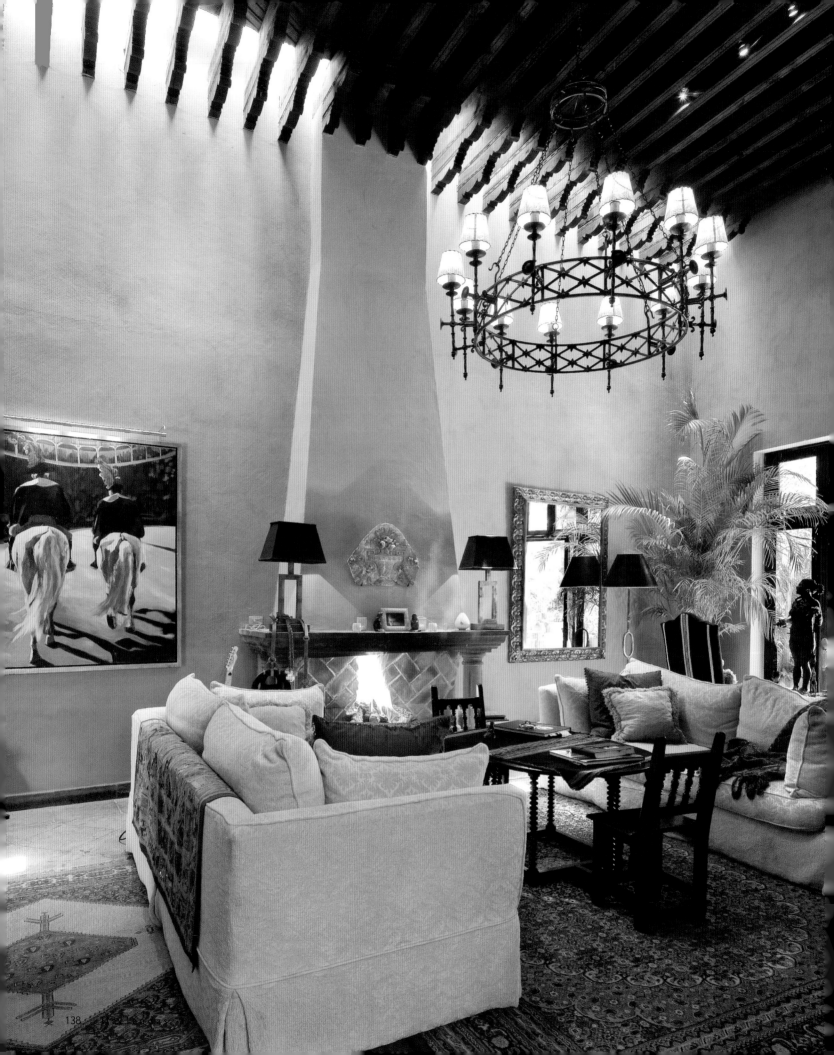

Mexican materials and ways of building were put to use. Everything is custom made and handcrafted, using lots of rock, hand-carved cantera stone, and masonry. Carol says the local joke is that they are all building houses to last three hundred years, but some of them have barely thirty years left to live in them. Carol and Bob will make the most of their time, spending as much time as possible on the outside *sala* for their late *comidas* (meal). Reading takes place on the rooftop terrace.

A B O V E : Star-shaped occasional tables and Moroccan textiles complement the billowing dupioni silk drapery of the French door. O P P O S I T E : The great height of the ceiling allows a successful mix of antique children's chairs with a coffee table, a pair of modernist brass lamps, a contemporary iron chandelier, and brocaded sofas.

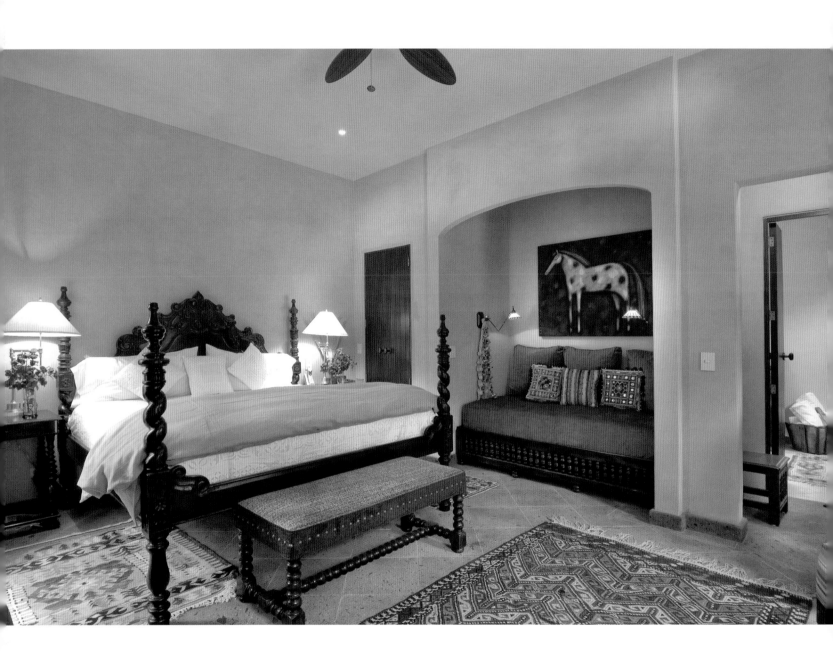

ABOVE: The bedroom comes alive when painted with citrus colors.

OPPOSITE: The walls are set off with a lemony-citrus color that flows into bookshelves and niches. The accents of the wood doors and rare carpet complement the lemon hue.

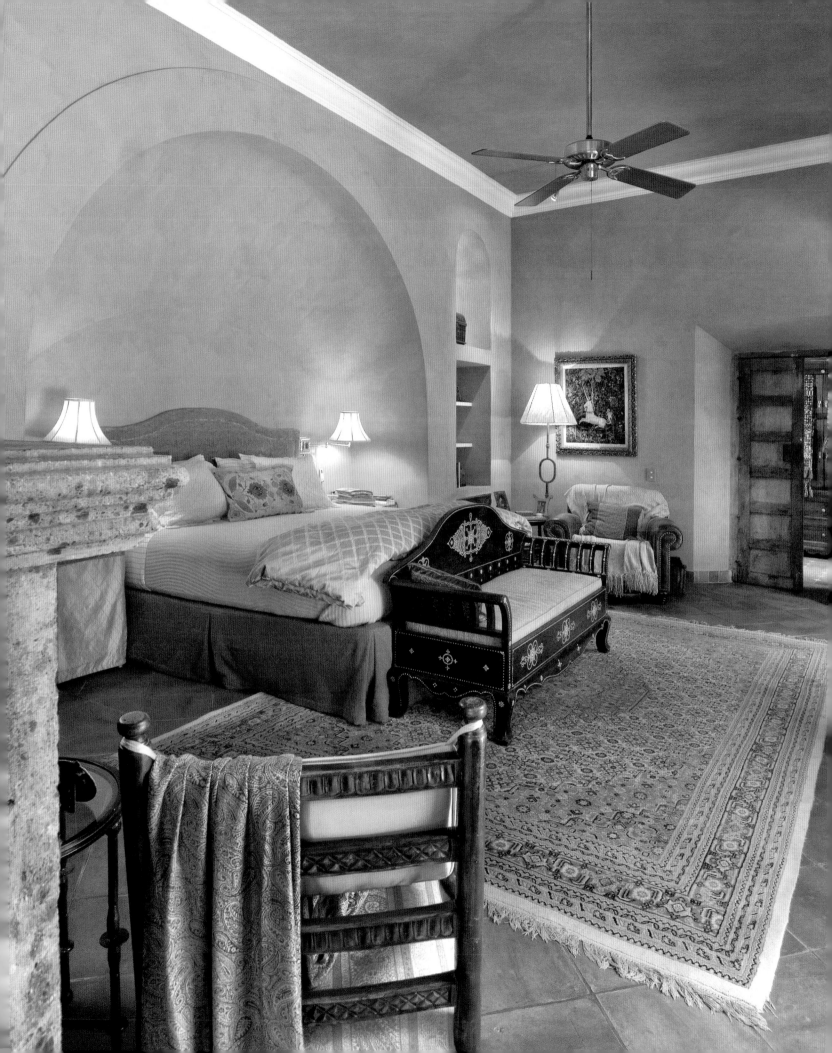

Rancho dos Vidas

ARCHITECT: Michael G. Imber, Architects

PHOTOGRAPHERS: Michael G. Imber, Hester & Hardaway, Paul Bardagjy, Jack Thompson

In the scrub country between San Antonio and Laredo, Rancho Dos Vidas was built as a ranch headquarters and family hunting lodge. The compound takes its forms, geometries, and details from early Spanish colonial architecture in south Texas and northern Mexico. Many examples such as missions, haciendas, presidios, and even public buildings are familiar outposts of the frontier. The primary force behind the design is the "event of the hunt." The design process became one of accommodating all the aspects of hunting, while offering a variety of experiential spaces.

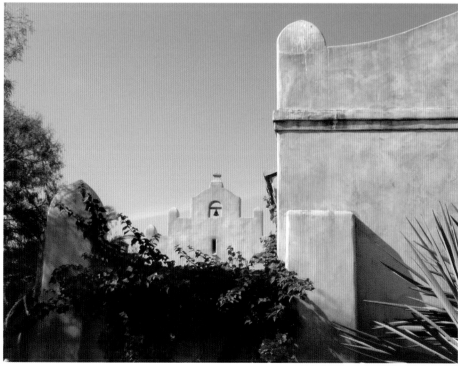

ABOVE: Horses can get a drink and rest in the shade in the forecourt of the ranch.
LEFT: The bell tower of the front facade.
OPPOSITE: The courtyard of a ranch design that is rooted in classicism.

The lodge is approached along the natural path of the Sendero, cut through the brush from the north, and running over a small hill that overlooks a lake. The design of the compound was planned to be an inner area protected by exterior walls. The harsh Texas surroundings are mediated by a main court that features the soothing sounds of a fountain and offers comfort in an intimate gathering space.

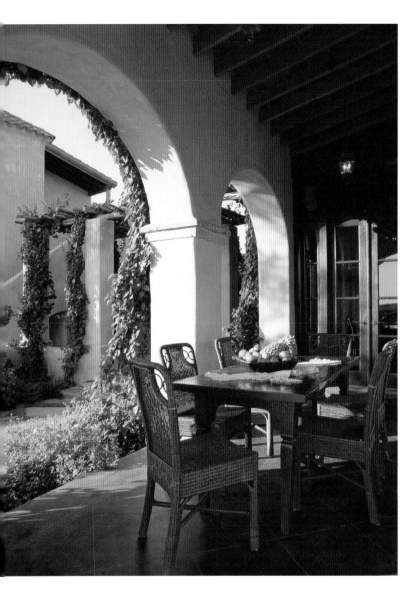

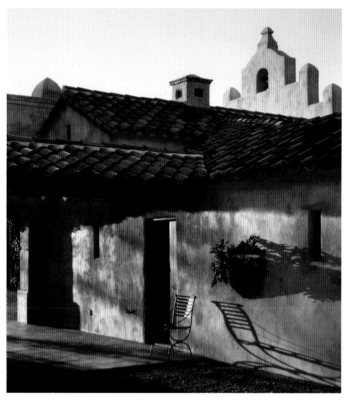

ABOVE LEFT: Breakfast is served on the loggia outside the kitchen. ABOVE RIGHT: A lonely sunset on the back patio. RIGHT: The courtyard and horse-trough fountain are viewed from the bedroom window. OPPOSITE: The arcaded loggia, terraces, patio, and pool are bathed in late-afternoon sun.

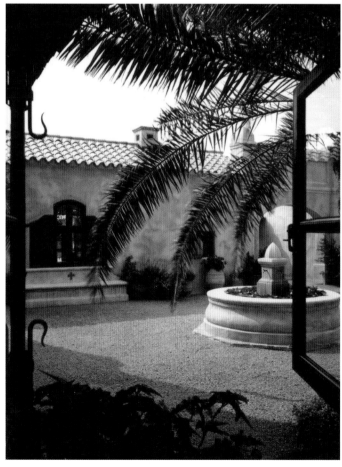

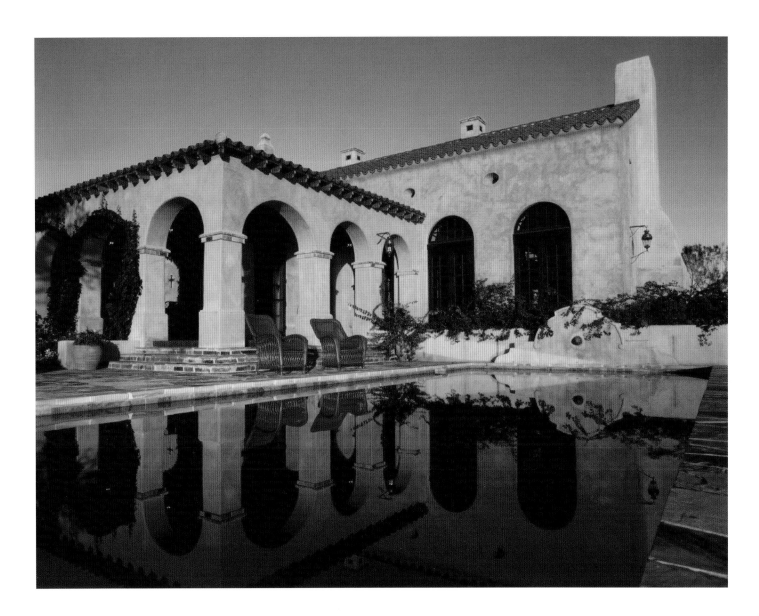

Arrivals and departures enjoy this area as one of the aspects of the hunt: the collecting area. It also provides a simple connection to the supporting court through a grand arch. The supporting area is an outdoor workspace, surrounded by chicken coops and a low snake wall, which dissuades wild animals, including snakes, from climbing over the unpleasant textures and height. A nearby timber pavilion is used for banquets and is linked to the lodge via the mudroom and the gun room.

A large mesquite door is aligned with the Sendero and opens to the lofty beamed entry hall into the great room—the warm gathering place at the heart of the lodge. A master-bedroom wing is at one axis of the house, and the guest tower is at the other. A gallery serves as a main circulation spine for the second bedroom, great room, powder room, and dining room. The private east veranda serves as the family's quarters, while the west veranda is considered a more public area. The west veranda shades the

dining room and is often used for outdoor dining, with spectacular views across the marsh lake and the sunset beyond.

A kitchen courtyard is the center of all activities of the lodge; the kitchen, guest quarters, and tower all focus around a splashing fountain and are shaded by a beautiful bougainvillea-clad loggia. Through the loggia, a raised pool terrace spreads out, overlooking a firepit, a genuine outpost in the wilderness and a favorite evening gathering spot.

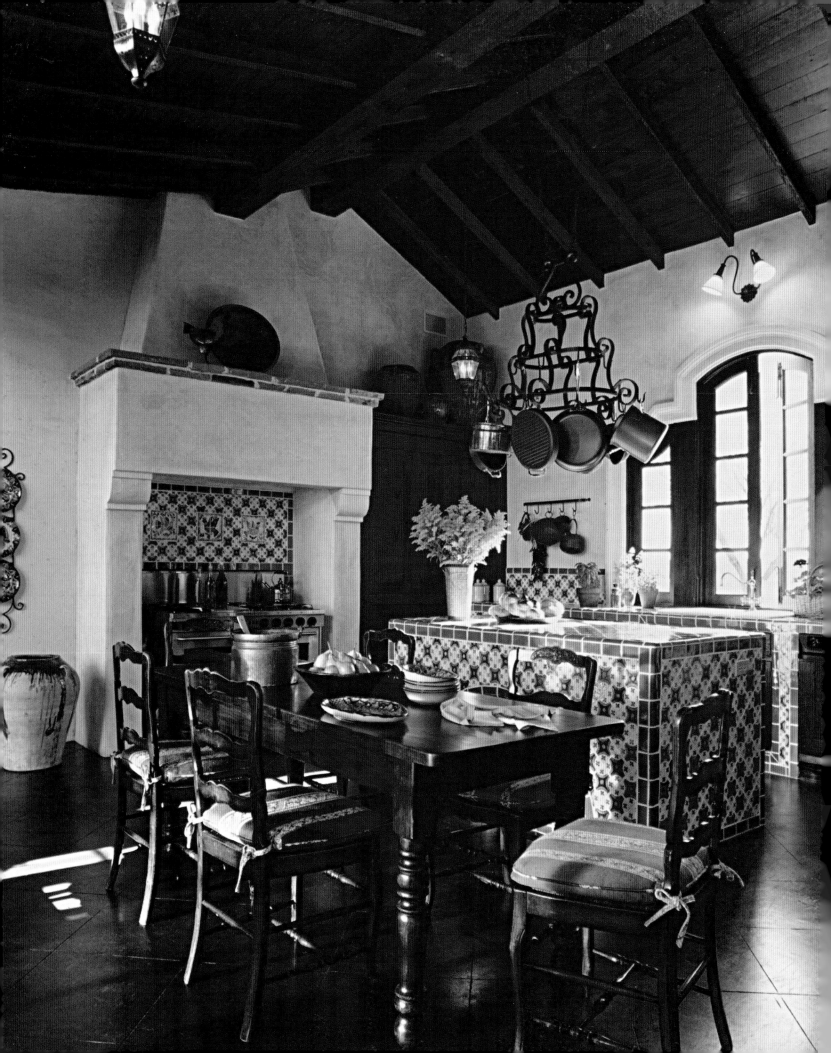

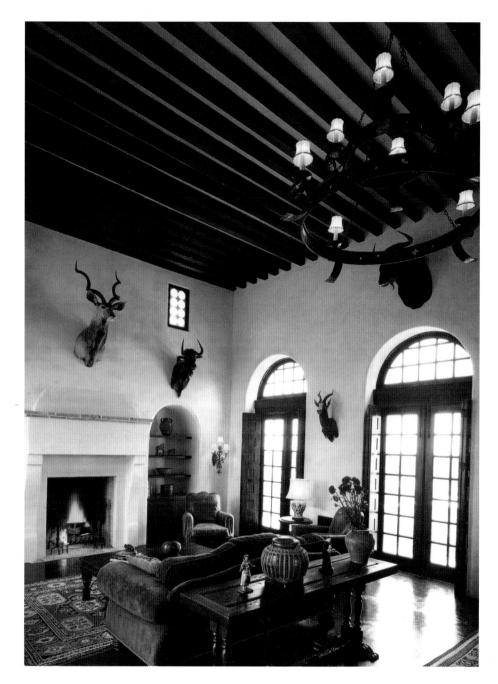

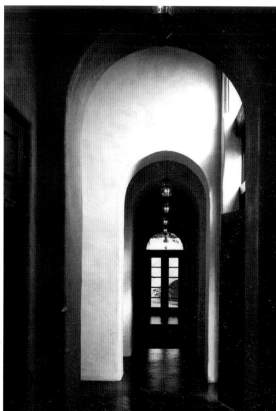

OPPOSITE: The Western-style kitchen has an island, stove backsplash, and kitchen counters covered in Mexican tiles.

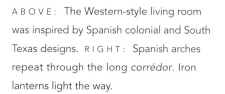

ABOVE: The Western-style living room was inspired by Spanish colonial and South Texas designs. RIGHT: Spanish arches repeat through the long *corrédor*. Iron lanterns light the way.

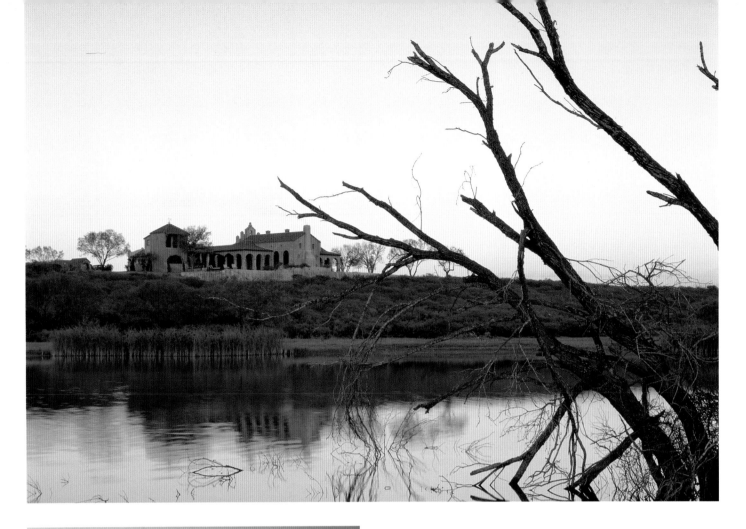

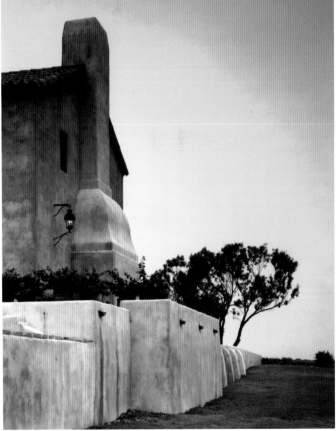

ABOVE: Rancho Dos Vidas is viewed across the river. LEFT: A buttressed "snake wall" surrounds the perimeter of the compound. RIGHT: The approach to the main entrance of the ranch through the South Texas Sendero.

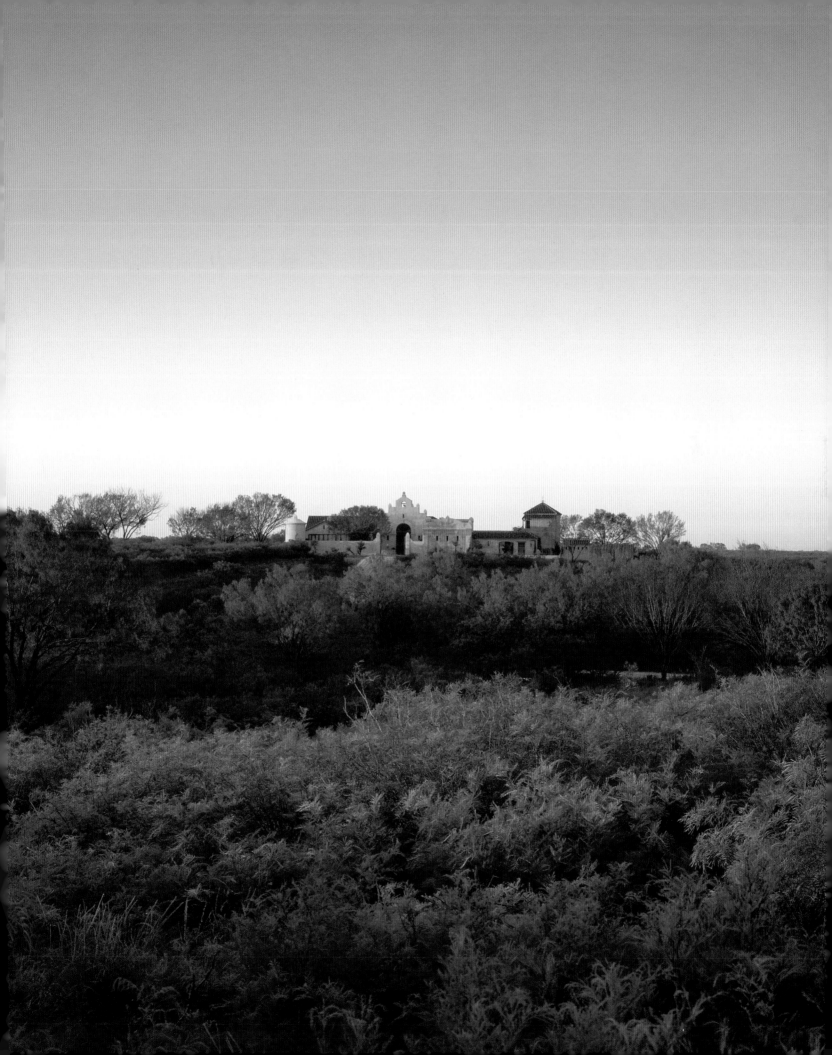

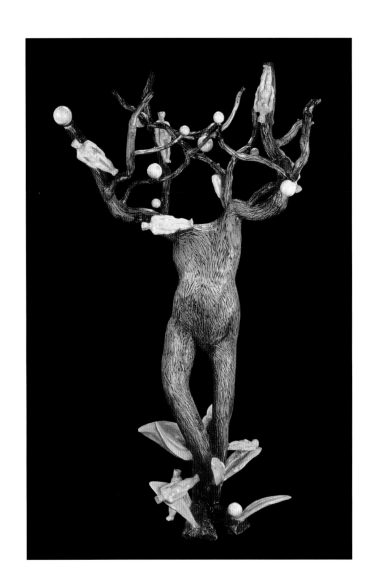

PART IV

This is a newly constructed home. We came to look at this property close to the botanical gardens several times and were having a difficult time deciding when, one very early morning, we stood on the land overlooking the view of the town below, and we suddenly heard the odd, very eerie and beautiful sound of the flapping wings of a flock of ibis flying close overhead. That was the omen in the moment we needed. We have both east and west orientation, sunsets and sunrises can be remarkable, and the walking rains *move across our horizons.*

—Sylvia Trumbull
Casa del Camino

OUT ON A LIMB
Margarita Leon
Wood, oil paint, epoxy
Dimensions: 55"h x 38"w x 36"d.

Candelaria

ARCHITECT: Manuel Barbosa

PHOTOGRAPHER: Ricardo Vidargas

The approach to the distant Candelaria, courageous in its separateness from neighbors and noise, is almost a safari. The passage through scrub, cacti, and mesquite shows few signs of earlier settlement. The land is speckled with large plants of the prickly pear cactus, whose flat, padlike stems intensify with buds as they blossom for one day of life, with yellow turning to orange flowers and reddish to purplish edible (with proper preparation) fruits. A jewel in the midst of a vast landscape outside the city of San Miguel de Allende, the hacienda sits on a low ridge at the bottom of a sloping hillside, with views toward the ancient, urban beauty of San Miguel. The circular drive at the front entrance of the house is bordered with a colorful landscape of garden flowers, vines, and creeping ground covers. The wood double doors, under a modest tiled overhang and church bell, are understated and thoroughly welcoming.

BELOW: Candelaria in the distant desert of cactus and manzanita scrub.
OPPOSITE: The front drive circles around gardens of native flowers and trees.

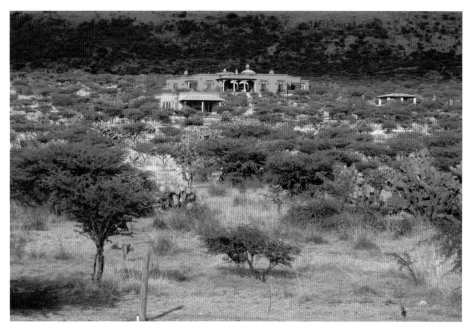

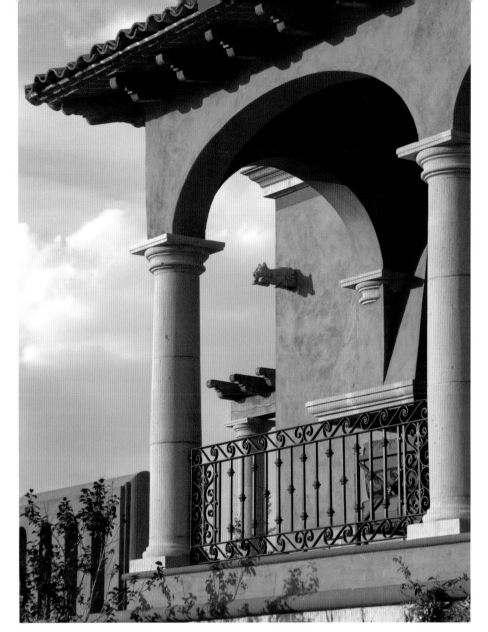

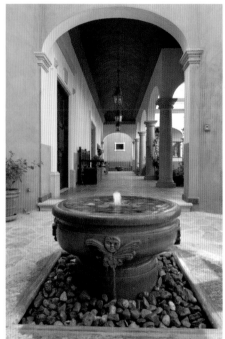

LEFT: Architectural details, such as the carved fox, are found throughout. Animal and angel representations are important in Spanish design. BELOW: A stone fountain with carved angel marks the axis of this arcaded *corrédor*. RIGHT: A large covered terrace for dining and cooking offers distant views on both sides.

The owners' favorite room is the large living room. An elaborate wrought-iron chandelier of considerable size defines the clutch of the interior furnishings; couches and chairs are arranged on either side of the fireplace. The voluminous room is accented by the natural light pouring through the double doors that open to small balconies or terraces. The house has a number of inviting places where one or two can sit, dine, converse, or read. A wood-paneled library, often used as an office, is one place for such quiet mo-ments. A large terrace is set up for outdoor dining, with its own fireplace under cover. A few steps away is a large terrace simply furnished with chaises longues for reading and getting a little sun.

The house was finished in 2006, however, the owner says that in Mexico it seems that "you build a house and then you rebuild a house." Making a home is always a search for a kind of perfection. Perhaps this is what the owner envisioned the day she discovered the location while out riding horses.

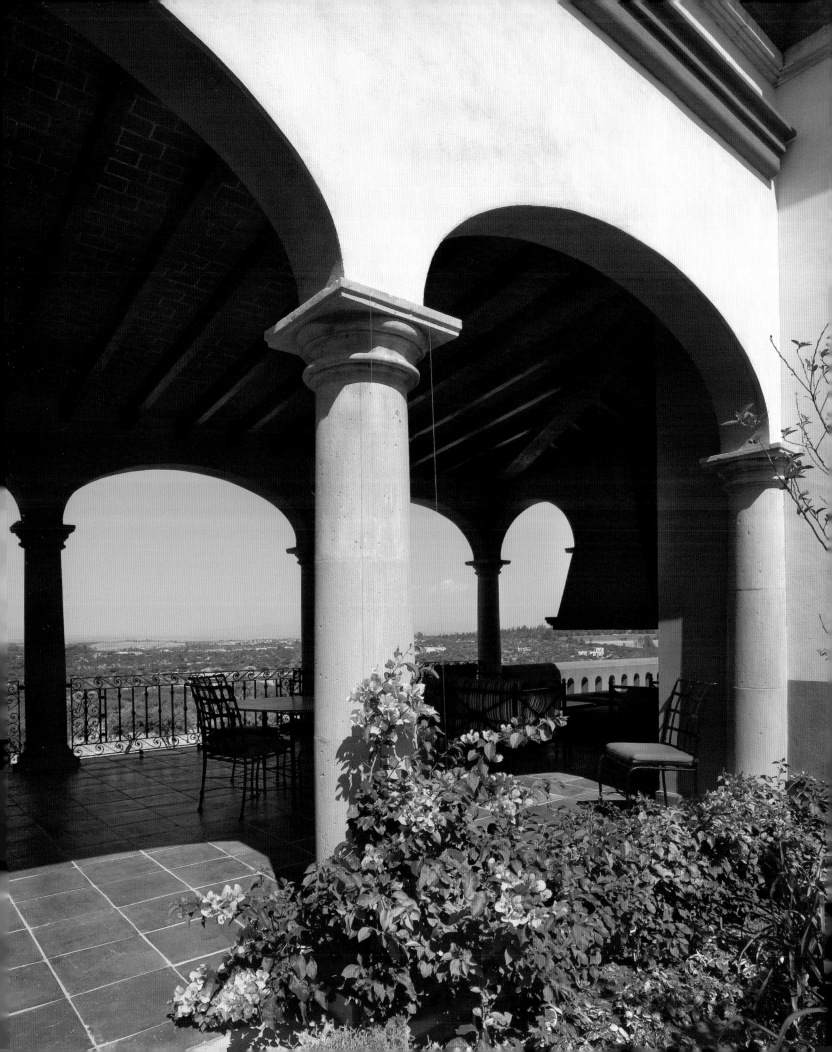

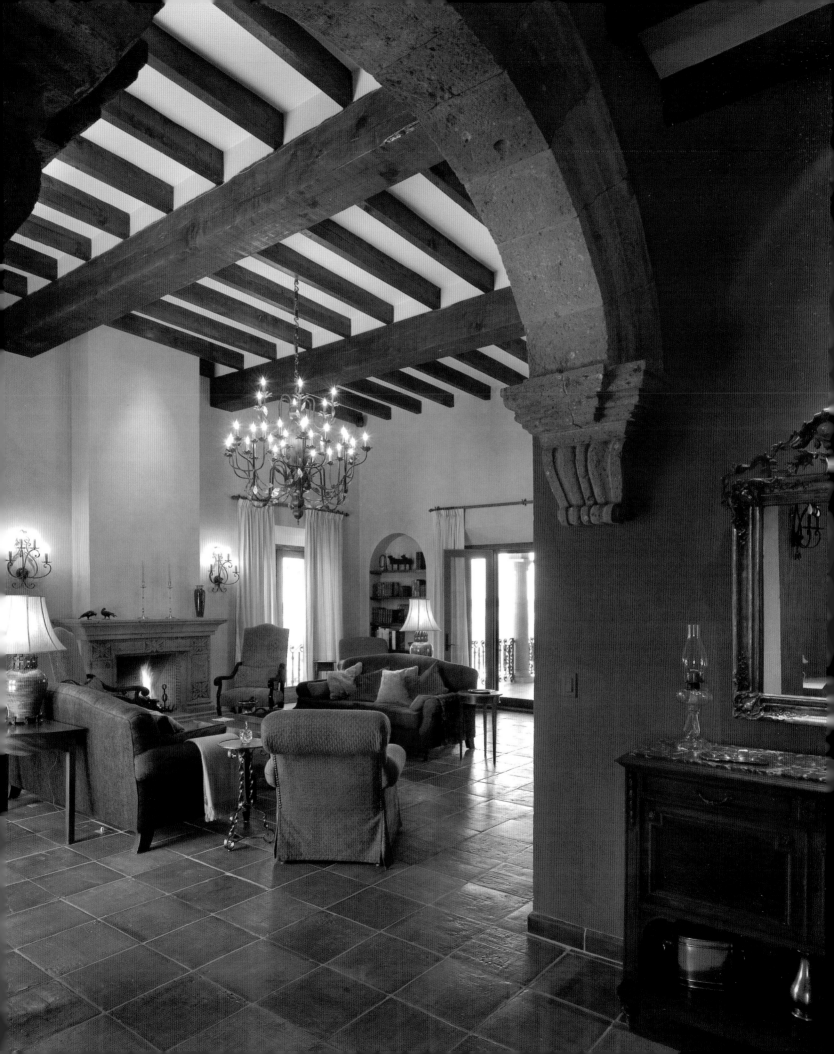

ABOVE LEFT: The loggia is furnished with antique saddles, chairs, and chests. ABOVE RIGHT: The hall to the master bedroom has a niche for a large sculpture. Mottled desert brown and red tiles appear throughout the hacienda. OPPOSITE: A large stone arch marks the entrance to the living room.

ABOVE: A large vanity has old country-style cabinetry and bath fixtures. A flower-petal chandelier is a note of grace. RIGHT: The master suite is decorated in pale lemon fabrics with a seating area near the fireplace.

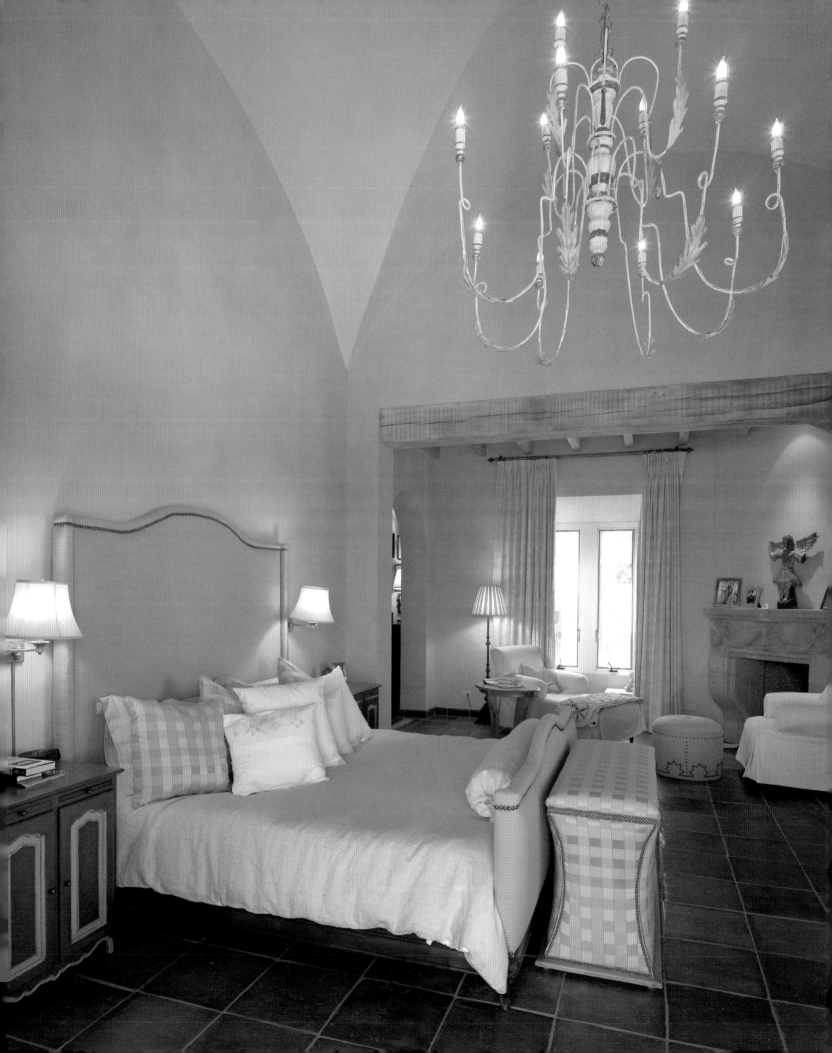

LEFT: A Miró painting and contemporary leather chair. RIGHT: The bell tower and tiles over the main entrance feature the patina and sky-blue colors found in the owners' Miró painting.

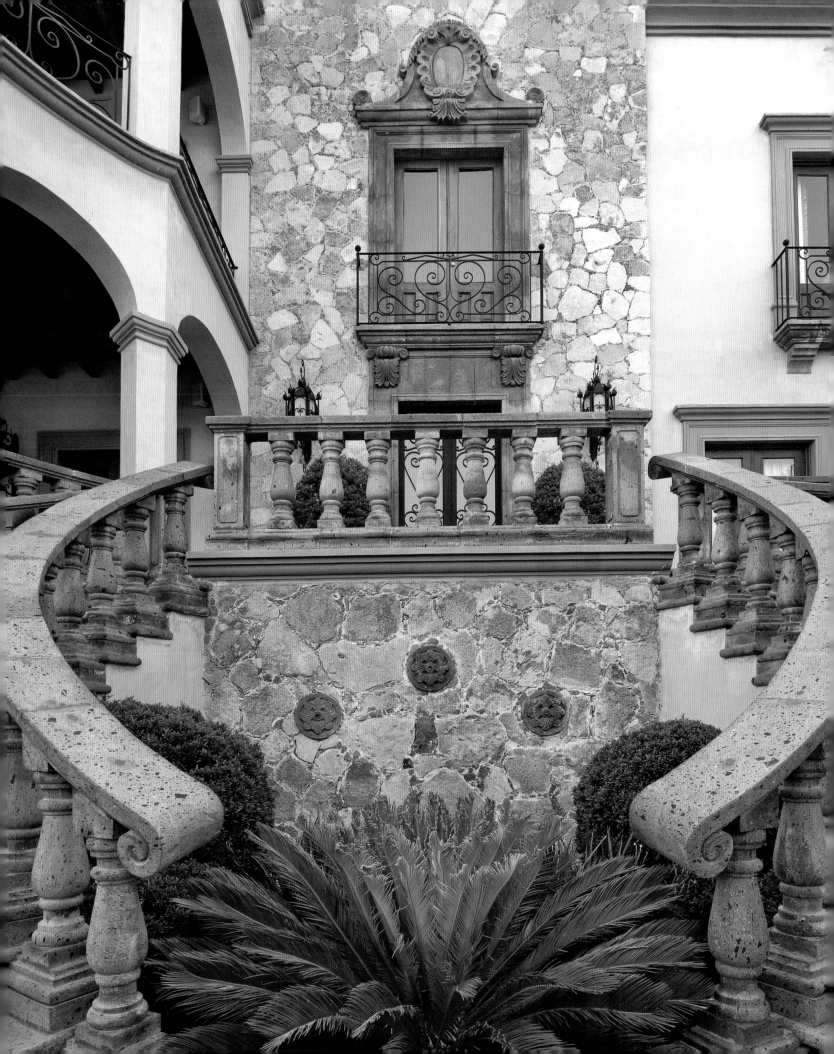

Casa Agave

OWNERS: Terry Hill and Susan Stuart Hill

ARCHITECTS: Manuel Barbosa, Oscar Torres, John McLeod

PHOTOGRAPHER: Ricardo Vidargas

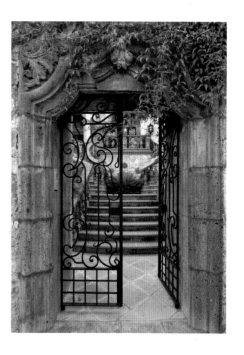

As the sun rises over Casa Agave, a voluptuous formality awakens in each room, terrace, and garden that comprise this unique and stately home. The design process evolved over a period of two years, involving the owners, architects, and contractors who considered numerous concepts. A major consideration was the spectacular location of the property and its 240-degree range of views. Another significant consideration was a design that takes advantage of this broad spectrum of views, while at the same time ensuring the owners a high degree of privacy.

The dual cantera-stone entry staircase was the creation of the architects and contractor. This important architectural material is used throughout the entrance as well as the entire front of the home and into the courtyard. The curvaceous nature of the design plays well against the linear forms in the rear garden with a more lenient and pleasurable embrace. The circular two-story foyer is part of the overall motif in which every part of the house opens to an adjoining living space. Terry Hill says that the foyer reminds him of the residential scale of Dallas Hall on the SMU campus in Dallas.

ABOVE: The front gate leads to the main entrance from the street. BELOW RIGHT: A warm and welcoming living area is enjoyed in the afternoon and evening. BELOW LEFT: The courtyard features a fountain with tall cypress trees in the background. OPPOSITE: An elegant double staircase leads to the main entrance. The second-story rooms have small flower balconies.

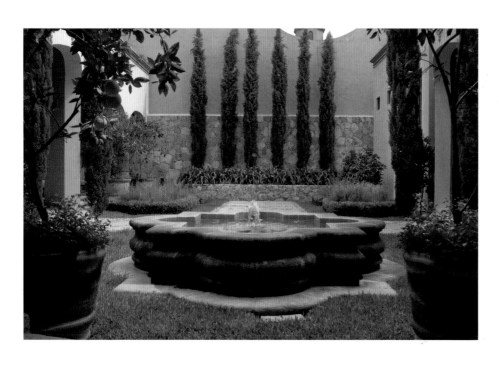

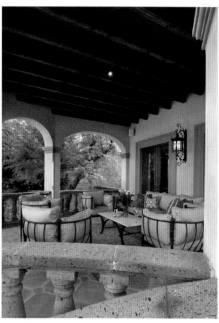

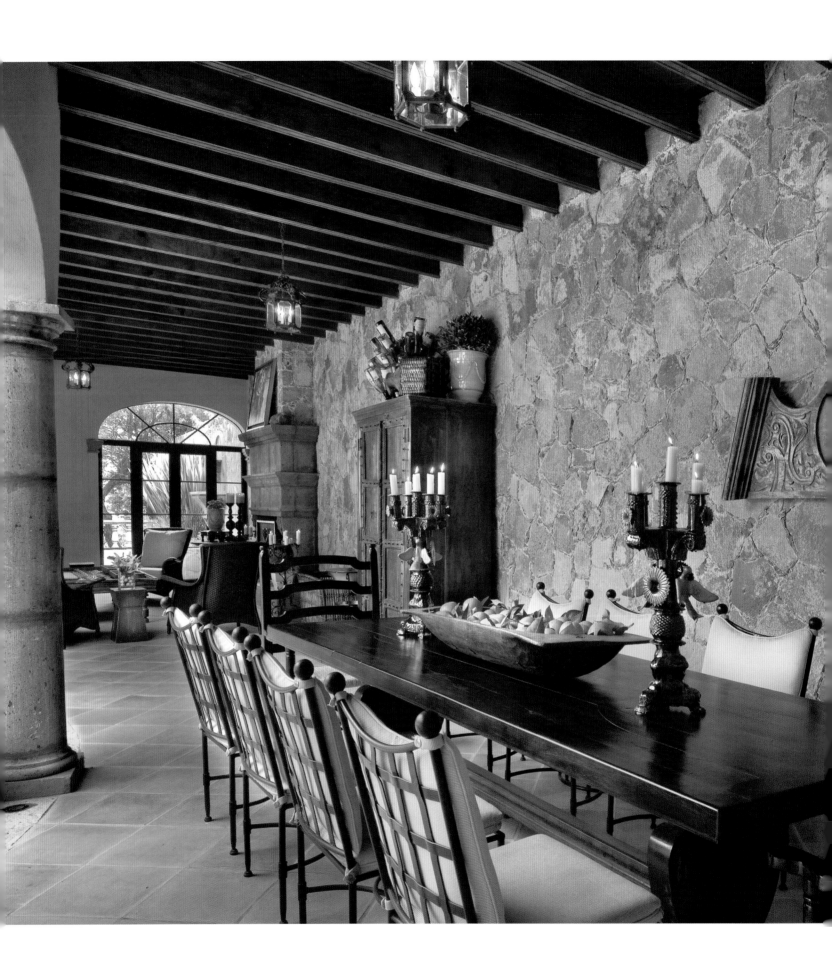

The wrought-iron gates and railings were designed by Susan, a Dallas design professional, and by Oscar Torres. This project is one of her favorites; she was the lead designer and oversaw the installation of both the interior and exterior furnishings. Susan and Terry together designed the stone surround for the front entrance door. All the stone in this unusual color was extracted from one location in a quarry and hand carved to remind them of a special place they know in France. A home in Mexico is the culmination of the love of the hands that created it, and Casa Agave shows its collaborations.

B E L O W : The large fireplace and seating area is at one end of the long, stone loggia.
L E F T : Elegantly furnished with a long harvest table, comfortable chairs, and a separate conversation space in front of the fire, this loggia is an irresistible pleasure.

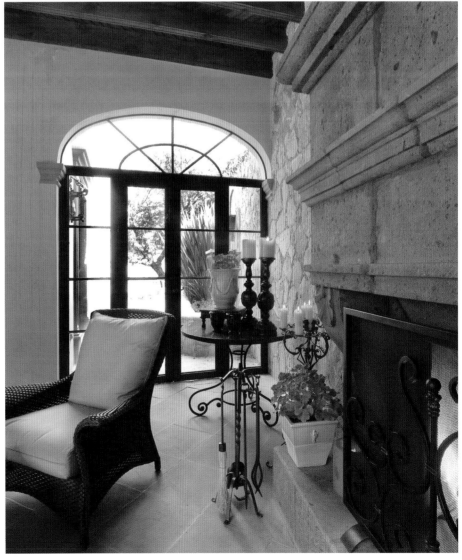

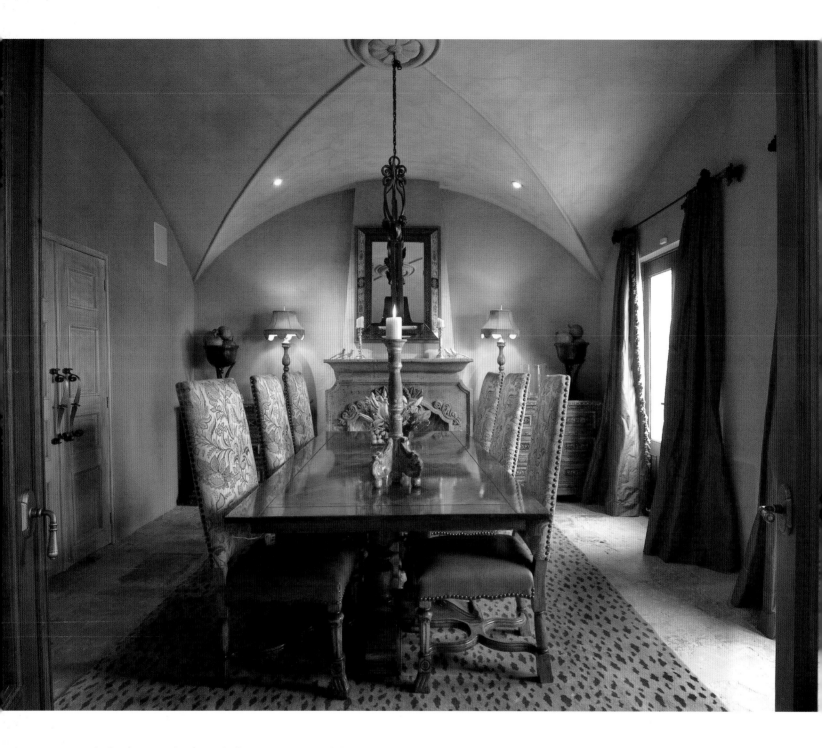

The kitchen was the most challenging room in the house to design. Both Susan and Terry are terrific cooks and enjoy spending time together in this room. Following the motif of an open-flowing floor plan, they worked diligently to bring views into the kitchen. They also de-

signed the cabinets and island to resemble pieces of antique furniture. One of their favorite areas is the small table adjacent to the kitchen fireplace. They enjoy their morning coffee in front of a fire on chilly mornings when the sun takes its time to warm up the day.

ABOVE: The private dining room off the living room has a graceful lightness due to the wall color and the double-vaulted ceiling. Dupioni silk drapes frame the French doors to the loggia. RIGHT: The living room is animated with upholstery, flowers, and light from the fire. Topiary cypress flank the fireplace.

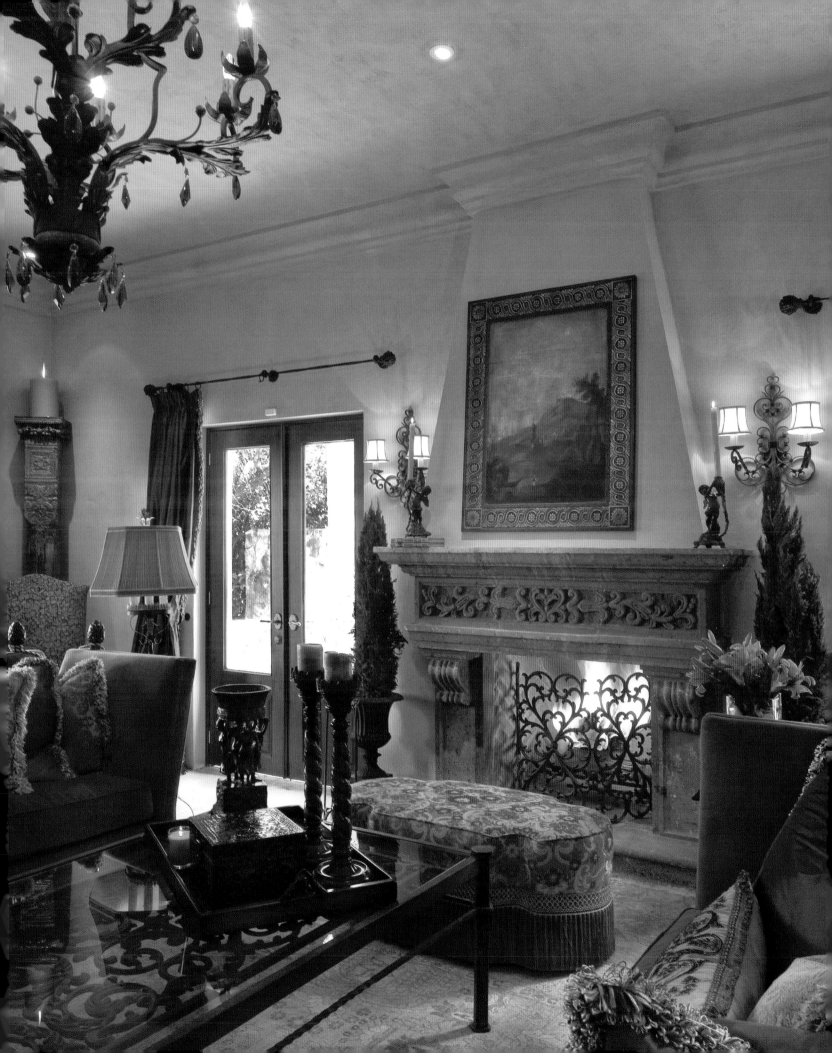

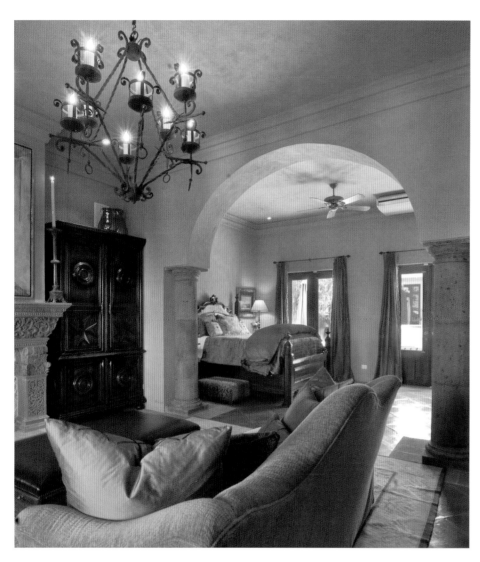

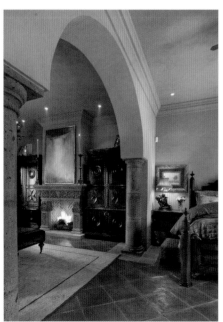

ABOVE: The master suite is divided by a large arch and two columns, with a comfortable sitting area in one space and the sleeping area and balconies in the adjacent space. LEFT: A view of the seating area with the fireplace and two armoires. RIGHT: The kitchen is a masterful combination of Spanish and Texan features. Light enters through the high windows under the *bovéda* ceiling and the narrow wood-paned windows. A small wood-burning fireplace warms the breakfast table.

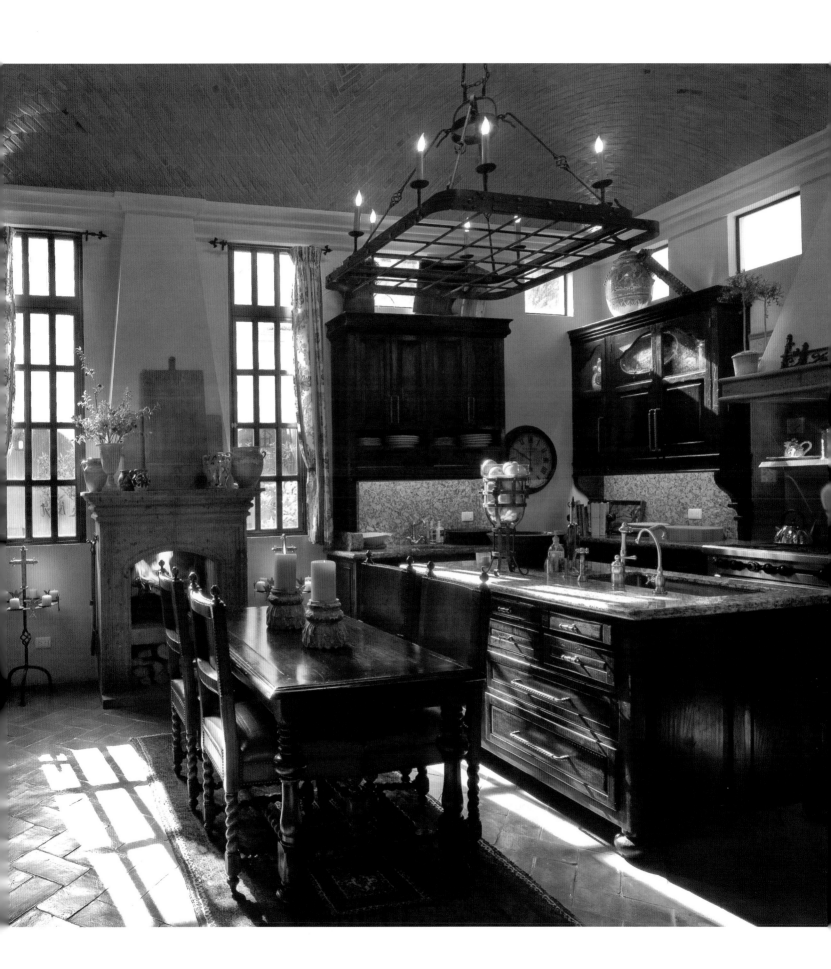

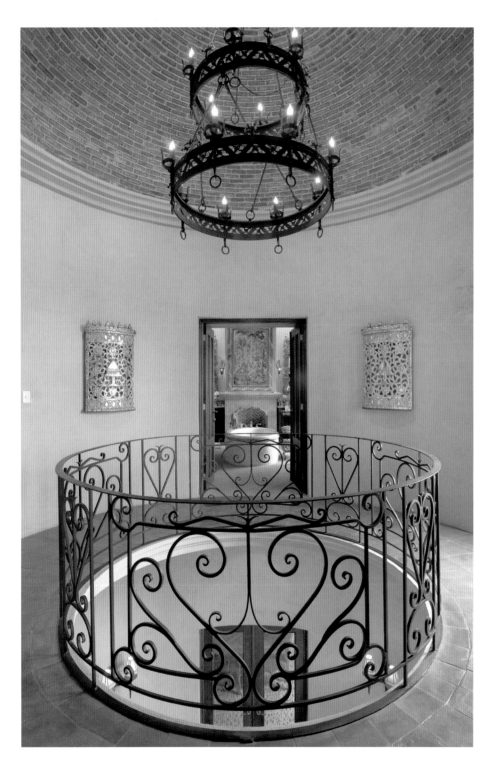

ABOVE: Stairs from the foyer lead to upper floors. BELOW: A gate opens to the circular first-floor foyer and the second-story railing. RIGHT: A luxurious private bath has an oval-shaped tiled tub. An antique tapestry mounted above the fireplace separates twin gilt mirrors and helps define personal areas.

ABOVE: The circular entrance rises to the second story. The railing allows guests in the foyer below see the chandelier and the beautifully worked *bovéda* ceiling. The double doors open to a private bath.

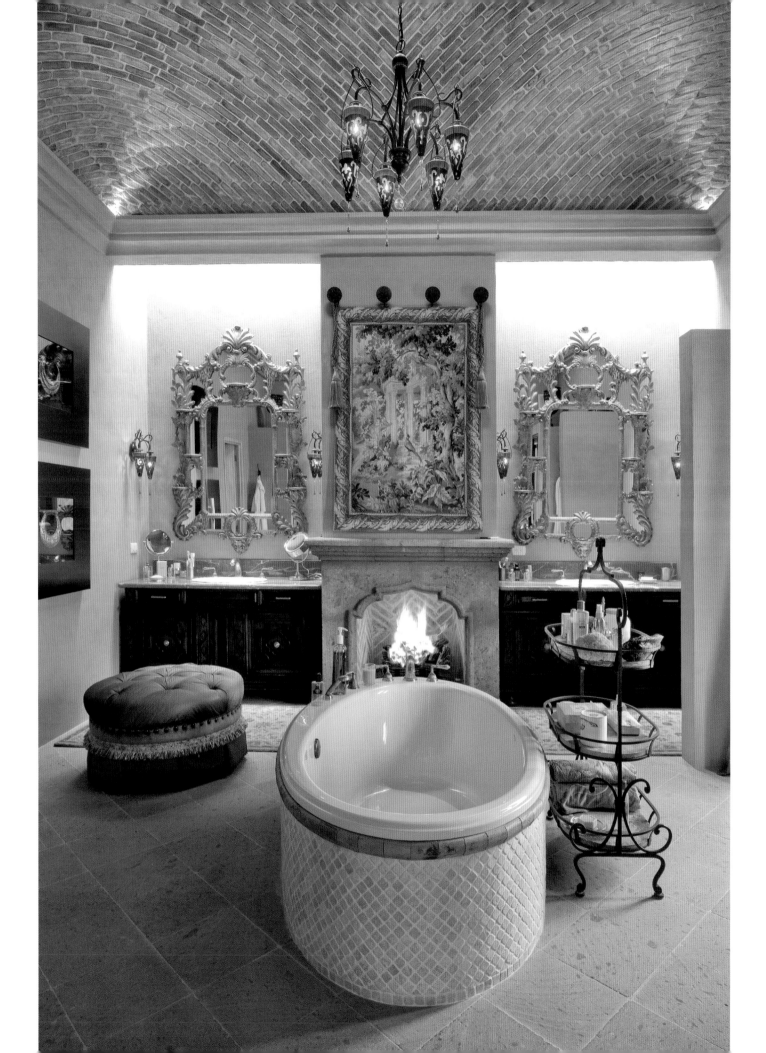

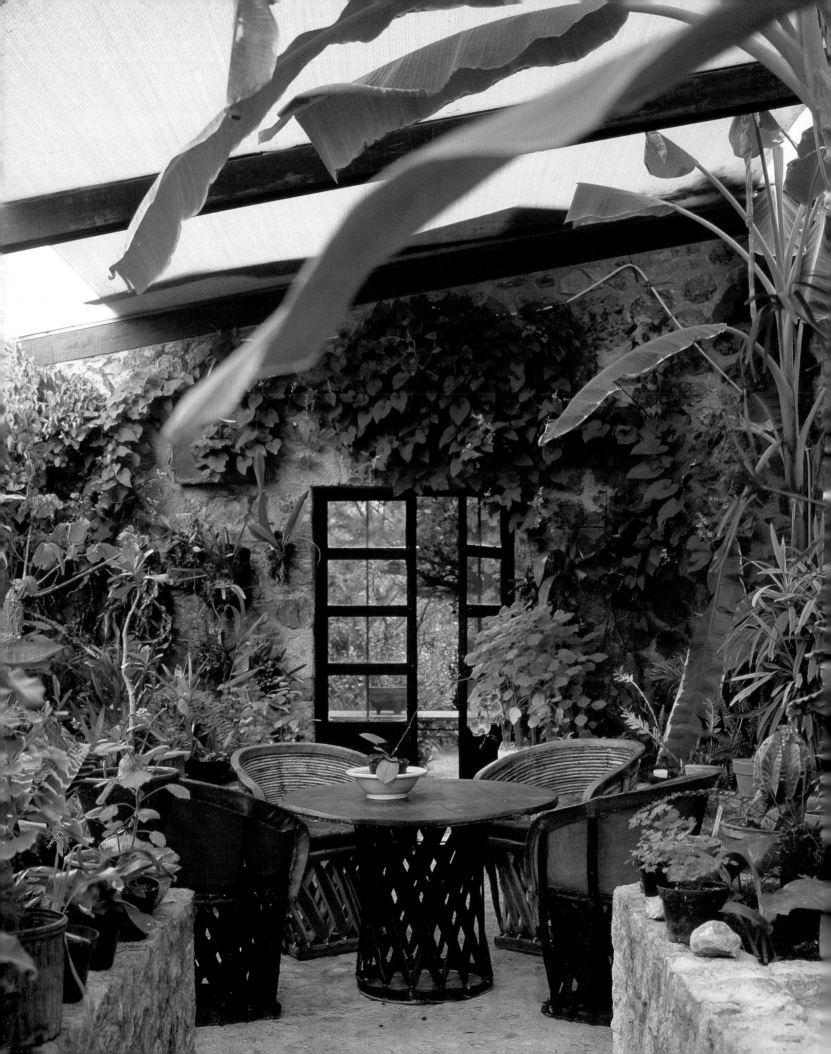

Marroquín de Abajo

OWNER: Alfonso Alarcon

ARCHITECT: Alfonso Alarcon

PHOTOGRAPHER: Christiaan Blok

Alfonso Alarcon is a landscape designer who left Mexico City eighteen years ago to discover his future home in the country. He fell in love with a gorgeous piece of land. It was a large parcel of nearly 150 acres with no water or electricity, and the dirt roads were impassable. He convinced friends to buy the property with him and start working to improve it. There is no one better than a landscape architect to take on such a project. The first "improvement" was to dig a well; then they created roads, and lastly ran electricity. Now there is a terrific community of friends who have seven and a half acres each.

Alfonso is an artist, adventurer, and arborist. He is willing to build a house one stone at a time and to create areas around the house such as a large cobblestone picnic area. He created a pond with lush landscaping and bought and restored a one-hundred-year-old wooden cottage from the state of Michoacan. The cottage is now in place on his land, and he uses it as a garden house. His favorite place is the greenhouse, which is accessible from the living room and bedroom. The greenhouse is the center of his collection of lush tropical plants, including orchids and other exotics. He built an oval stone spa designed to appear as a large fountain featuring a lion's head at the end of the

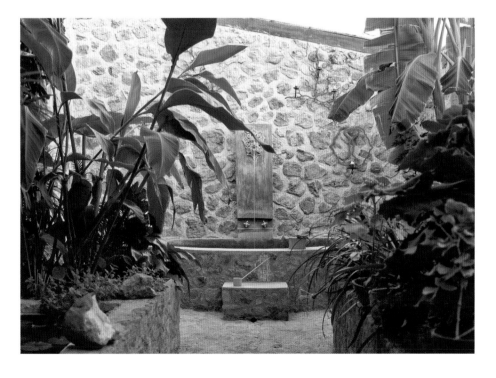

ABOVE: The sunlight accentuates the texture of the stone and the dark doorframes. A long, sturdy worktable is suited to Alfonso's passion for growing timeless bonsai.
LEFT: This is not a koi fountain and pool, but rather a zen tub of stone for bathing.
OPPOSITE: Another greenhouse garden houses varieties of plants and serves as the main dining space.

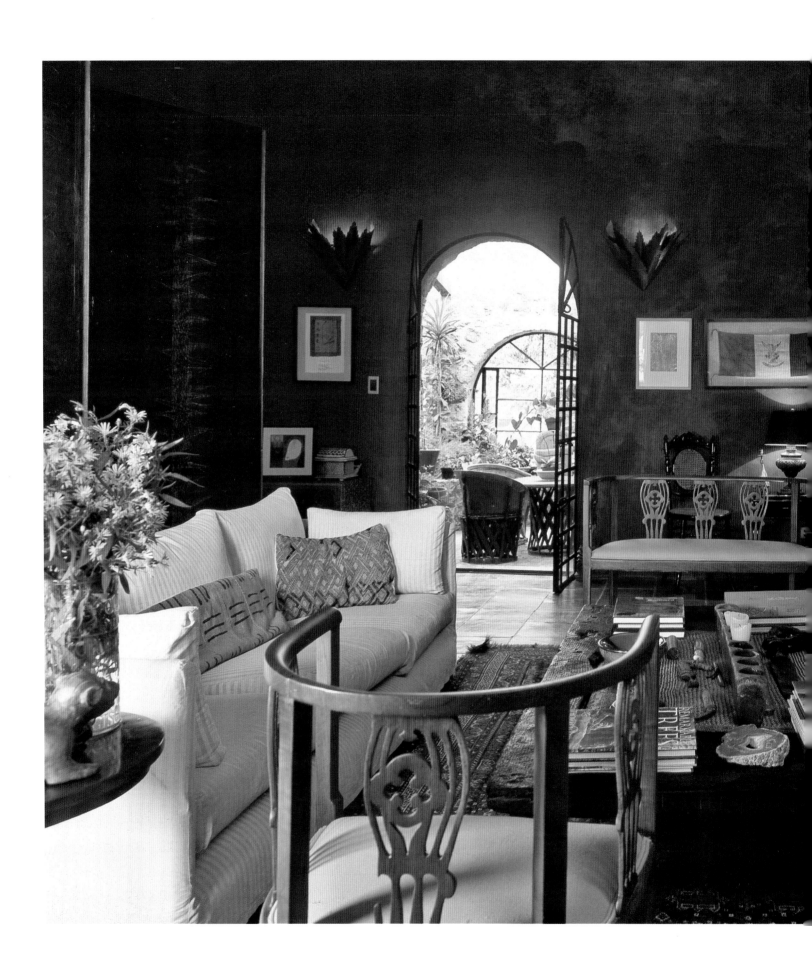

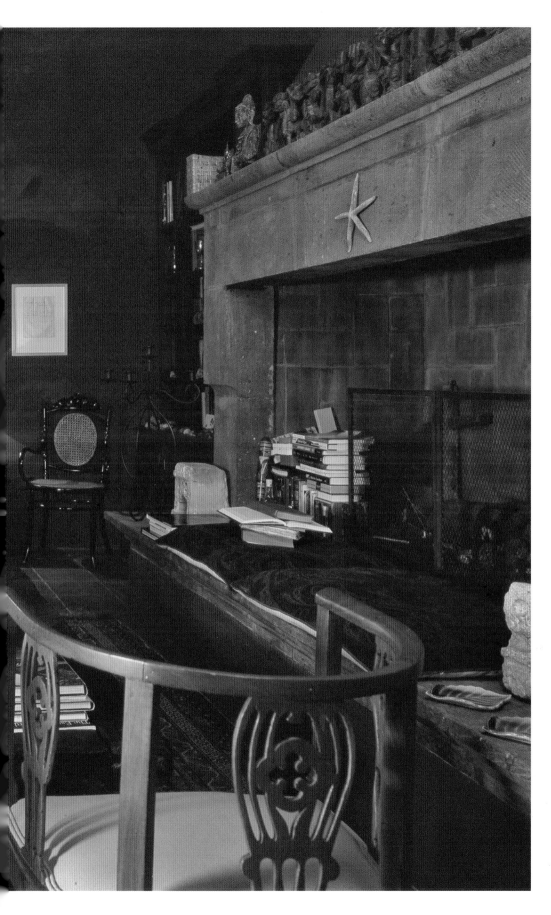

The living room is the center of the owner's
eclectic collection of artifacts and furnishings.
Just a step from the garden rooms, the inside
is an oasis of British colonial restfulness.

greenhouse. He feels that the tropical oasis
in the middle of the arid region where he,
his wife, and four Labrador retrievers live
is a luxury, and he looks forward to spend-
ing time in this wonderful space. A more
luxurious place is difficult to imagine.

Alfonso is something of a collector.
He has a collection of history books dating
from the seventeenth century. There are
nineteenth-century paintings from the
same period, as well as a collection of Mex-
ican pre-Columbian pieces that he brings
back from his travels. He has learned
elaborate bonsai procedures and once
owned a "forest" of bonsai. Such talents do
not end at the front door. The living room
is a collection of artifacts gathered while
traveling. Interior spaces feature obscure
techniques such as layered wax and pig-
ments over walls and floors, hand-scored
clay floors, and pebble "rugs," which medi-
ate the heat to maintain a cooler interior.
Every space is personal; each has the touch
of a talented hand. Each is a little piece of
paradise in itself.

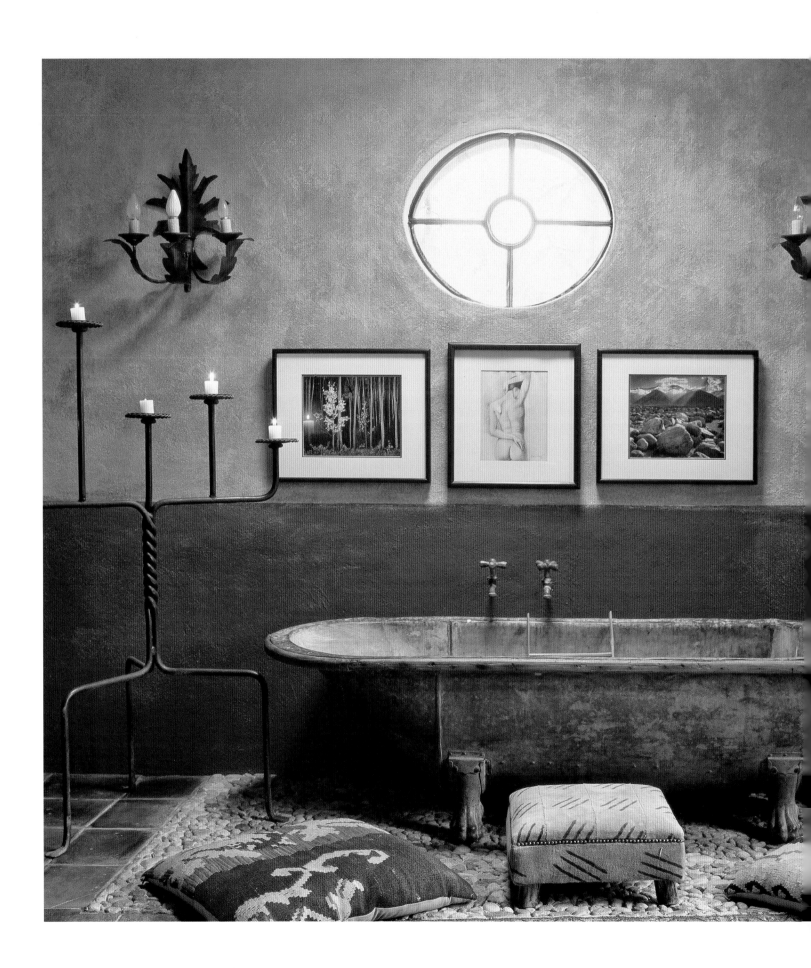

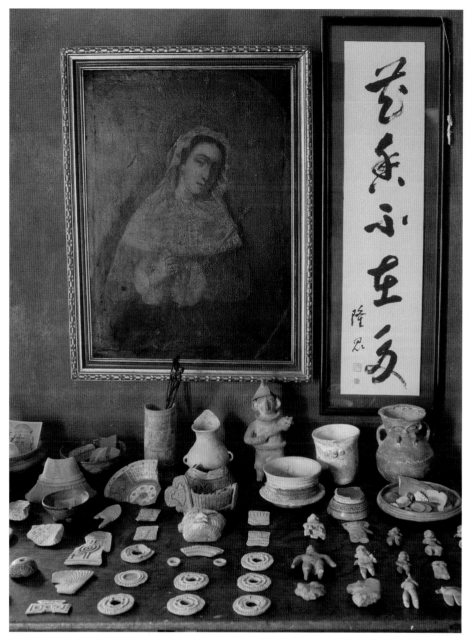

ABOVE: The owner has an interest in fragments of ceramic and pottery work from all over the world. This collection features a group of tiny figurines used as amulets and prayer spirits from the ancient Middle East and Western Hemisphere. LEFT: After a long day of working with the landscape, a bath can be enjoyed in an old tub with wood trim and a pebbled floor. Serene and beautiful, the room has candlelight, Ansel Adams prints, the colors of the desert, and a few woven pillows.

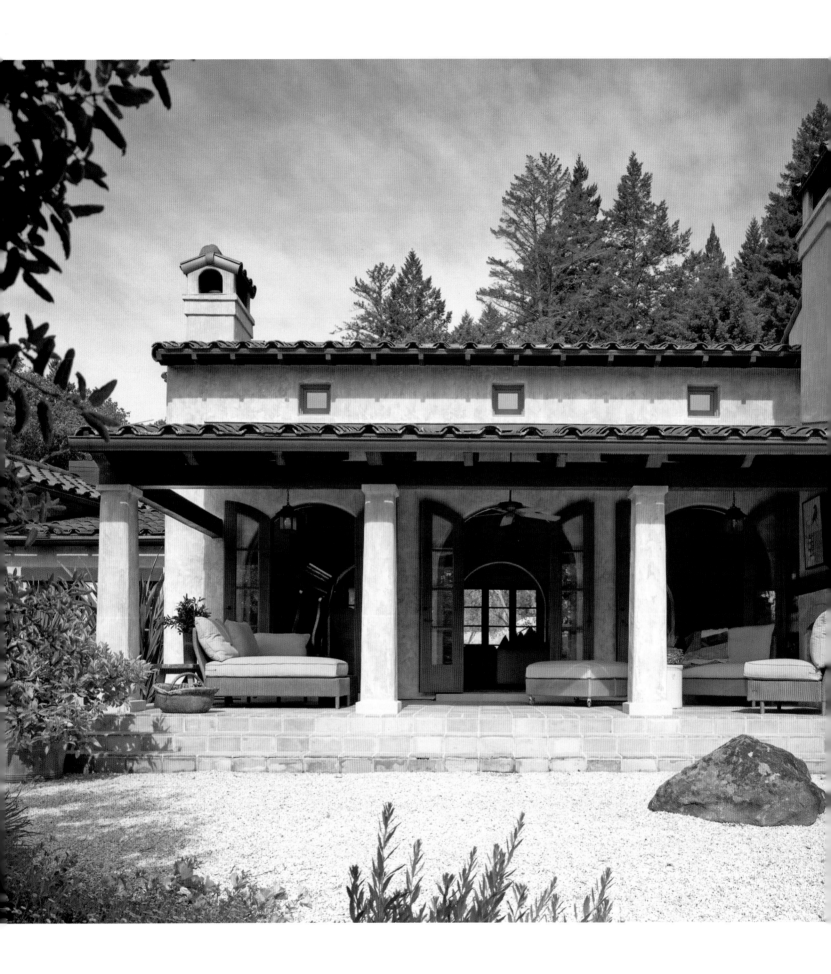

Valley of the Moon

OWNERS: Bob Heisterberg and Susan Skinner

ARCHITECT: Marley + Wells Architects

PHOTOGRAPHER: Tim Maloney

Bob and Susan are on permanent vacation here on the east side of Sonoma Mountain in Sonoma County, California. The site overlooks the beauty of the Valley of the Moon vineyard region in Glen Ellen. Not much more than a mile away is one of the homes of Jack London, a historic ranch and farm where he wrote, kept livestock, and planted vineyards. This new hacienda is located in an area that did, and still does, make its way agriculturally.

After lifetime careers in the financial industry of New York, the owners desired a home that was worlds apart. The first approach to their hacienda offers an overall

BELOW: Just steps from the living room, the porch has a fireplace and exposed roof tile between the overhead beams.
OPPOSITE: A view of the porch from the courtyard. Views from the porch include the Valley of the Moon.

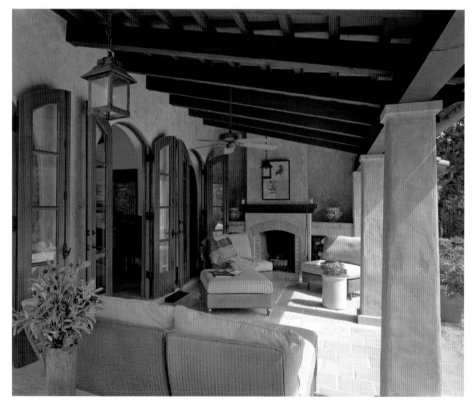

impression of the generous siting of the house. However, upon entry to the protected front court, only a small portion of the design is experienced. In hacienda-style building, there are many intimate spaces, not obviously known, that accommodate a variety of activities. There may be a room for music and another for painting. Here there are adjacent buildings for guests, a gym, and a pool cabana, which are found through a series of smaller courtyards under low colonnades. The design is intended to emphasize the human scale in an extensive setting. Tiled eaves are kept low and the scale intimate, from the first step into the compound. The structure

was left open to the views, which included leaving the undersides of the tile roofing exposed wherever possible on eaves, overhangs, and porches. The terrain is steep, but the architects fit a wonderful, natural-rock lap pool with tiled spas on the site.

Bob and Susan wanted a traditional home in perception, with a few modern dictates of space, light, and order. Orientation and environmental constraints of building in California were also an influence on the design. To achieve the essence of the sixteenth-century style, the materials were kept authentic and the color palette warm. Restraint was an aesthetic. Fabulous and simple, Saltillo tiles were an early

BELOW: The approach to the hacienda is from the west toward the walled court. The chimney for the library is on the right. RIGHT: The garden and terraces are on the east side of the hacienda. The dining room is at the center; the master suite is at the far left. BELOW RIGHT: The entry court has a fountain. The living room gallery is at the center, and the library and office are on the far right.

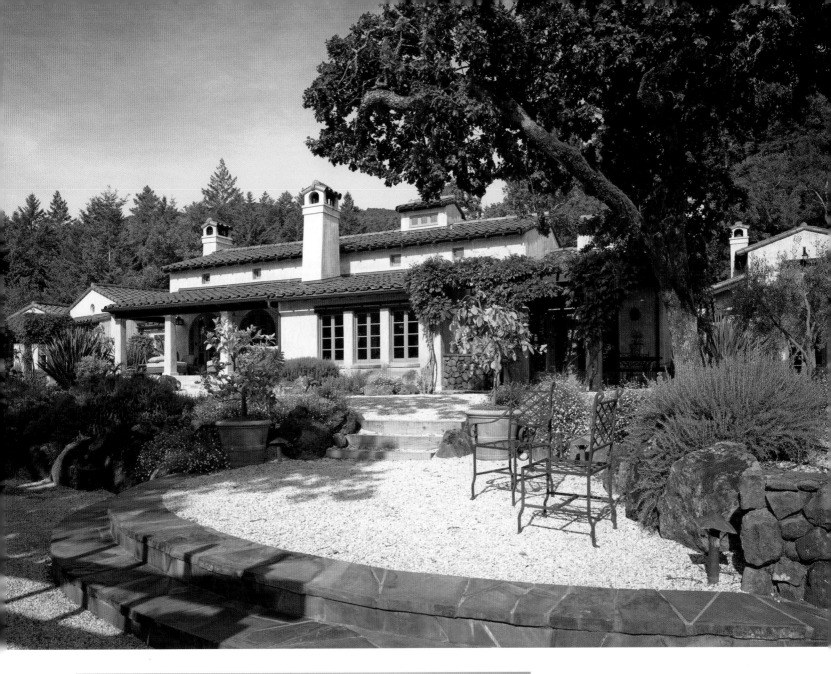

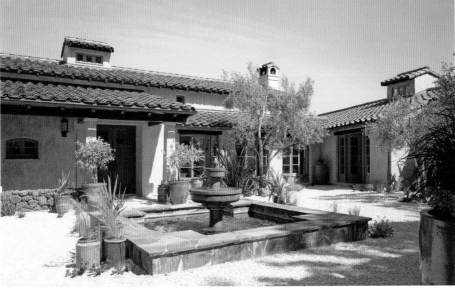

selection of the owner, and the use of this material throughout the house was embraced by the architects. Such a traditional material is in keeping with the spirit of the hacienda style, and also promotes a modern concept, linking the interior and exterior spaces. Saltillo pieces were also used for accent spots and on countertops and fireplace surrounds. Thick interior walls and simple arched forms create the sensation of elegance and austerity: the best aspects of the traditional hacienda.

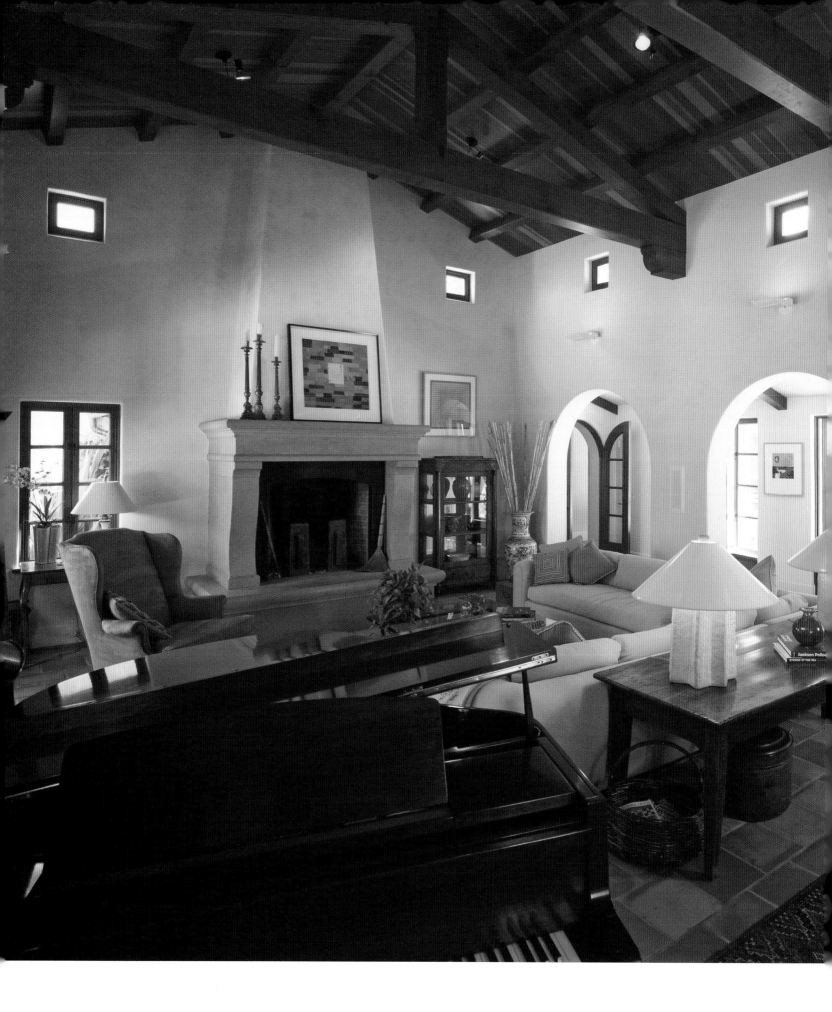

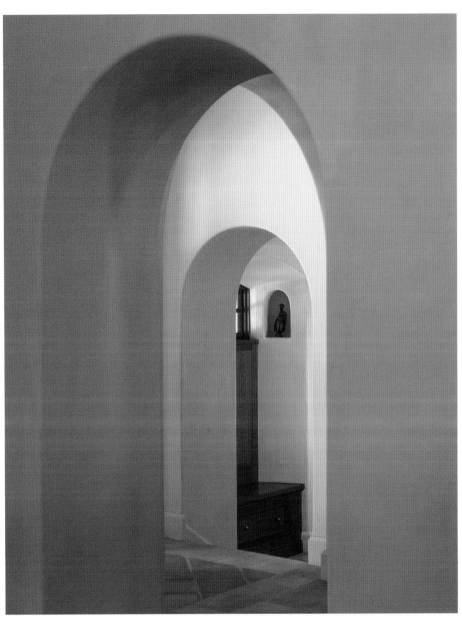

ABOVE: The view from the living room through the foyer and into the kitchen shows four arches. LEFT: The spacious living room features reclaimed fir used in the ceiling and trusses. The gallery *corrédor* at right opens onto the courtyard.

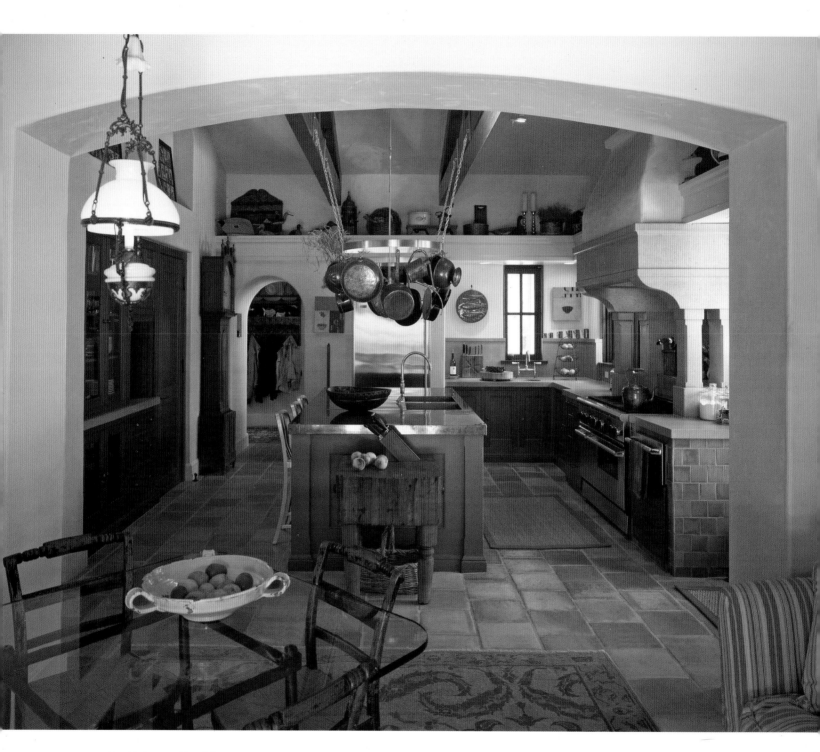

ABOVE: The kitchen and breakfast rooms
feature a copper-topped island and lunch bar.
The counters are clad in concrete and tile.
OPPOSITE: The master suite opens onto
the eastern terrace. The sitting room receives
the cool morning sunlight.

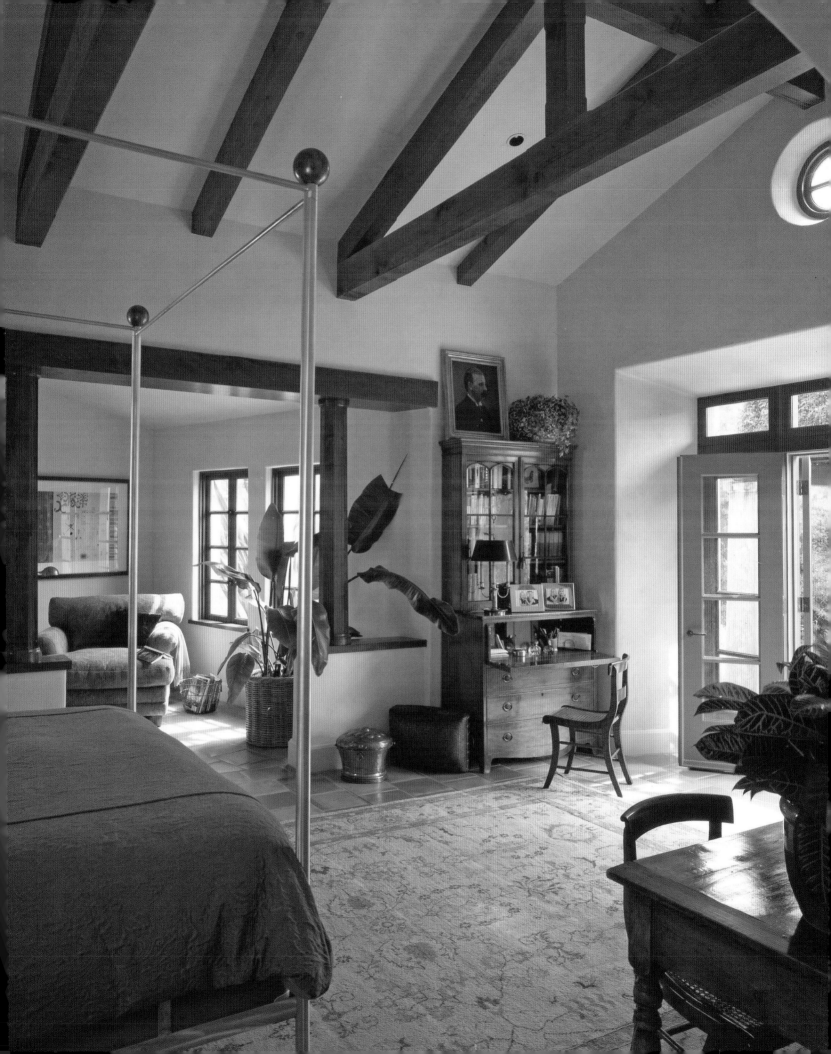

Casa Vista

OWNERS: Barbara Pruzan and Ian Altman
ARCHITECT: Nicole Bisgaard
PHOTOGRAPHER: Ricardo Vidargas

The beauty of the natural surroundings in the Mexican landscape adds a dimension to the architecture of this new home. Slight variations of the hacienda style and of traditional materials make it a unique and very personal place. Barbara was traveling twenty-three years ago on the recommendation of a close friend and discovered this area. She fell in love with the location and knew that one day she would build her dream home here with a special someone. The house, designed by Nicole Bisgaard, was completed in 2006 using the traditional materials of adobe and stone. Nicole's bold design, however, called for the rare brown cantera, which gives the structure a fierce authenticity and an authoritative presence in the landscape.

Nicole utilized the repetitive design motifs of hacienda architecture while employing granite, wood, brick, tile, and

BELOW: Casa Vista rises from the landscape as a hacienda of old Mexico.
RIGHT: Brown cantera walls and tile roofs are set back from the valley, with fields and river in the distance.

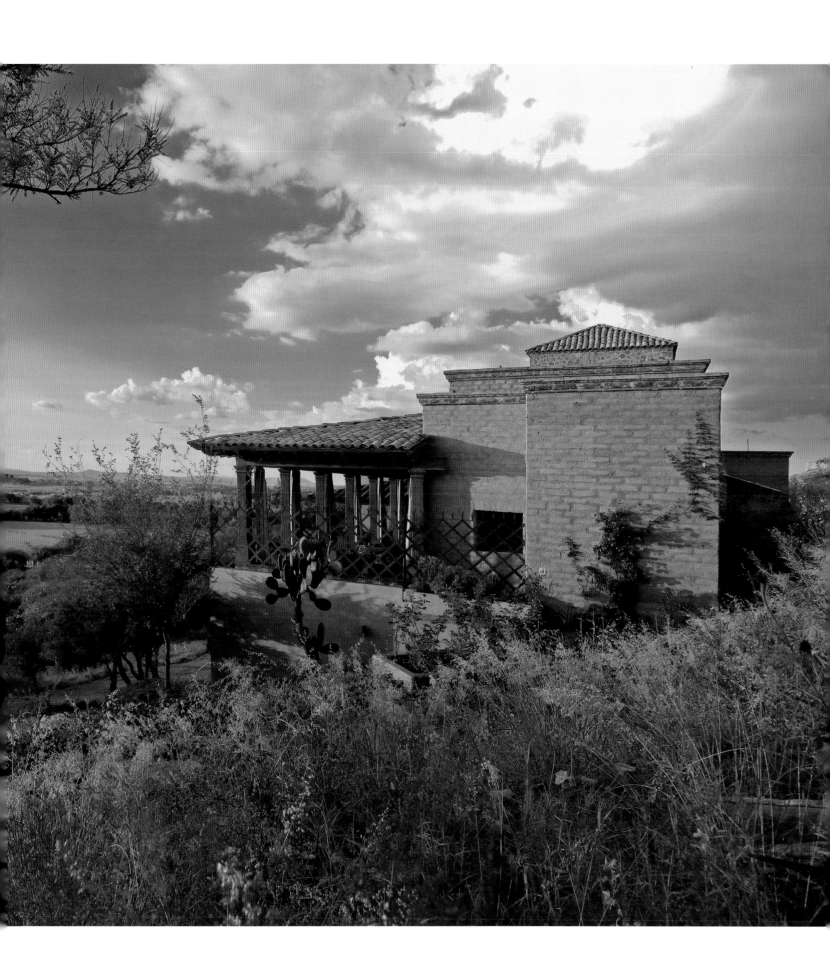

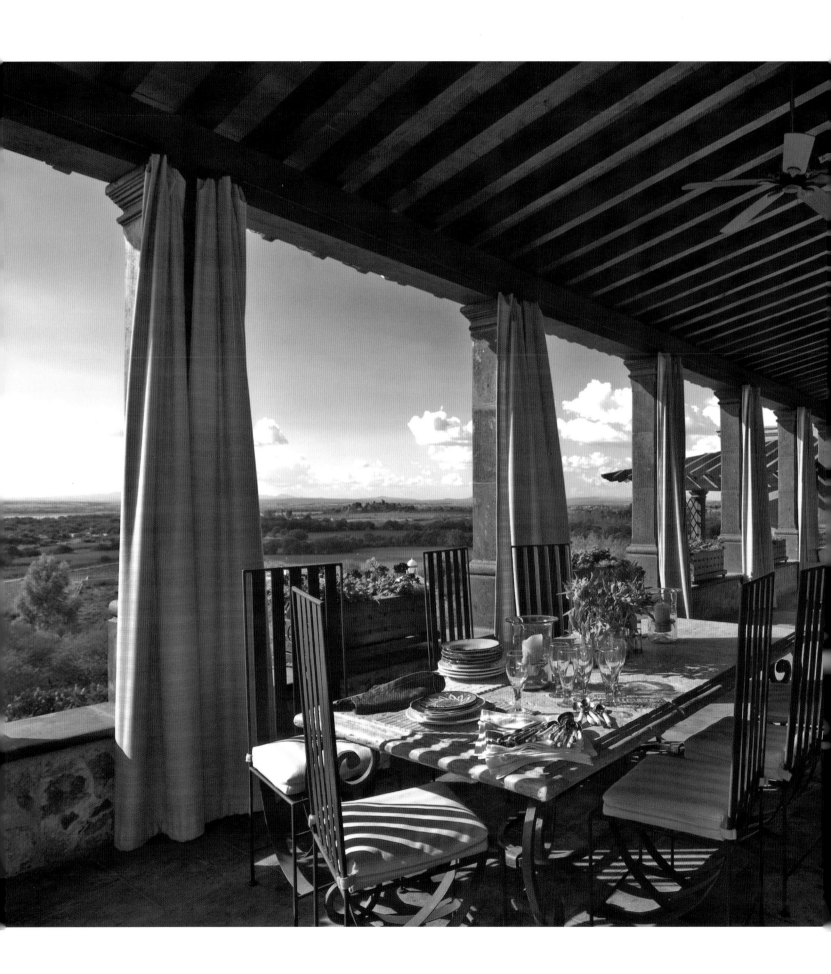

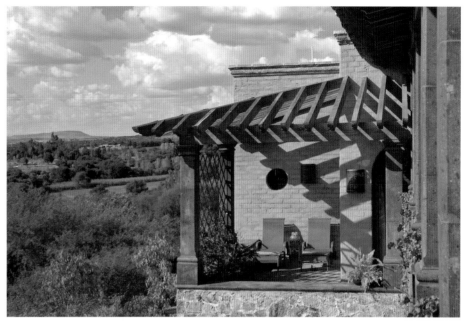

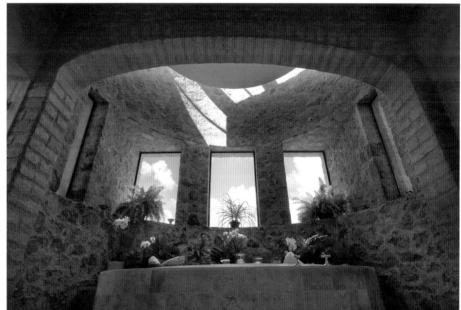

ABOVE TOP: Small private terraces allow enjoyment of the climate at any time of day. ABOVE BOTTOM: The master bath is a tropical garden of orchids, sunlight, and stone. RIGHT: Topping the circular walls of the master bath is a skylight that surrounds the top of the column. LEFT: A larger terrace for gatherings. Drapes can be drawn against the heat of the late afternoon.

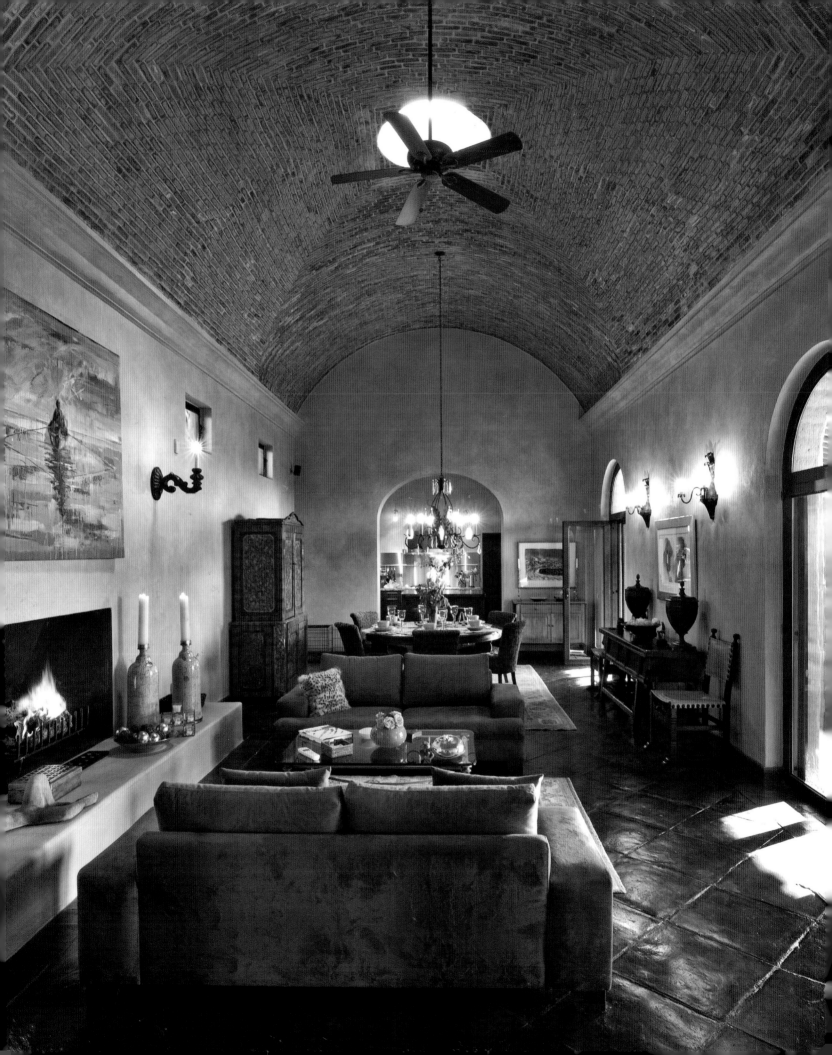

travertine in contemporary uses. The master bath is a garden of orchids and stone reaching up to a circular ceiling with a "moat" of skylight enclosing it. The bathing room with Barbara's special chaise for "just relaxing" is close at hand.

Ian and Barbara love to entertain and have friends over for meals. Their kitchen is spacious, with dark tile flooring and a Tuscan color fresco on the walls, cable lighting, and overhead *boveda* vaults. It is efficient and inviting, and the outdoor sala is always ready for guests. If needed, luxurious drapes offer protection from strong breezes or the hot afternoon sun. The views are lush, green, and endless, giving Barbara and Ian the everyday joy of being in a place they love.

When they decide to venture off, they take day trips to the nearby colonial towns of Guanajuato and Queretaro, where art, food, and music can be enjoyed in the open markets. Their collection of the work of local artists is beginning to fill their hearts and their home. They feel at peace in the home they have built together and know that this is where they are meant to be living.

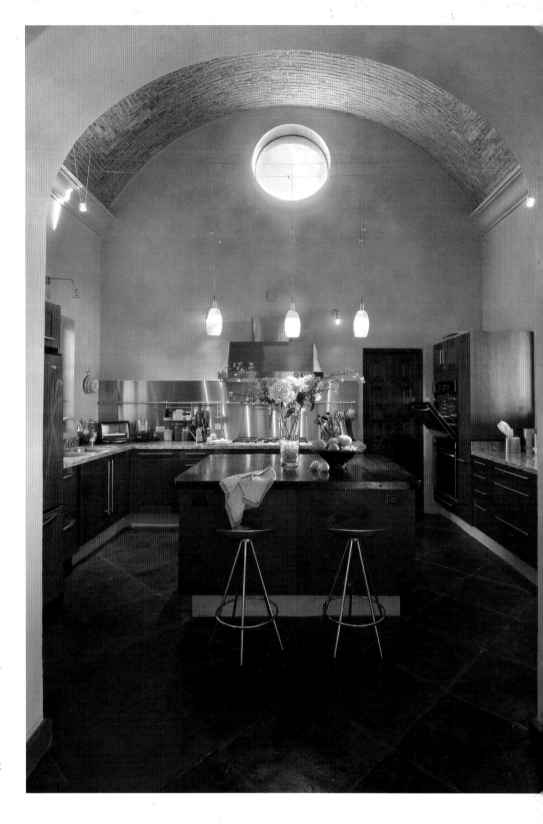

OPPOSITE: The deep, rich saddle stain of the saltillo tiles enhances the patina of the walls and emphasizes the *bovéda* brickwork above the living room and dining area.

ABOVE: Efficient with a center island, stainless steel, granite, and cherry wood cabinets, the kitchen is adjacent to the dining area for convenience and continues the living room design.

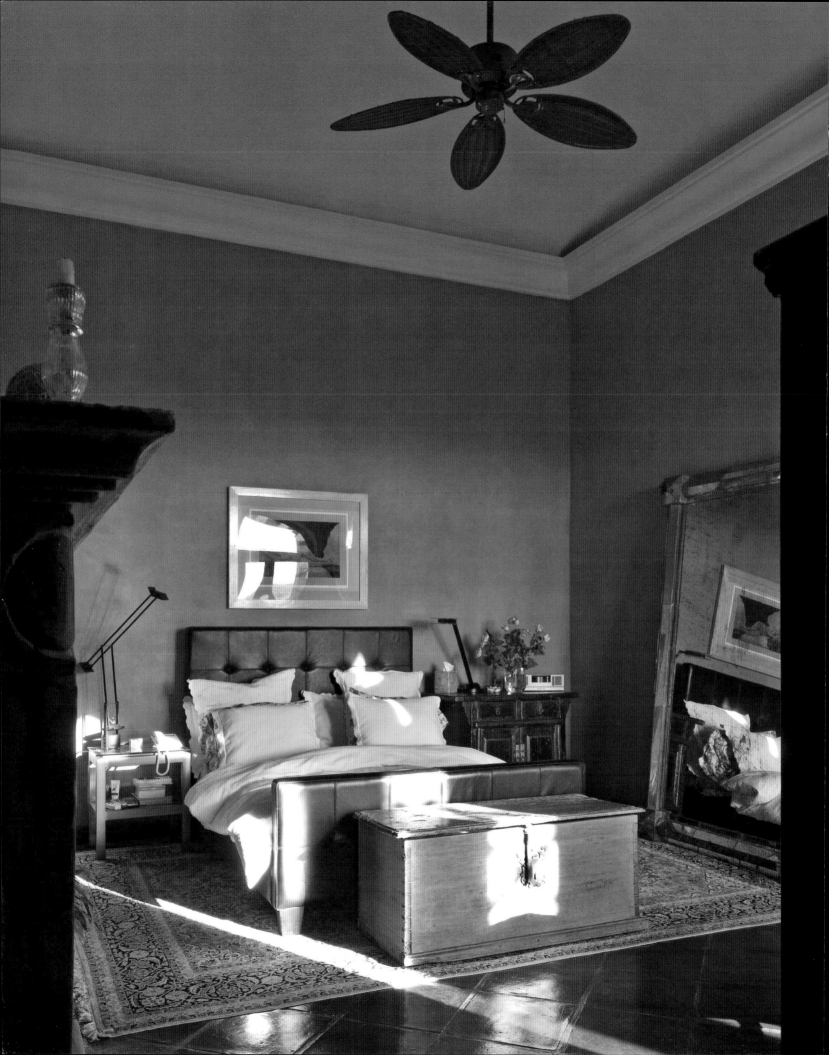

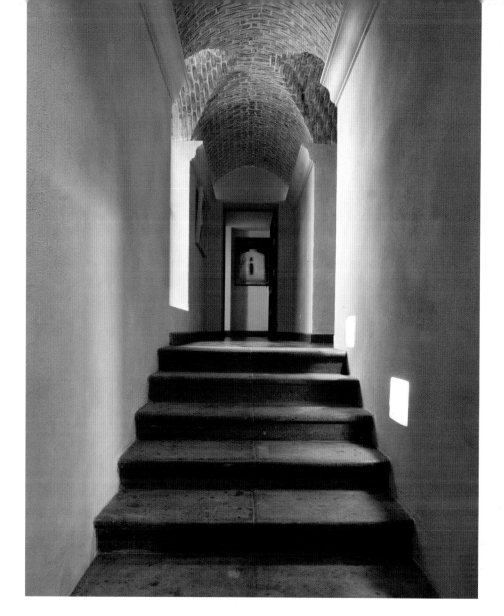

LEFT: The black leather headboard and the wooden chests complement the color of the walls. The gilded mirror gives a sense of depth.

ABOVE: Steps lead to upper rooms that continue the intricate brickwork overhead.
BELOW: Barbara's special chaise is always a favorite place to relax.

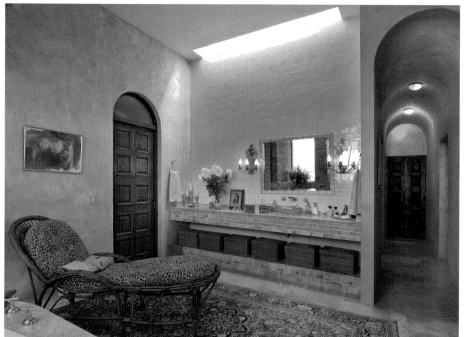

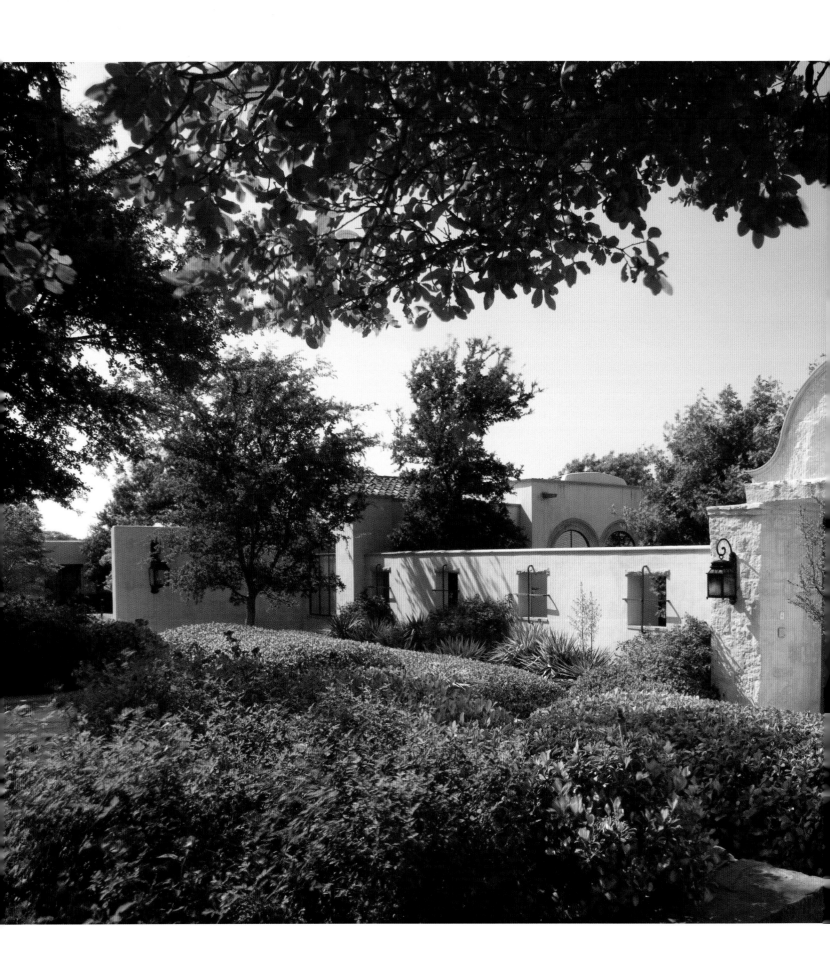

Aledo Ranch

OWNERS: Mr. and Mrs. David Moritz
ARCHITECT: TurnerBoaz, Weldon Turner
PHOTOGRAPHER: Charles Davis Smith

Style sometimes takes years to travel from one location to another, and perhaps even more time to become understood. The hacienda has been with us for four hundred years and is the result of years of adaptation to its environment and climate, and the availability or importation of resources and design fashion. The hacienda in Mexico was an organic form, able to accommodate alterations over time. It was built for continuous long-term usage. When a hacienda outlived its founding family, its design allowed it to become a government building and never go out of use.

ABOVE: The entry gate to the main house.
BELOW: The large two-story rectangular shape recalls the exterior of the old Spanish missions. Next door is the crow's nest.
LEFT: The courtyard is enclosed by lovely white walls that connect a variety of buildings. Landscaping borders the walkways.

The Aledo Ranch was designed with a bit of tradition in place. Although a Texas ranch, the building was casual and festive, and appeared tailor-made for small or large

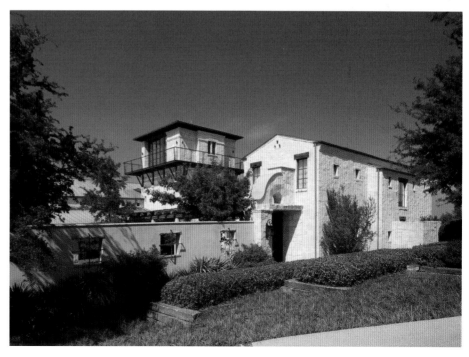

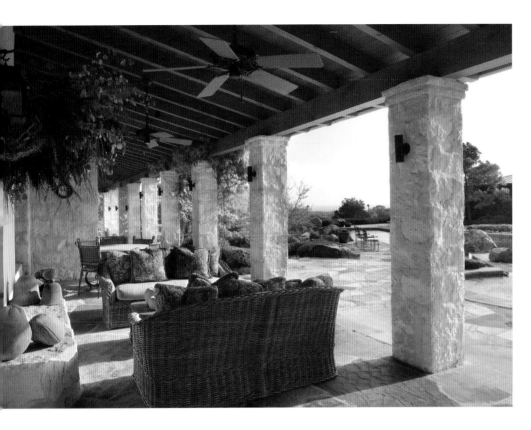

numbers of immediate family, extended family, and guests. This splendid example of the redefined hacienda is stunning from a distance, tucked into the hills and trees with just a note of age-old architecture standing out here and there. Several buildings catch the eye. A graceful half-bell arch over a stone lintel and gateway enclosing a wooden double-door entrance is a visible and inviting feature. A "crow's nest" surrounded by an iron walkway and railing looks over the valley in every direction and is also noticeable from a distance. One might suspect a monastic retreat at the end of the long and winding road.

The white stone structure, upon close inspection, is a delicious yellow limestone quarried near San Antonio. The stone and other building materials were part

ABOVE: The loggia below the crow's nest has casual seating in front of the fireplace and an area for lunch near the pool. RIGHT: The *zaguan* has an immaculate hush as the stone walls radiate the sensation of walking into a church. The entry leads to a dining room.

of the tradition of the vernacular ranch architecture of Texas. Giving the limestone a rough stone look was difficult, but the architect claims that "the goal was to have the stone walls look like they could have been remnants of a century-old ranch."

The interiors are immaculate in concept and design. The main entrance foyer is spacious yet simple in decor, utilizing a modified version of the traditional Mexican *tahaminil*, a design in wood that is layered between the wood beams of

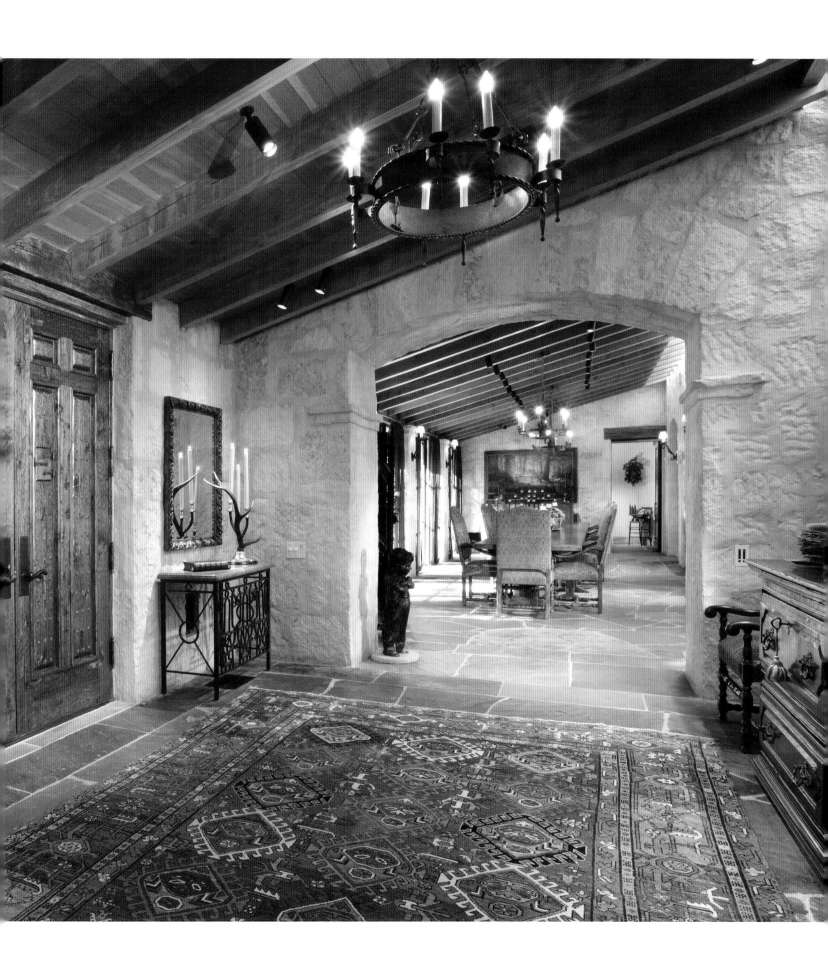

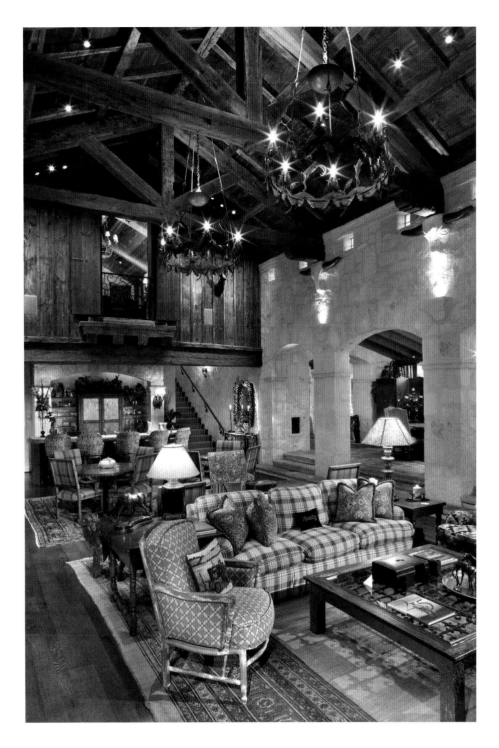

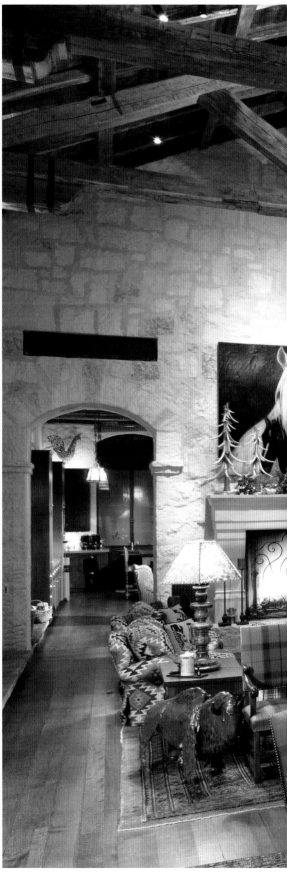

ABOVE: Steps down from the dining room, the great room provides a bar, game tables, and an upstairs game loft. RIGHT: The other end of the great room is warmed by a roaring fire in the fireplace. Overhead joists rest on posts capped with the casts of cattle heads with real horns. Archways lead to the kitchen.

the ceiling. The entry opens into a large dining room with flagstone flooring. A lodge-sized great room is steps down from the dining room through a series of arches. The great room is stocked with toys for children, game tables and a bar, comfort-

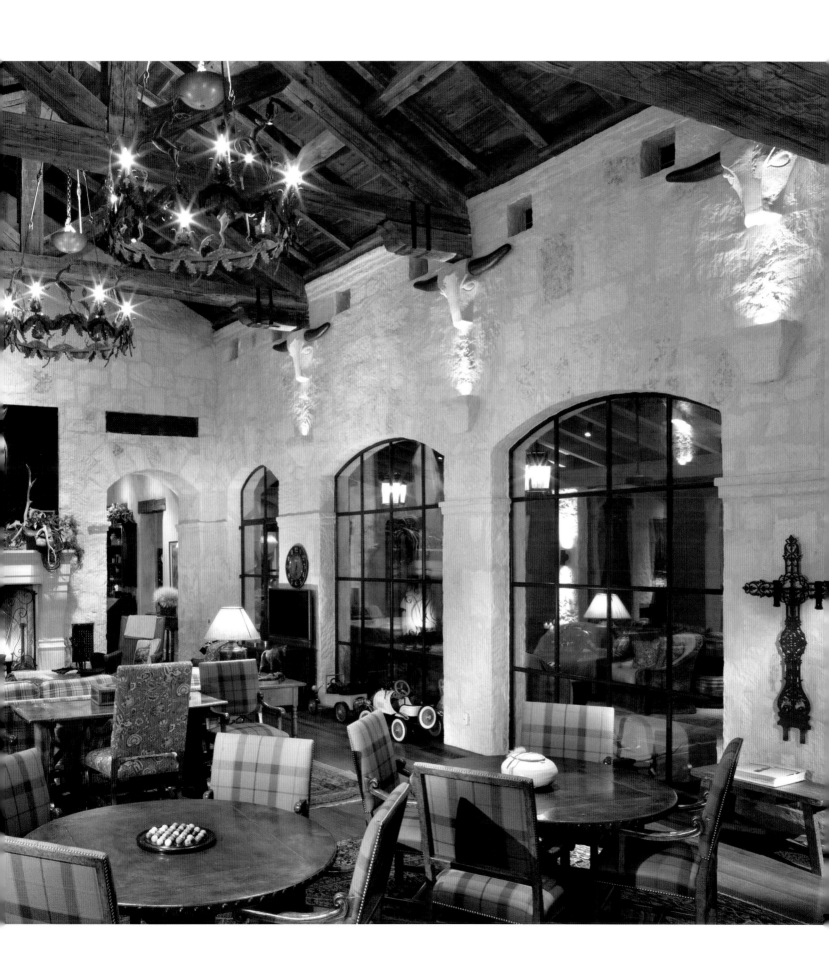

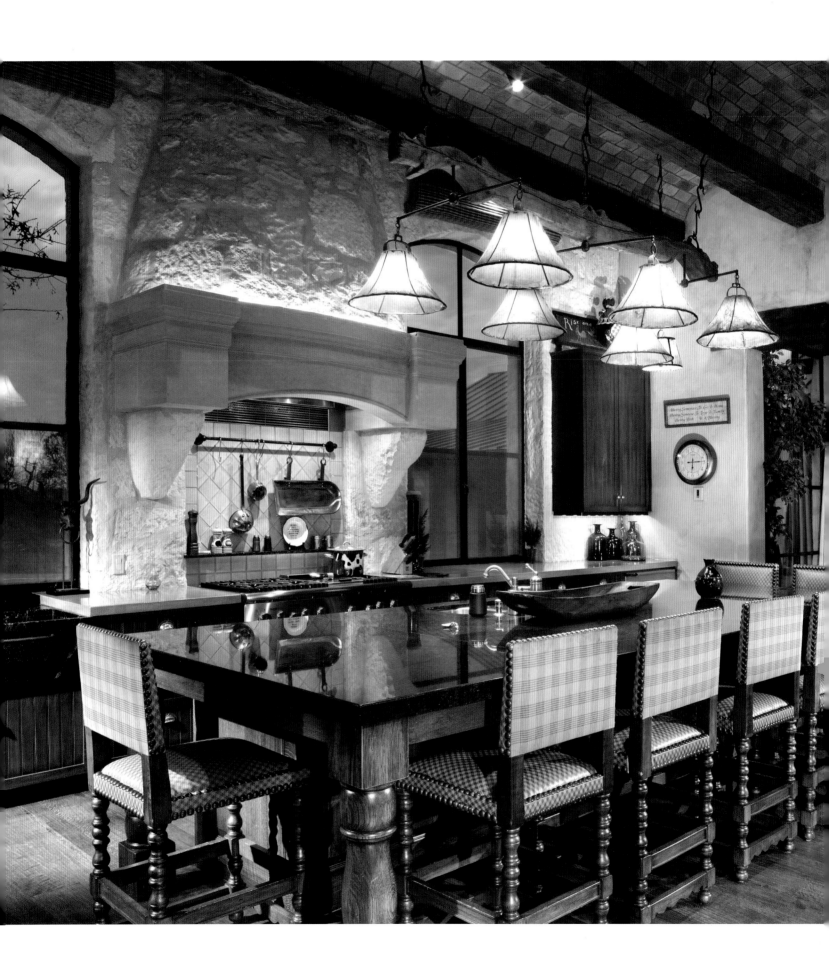

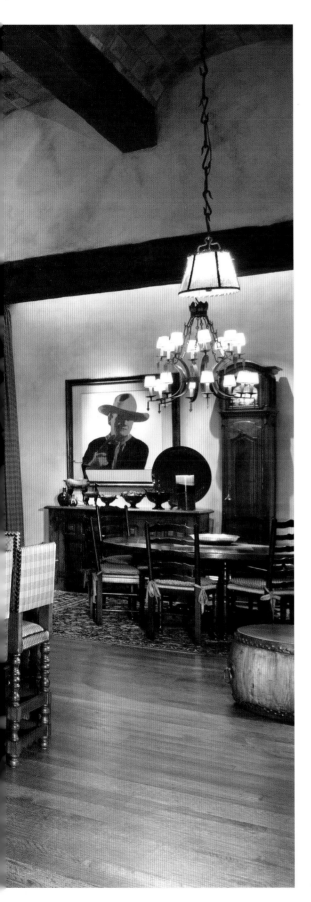

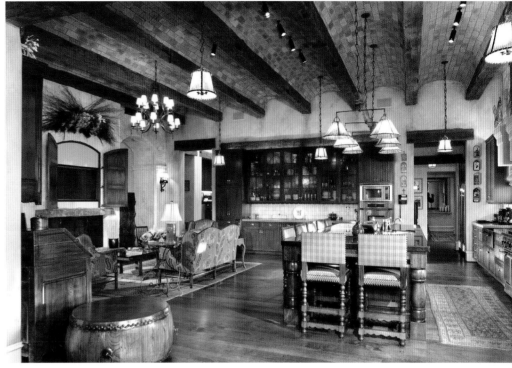

LEFT: A breakfast table seats eight. High arched windows overlook the plains. In the nook, Andy Warhol's *John Wayne* watches over the festivities. ABOVE: There are times for cocoa by the fire in the kitchen.

able couches, and saddle-based end tables for sitting and talking by the fireplace. The kitchen is accessible through the doors at the end of the great room. The kitchen has two tables, one to seat eight or ten and another for six or eight. The walls are made of the gorgeous Old Yeller limestone, as is the stove hood, which is carved and buffed to a creamy perfection. Overhead is a straightforward variation of the *bóveda* ceiling—multicolored bricks in a lateral pattern for shallow vaults between beams. Light fixtures are graceful and feminine. To capture the spirit of the place, Andy

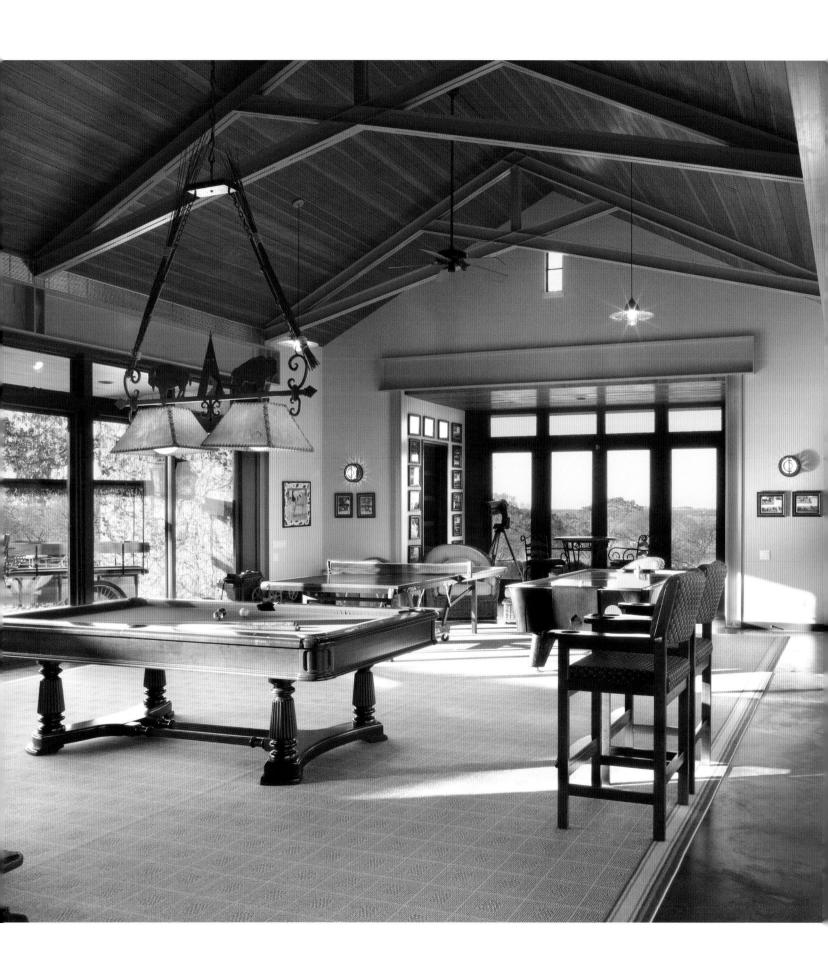

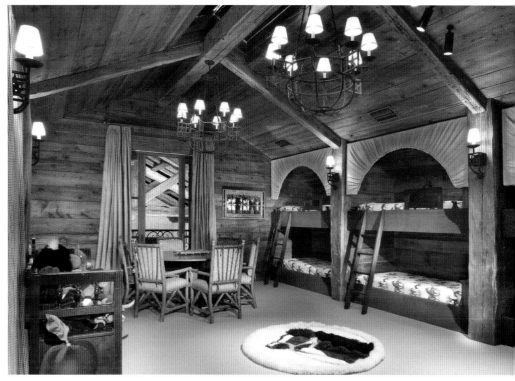

Warhol's *John Wayne* hangs in the children's breakfast nook.

The ranch is a collection of game rooms and bunkrooms, pergolas and pools and fountains. This Texas hacienda will surely last another three or four hundred years. As it should.

A B O V E : The bunkhouse above is full of toys and games, and can sleep a bustle of wranglers. L E F T : The billiard room is an indoor holiday of shuffleboard, ping pong, and a coffee cart on the balcony.

Ziebell Sanctuary

OWNER: Don Ziebell

ARCHITECT: Don Ziebell, Oz Architects

PHOTOGRAPHER: Werner Segarra

In Scottsdale, Don Ziebell created a home that he feels has a connection to hacienda architecture, although he believes the house is closer to a rural Mediterranean style. Again the roots of Spanish colonial architecture mingle a little with Italian rural styling—just enough to qualify as a contemporary variation of the theme. The home was constructed with a mix of antique, reclaimed, and modern materials. The architect used antique roof tiles, centuries-old oak beams outside, and pine beams on the interiors. There are Louis XIII French limestone fireplaces and

walnut doors with their original ironware. Four-hundred-year-old oak flooring and fountains made from ancient stone basins all contribute to the sophisticated mix of chronicle and manner. The front door is from colonial Mexico, as are many of the furnishings. Don feels the soul of his home rests within the pieces he has collected and imported, and they express themselves with grace.

Most buildings constructed two hundred years ago or earlier, were, by definition, what we now refer to as *green* buildings. They use indigenous materials designed to mediate and protect from the local climate, be responsive to sun and wind, and be handed down to future generations. Don travels extensively, and his habit of bringing back artifacts that may become a fireplace or dining table or

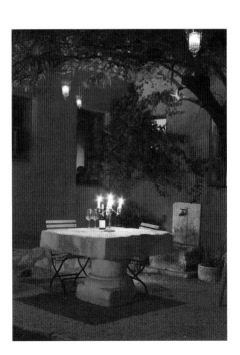

LEFT: A romantic setting with a stone table for two is tucked into a corner of the courtyard. OPPOSITE: Serene homestead-style architecture, with tile roof and rustic posts and beams. The dayroom opens onto a courtyard pool.

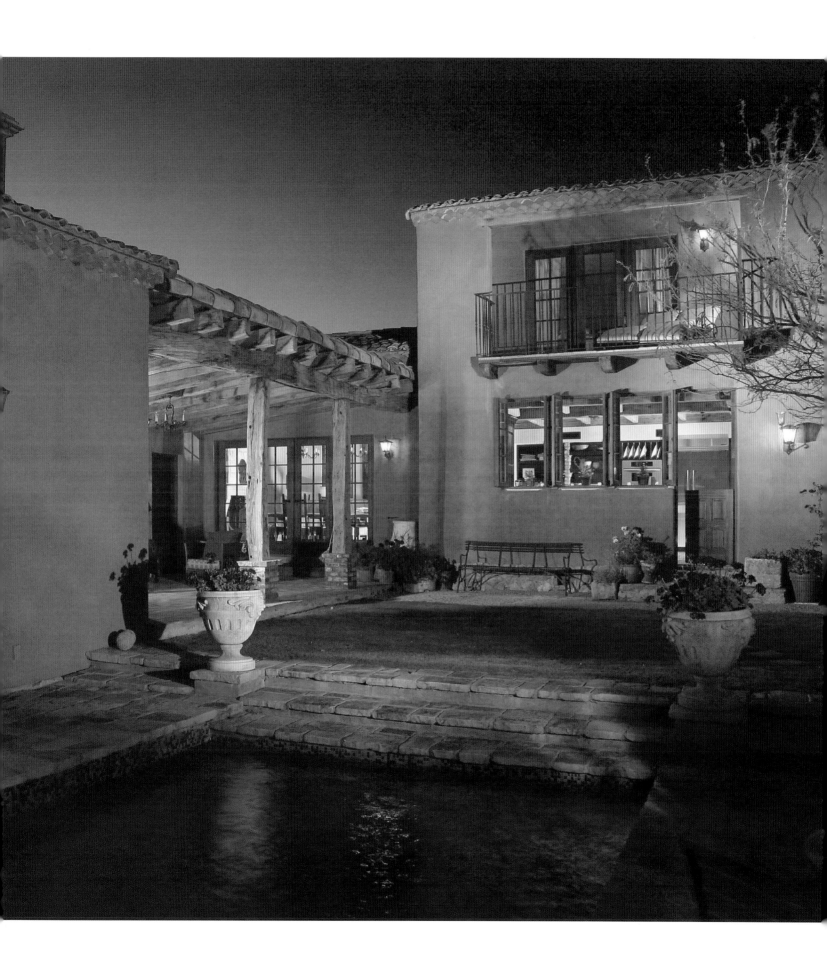

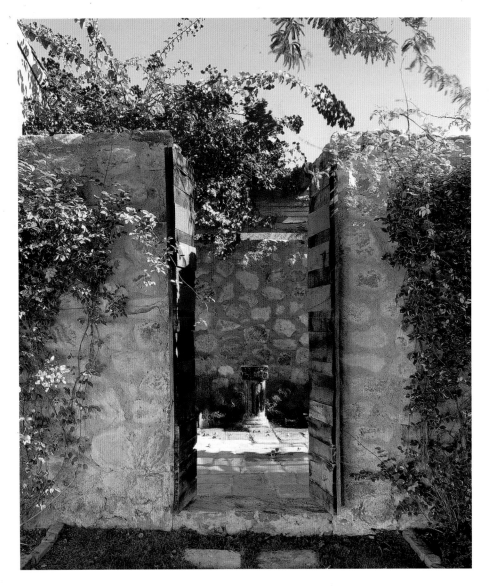

LEFT: Rustic wood gates lead through bright bougainvillea to a tiled outdoor courtyard. BOTTOM LEFT: A corner door to a bedroom from the courtyard. BOTTOM RIGHT: A view of the courtyard with the doors of the dayroom open. OPPOSITE: The dayroom opens to outdoor loggia living.

painting has flowered into a small import business, Antiquities, LLC. His dining table is a five-hundred-year-old monks' table, covered with knife marks and gouges, which promote a powerful experience and great conversation. Thousands of people may have used this table in the same way. The first time the overhead candle chandeliers were used they dripped mounds of wax, requiring guests to sit around making new gouges while clearing the wax.

The house was designed with a real connection to the outdoors. Conceived of as a collection of different buildings in a living compound, similar to the old haciendas, parts of the design "explode" and separate around a central space. Many of the interior spaces are connected to outdoor spaces directly; many outdoor spaces are covered and some are not. Outdoor rooms are furnished with an indoor flavor; the loggia has soft seating and a jute rug and contains a raised cooking fireplace that

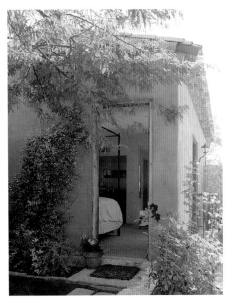

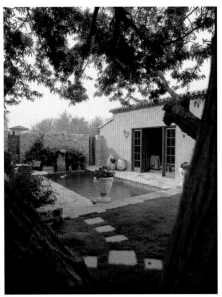

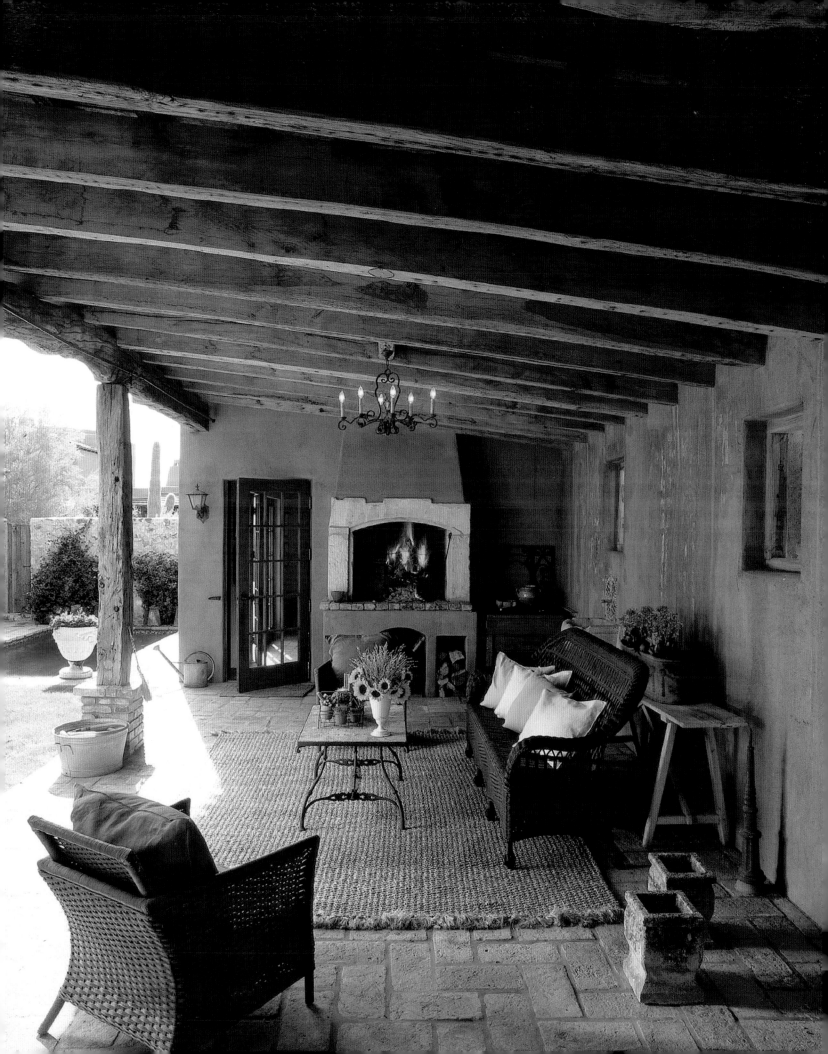

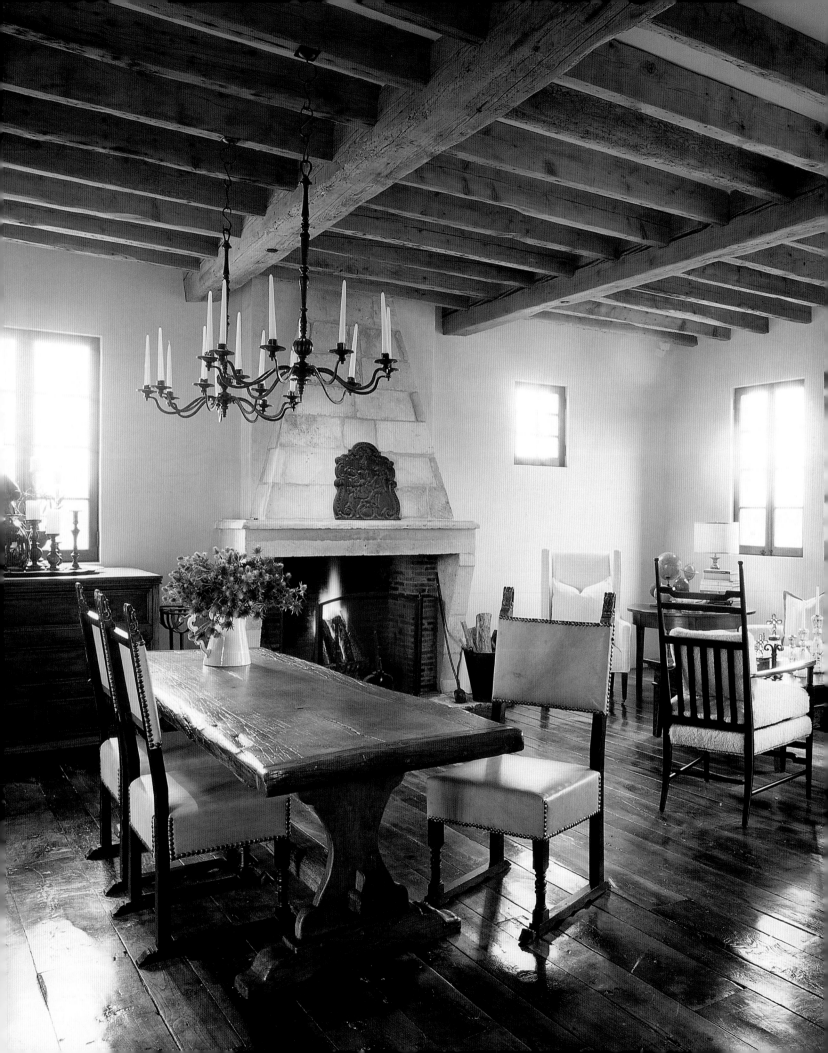

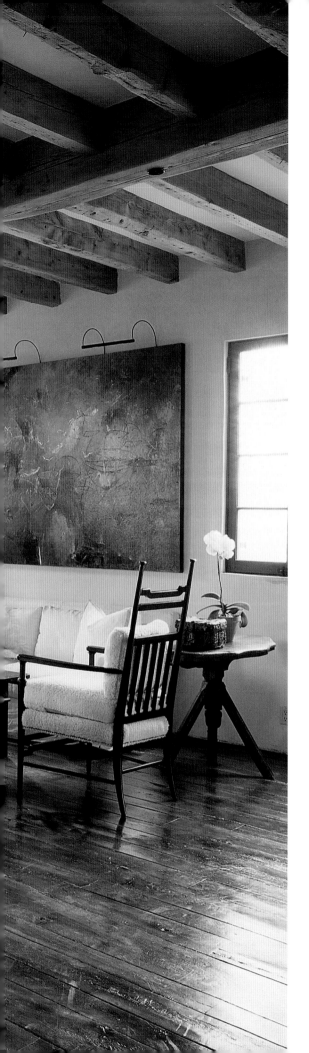

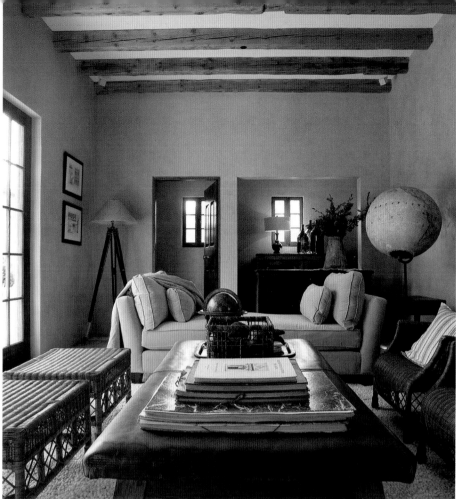

uses wood, in lieu of a barbecue, and an old stone sink.

The home is a favorite with Don's young daughter, who loves the three-inch-thick terra cotta antique fireclay bathtub. Rescued from an old H. H. Richardson estate on the east coast, it keeps water hot for hours, allowing her to lounge for at least that long.

The house is a sanctuary to Don, his family, and friends. After a recent holiday, his brother was talking to his six-year-old daughter. When asked what her favorite part of Don's house was, she replied that she liked "the big room in the middle." Don's brother asked which room that was, and she said, "you know, the big one with the tree." You can't get a greener house than that.

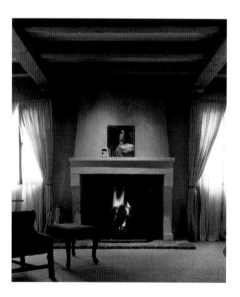

ABOVE: A dayroom has a daybed, globes, and books. BELOW: The dramatic colors and fireplace with painting recall a house in Tuscany. LEFT: The large living and dining area has a stone fireplace and soft wood floors. The trestle table and leather chairs add charm to the room.

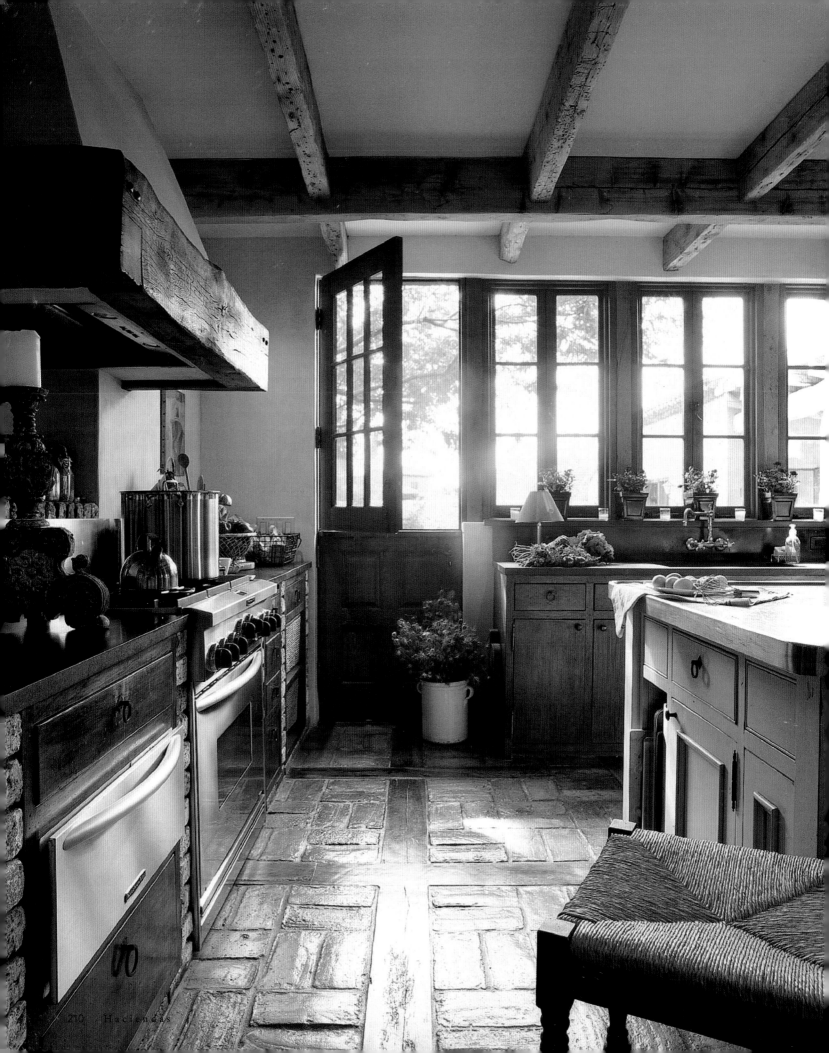

LEFT: The Dutch door lets morning air into the large kitchen.

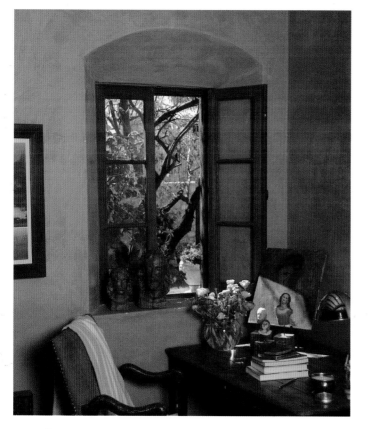

ABOVE: A crystal chandelier hovers above the freestanding bath, with the soft sway of the curtains behind. LEFT: From the desk in the studio the late afternoon sunlight can be seen through the branches of the tree.

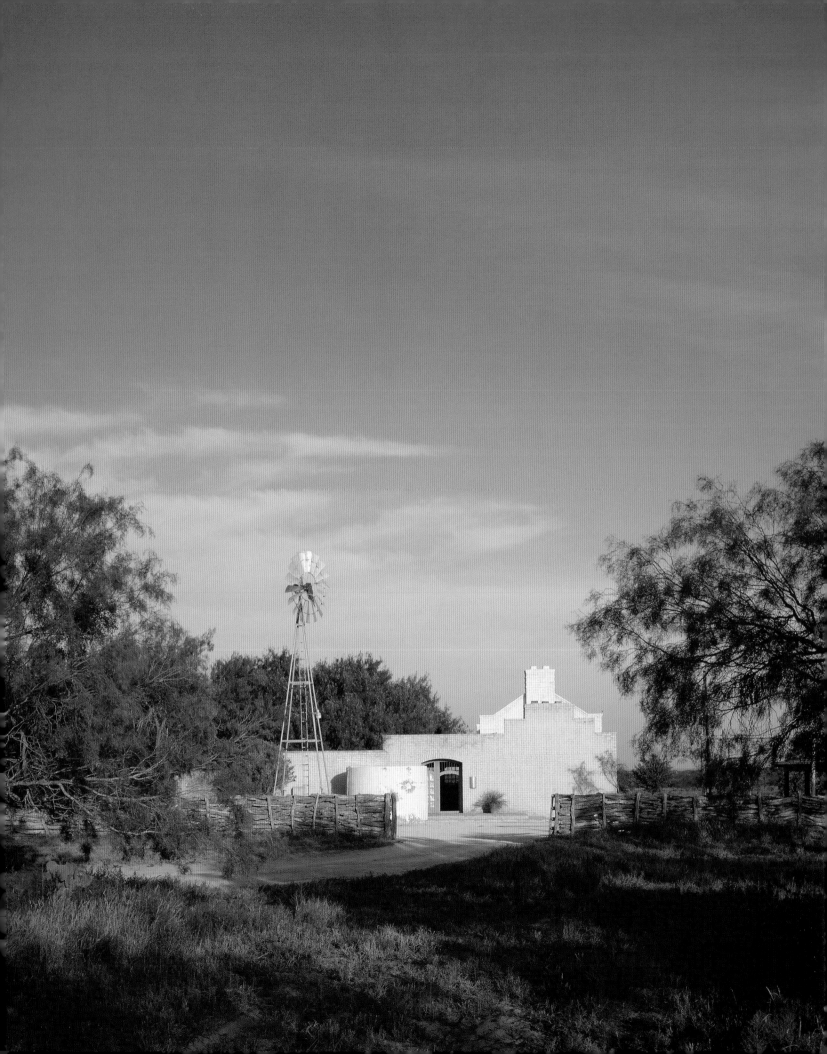

La Estrella Ranch

ARCHITECT: Lake | Flato Architects

PHOTOGRAPHER: Craig D. Blackmon, Black Ink Architectural Photography

The ranch is located within Texas's Rio Grande Valley, thirty miles from the Rio Grande River. The design called for a new ranch headquarters, incorporating two existing buildings on the top of a rise surrounded by native mesquite, wild olive, and Texas ebony trees. In the style of northern Mexico haciendas, a compound of new buildings (a guest room with an observation deck, a master bedroom with a private courtyard and outdoor shower, a family room, and a barbecue) was linked to existing buildings by porches, breezeways, and tall walls. A new wall, incorporating a windmill and water tank, signifies the courtyard. The central courtyard is cooled by the prevailing southeast winds from the Gulf of Mexico through well-oriented breezeways. Cold north and west winds are deflected over the courtyard and away from the porches by the placement of tall buildings and walls to the north and west of the compound.

The courtyard porches are designed as outdoor rooms, with dining and entertaining taking place there nine months out of the year. Tucked into a corner of one breezeway intersection is a bar with a large bull's head sculpture hanging on brick walls. Western-style wood furniture designed by the architects and cactus plants furnish the breezeway. The opposite end is furnished with game tables, dining tables, and rockers. Cactus designs and native animals are perforated into galvanized aluminized gates on a rough-hewn lattice at the main doors. Spindle arches top the main doors to let the breezes through. The building orientation and operable windows and breezeways are designed for natural ventilation and encourage a strong indoor and outdoor relationship for living that takes advantage of the South Texas climate.

ABOVE: The traditional geometries of farm and ranch architecture. BELOW: A view of the ranch entry, walled courtyard, and main house. OPPOSITE: A gravel drive leads to the ranch. A windmill and water cooler stand inside the rustic branch fence.

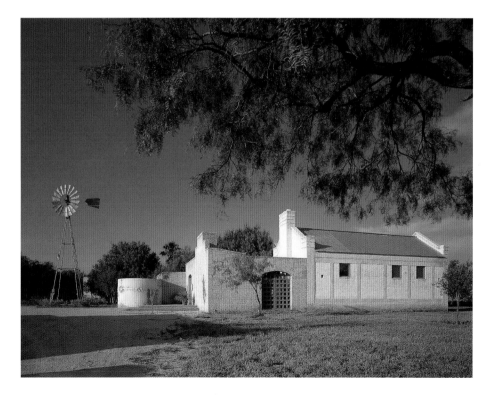

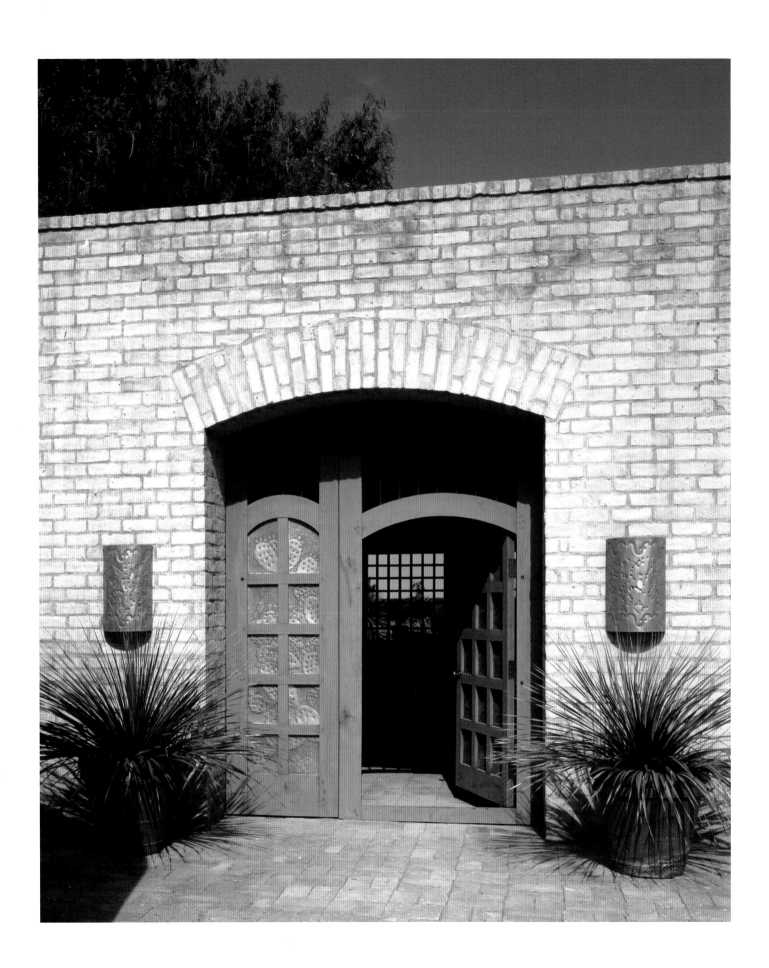

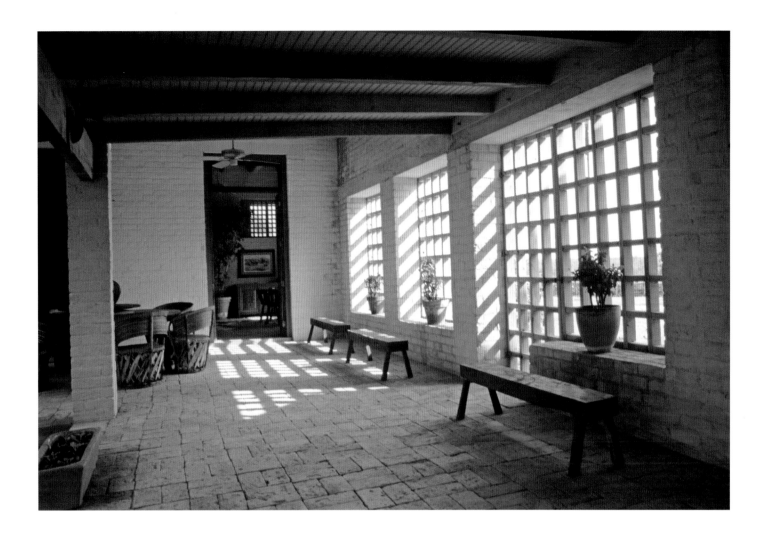

The inspiration for this hacienda came from nineteenth-century brick buildings around Roma and Rio Grande City, Texas. The brick cornices, recessed wall panels, and pilaster and door surround detailing from the old buildings were applied to the new buildings in the compound to create a "village." The hacienda was made to appear old by using a traditional Mexican paint consisting of buttermilk, lime, and powdered pigment and applying it to the brick. The porous bricks sponged up the pigment, leaving a wall resembling an old stucco wall in Mexico. The effort to create a "premodern"

architecture—by utilizing two-foot-thick walls, unpainted clinker bricks, vaults, and a *bóveda* dome—very nearly resulted in a style resembling a postmodern hacienda. Local masons and artisans, and materials from Mexico, were incorporated into the design. Wood flooring, doors, and furniture were fabricated from mesquite wood harvested from the ranch's dead and standing mesquite trees. All masonry products came from a brick factory only thirty miles away. The ranch takes on a thoroughly regional design with its use of indigenous forms that have been built in nearby border towns since the 1880s.

OPPOSITE: The entry gate of wood and punctured tin panels opens to the loggia. ABOVE: A latticed wall creates a breezeway on the loggia. BELOW: A table for drinks is at one end of the loggia, and a Bull bar is at the opposite end of the long corrédor.

PART V

You have to begin to lose your memory, if only in bits and pieces, to realize that memory is what makes our lives. Life without memory is no life at all...

—Luis Buñuel

SUEÑO DE OLEANDER (DETAIL)
Margarita Leon
Fired clay, eggshells, pigment
17"h x 35"w x 12"d.

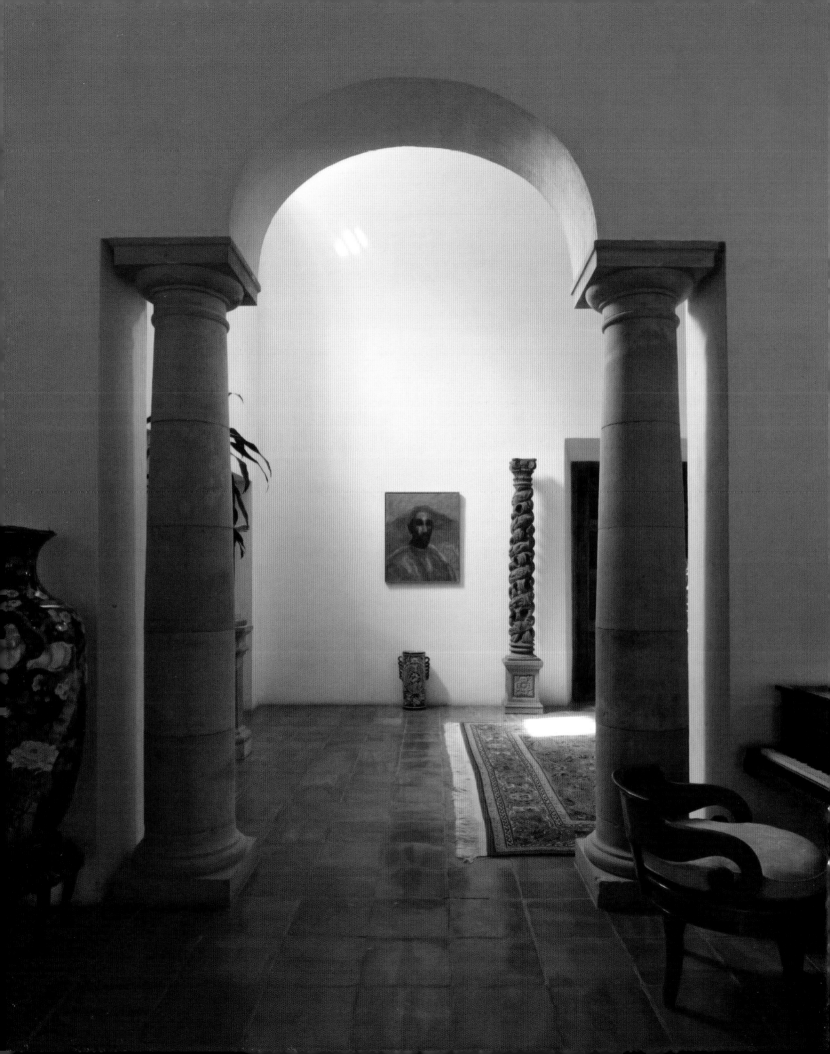

San Joaquin

OWNER: Xavier Barbosa de La Torre

ARCHITECT: Xavier Barbosa de La Torre

PHOTOGRAPHER: Ricardo Vidargas

Xavier Barbosa de La Torre is a man with a large family. He also considers many of his legion of friends to be family. It is those family and friends, great artists, who have given him an illustrious collection of paintings, photographs, and sculptures, which he cherishes and displays in the San Joaquin Ranch. They are treasured as much as his esteemed collection of saint statuary. The sway of the saints can be found in the cool breezes that blow past the statues in the loggia and flow around the corners of the hacienda. A carved soldier, seated on horseback, commands a corner in a hallway, hand held high in provocation, or in an act of annunciation. The art stirs the breezes and causes the leaves to flutter.

When Xavier went searching for his property in 1962, he found this beautiful plot of land just outside San Miguel. It is a working ranch where he raises fighting bulls on roughly 150 *hectares* (370 acres). The countryside used to be unobstructed and wild, and the hunt was the primary attraction. Today, the horses work only inside the ranch. In the past, Xavier and his family would take the horse carriage down the long cobblestone road from the hacienda into town to have fun and enjoy

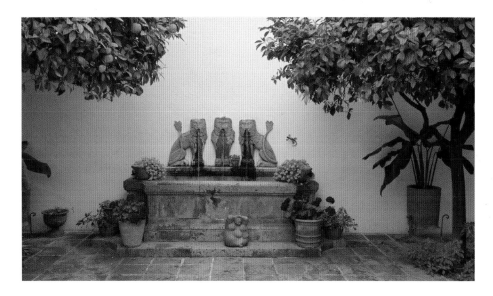

LEFT: The *zagúan* is an open volume of light and space. The portrait is of Xavier Barbosa de La Torre. ABOVE: The Three Lions Fountain in the courtyard is framed by luscious colors and ripened orange fruit. RIGHT: Richly carved and clothed, a painted angel is a benefactor of peace to the hacienda. BELOW: An intricately carved limestone fountain features a basin. A small pendimented roof protects the pillow-cut, white-tiled wall.

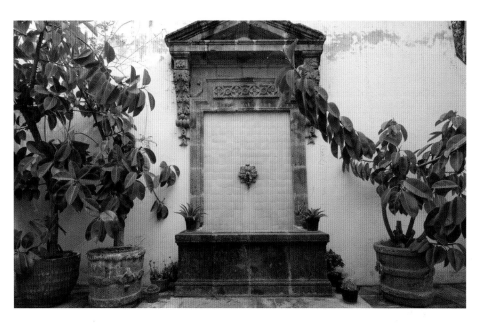

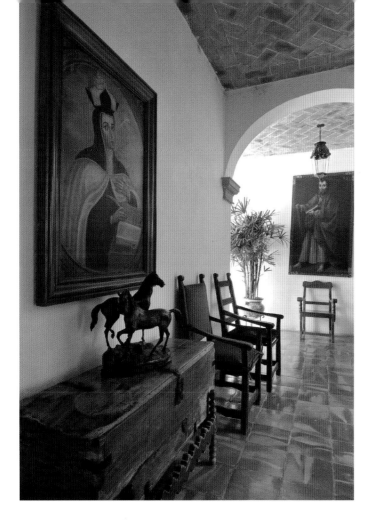

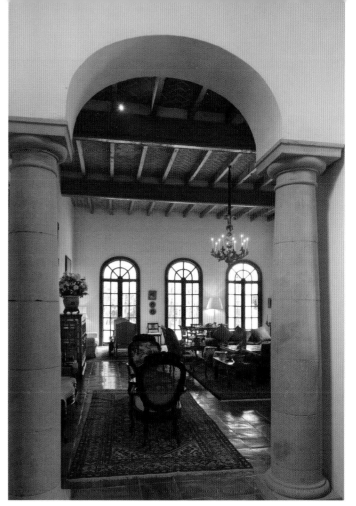

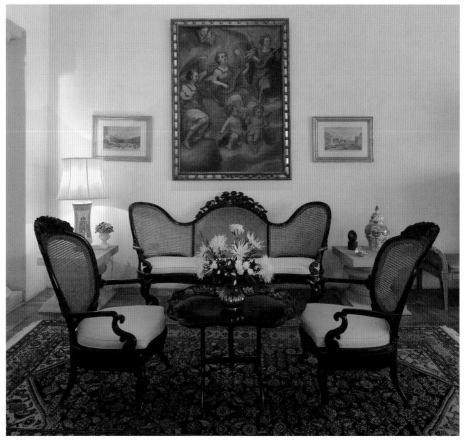

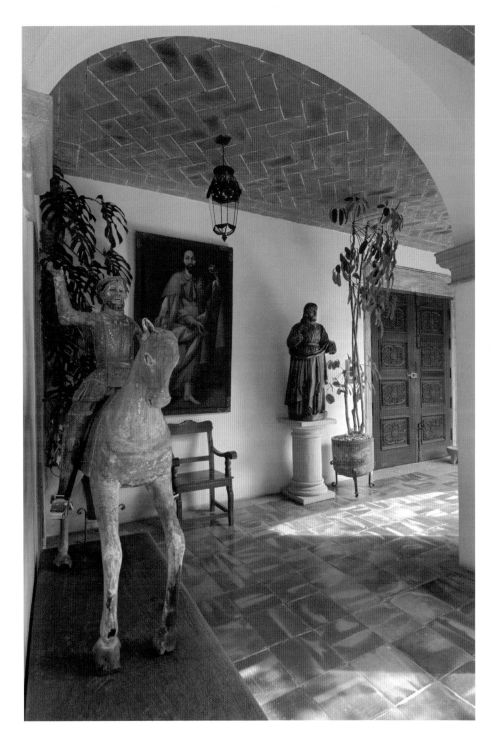

the fiestas. Some of the best fun at his San Joaquin home was having the hunts and *tientas*. The *tienta* brought the new female breed of bulls (cows) to be tested (they were also used in bull fighting) for their aggressiveness and cast to determine the breed. Friends came, and after the hunt, they would all gather and have a luncheon. Afterward, friends would gather to spend a good portion of the day with Xavier, and some of them would also enter the rink and dare to get the attention of the bulls.

Talent, courage, strength, and a great sense of adventure and love of art are essential to daily life in a hacienda. Xavier is proud of this location, of the beautiful house and the gardens he has built. His favorite places are his grand salon, the large living room that is in itself a series of vignettes and special places. He also adores his swimming pool. As an architect, he believes that building materials are especially important. He has created this place in the countryside using Cantera (limestone); Loceta Peron (floor tiles); wood beams (with new and antique brickwork above); interior and exterior arches of stone; French doors, wood doors, and iron hardware. These materials are what brought him his home, where he has views that will last a lifetime.

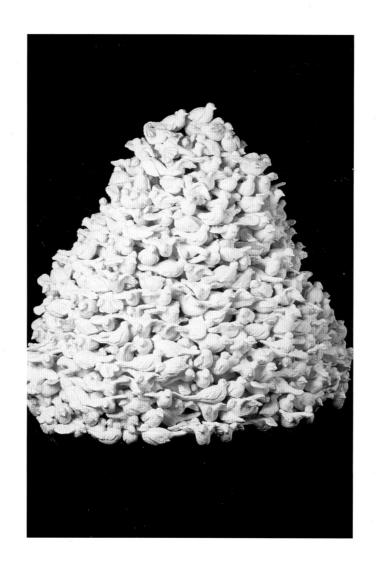

Acknowledgments

The journey to create this book was a complete delight in every way. I am grateful to many generous and talented people in the southwest United States and Mexico who made this book a wonderful experience. Generosity has no limits, and a passion for life is its own reward. Histories and echoes found in haciendas are the connective qualities of architecture, generally admired in their earlier forms from many countries. Here they are embodied with a unique romance and grace. To complement those qualities, I have had the good fortune to include the work of Venezuelan fine artist and sculptor Margarita Leon. Her work epitomizes the profoundness of emotion, passion, and strength that endures in all cultures and in their architectures. Thank you, Margarita. I wish to thank Ricardo Vidargas, without whom this book could not have been done. His photography is a treasure to us all. His personal and creative talents were guided by an unfailing and uplifting spirit. I am eternally grateful to have had the opportunity to work with him and hope to do so again. Thank you, Ricardo.

To all the photographers who participated in this book, I am grateful for your enthusiasm, commitment, and professionalism. It has been a pleasure to work with you. I wish to thank Chris Gangi, art director for *Phoenix Home & Garden*, for help in coordinating locations and photography. I am grateful to Karl Eifrig at the Prairie Avenue Bookshop in Chicago for his enthusiastic and thorough research into the depths of hacienda literature. My discovery of Douglas Newby of Douglas Newby & Associates and his lifelong passion for historical architecture was a blessing. His efforts to create a resource for architecturally significant homes in Texas is a well-recognized and ongoing love affair. Thanks also to Dottie Griffith at the Dallas Arboretum and the DeGolyer House. I thank the architects, designers, landscape architects, and homeowners for sharing their passions.

The passions that have helped me, too, are on the home front. I would like to thank Dawna Galarneau Miller, Bob Miller, Rick, Genevieve, and Nicole Galarneau for being a loving family. I couldn't have done my work without their love and support. To the poet Geraldine Helen Foote, thank you so much for everything you've done this past year for everyone, and for supporting my efforts. Marilyn Booth-Love and Ken Love, deserving of their name, are a gift. Thank you both. Kerry D. Hampton III is a true friend and a great humorist.

I am especially grateful to my editor at Rizzoli, Alex Tart, for her brilliant and unfailing guidance in daring and tenacious lands. I am most grateful to Lynne Yeamans for her creative talents as the book designer. And I wish to thank Pam Sommers for her invaluable skills and endless grace on my behalf. To Mr. Charles Miers, publisher of Rizzoli/Universe, I thank you profoundly, for including me in your group of authors.

Para Robert, Espero que campanas de Iglesia, la luz del sol y el canto de pajaros llene tus manyanas.

ESPARANZA, A NECESSARY CONDITION
Margarita Leon
Materials: Hydro cal
Birds each 8"l x 5"w x 4"d
Mountain: 5'h x 46"w x 46"d.

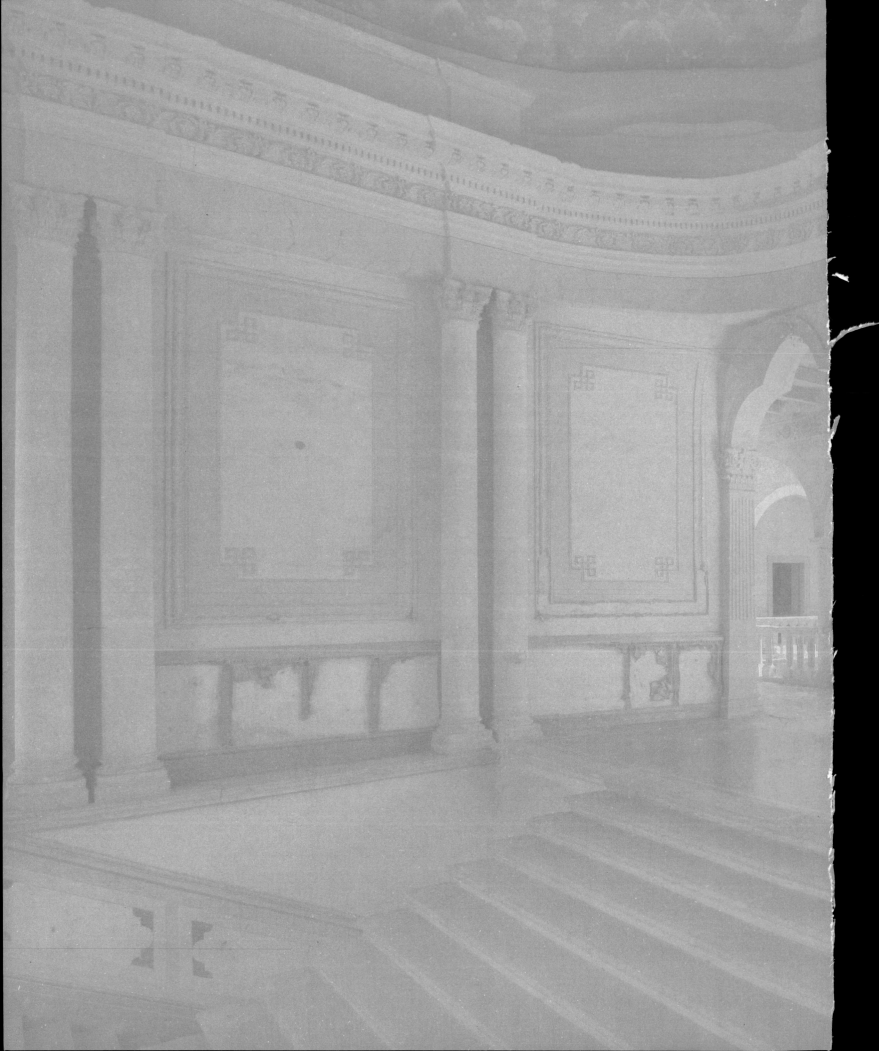